W9-ARQ-619

HPBooks®

Pro Techniques of

People PHOTOGRAPHY

Gary Bernstein

Published by HPBooks, Inc., P.O. Box 5367, Tucson, AZ 85703 (602)888-2150
ISBN: 0-89586-269-7 Library of Congress Catalog No.84-80199
© 1984 HPBooks, Inc. Printed in U.S.A.
3rd Printing

Publisher: Rick Bailey
Editorial Director: Theodore DiSante
Editor: Vernon Gorter
Art Director: Don Burton
Book Design & Illustrations: Kathleen Koopman
Typography: Cindy Coatsworth, Michelle Claridge
Director of Manufacturing: Anthony B. Narducci

THANKS

I am sincerely grateful for the generous help given by many individuals and companies.

Special thanks to:
Alfa Color Labs, Inc.
A & I Labs, Inc.
Robb Carr, Inc.

DEDICATION

For my three ladies, Anita, Romé and Caron . . . I love you.

Gary Bernstein
Los Angeles, CA

FOREWORD

I've had the privilege of observing Gary Bernstein at work. In the final analysis, this is the best way to understand this photographer. What makes him so special is his genuine and uncritical affection for people.

The photographs in this book reveal the extraordinary care Bernstein exercises in lighting and other technical detail. Yet, when you watch him at work, you are much less conscious of *technique* than *effect*. Light is merely his raw material. He uses it to permit us to see with a uniquely expanded vision.

Whether he photographs superstar, socialite, executive, model or child, Bernstein's warmth immediately puts his subject at ease. People feel safe in front of his camera—and honest emotions and character emerge.

There's a remarkable paradox in Bernstein's work—slick technique mixed with basic human emotion. This book affords you a fascinating and revealing insight into a fine photographer's way of seeing.

Hank Schwarz
Haller Schwarz, Inc.
Los Angeles, CA

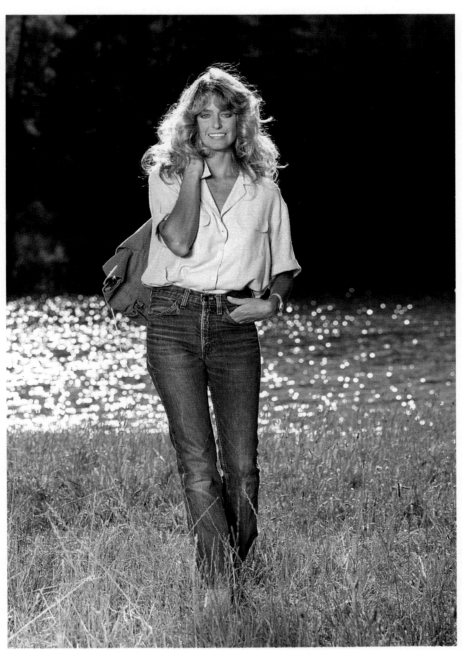

Farrah Fawcett
by Gary Bernstein
courtesy of the
American Cancer
Society

Contents

Introduction

I was 19 years old and already dedicated to the passion called *photography* when I mustered the courage to approach my idol. For more than a year, unknown to him, I had periodically crept into his studio, admiring the color and b&w images on his walls. Perhaps I had hoped that a form of osmosis would implant his special brand of two-dimensional drama in my mind's eye. As a believer that the artist's personality is apparent in his work, I had high hopes for a meeting.

Eventually, we met. I asked him my neophytic questions. In return, I received his silence. By his own declaration, his photographic techniques were secrets. He said no more! I left that futile meeting feeling empty and hurt. I believe to this day that his attitude reflected the height of insecurity.

It was then I vowed never to have aesthetic secrets, should the day come when others desired to learn from my images.

Since then, my life has been a total commitment to photography. Although my involvement has been a professional one for about two decades, the passion still burns. The medium is no less my *hobby.* Inherent in such emotion is the dedication to please myself as well as my clients.

In preparing this book, I was tempted to write the *usual* sections about lighting and filtration, lenses and cameras, shutter speeds and lens apertures. But because I'm a pragmatist, something would have been missing. To me, information without specific application is a nebulous entity. True knowledge is a consequence of practical application.

I decided to produce a truly *photographic* book, built around some of my favorite images. I'll discuss the tools, techniques and *thinking* used to achieve a variety of what I consider appealing end results.

I purposely avoided discussion of photographic theory for its own sake.

Instead, the book is composed of a series of essays discussing the medium in terms of *practical application.* Following the essays is a rich selection of pictorial examples, together with full technical information and the thought process that helped make the photographs. Some repetition is unavoidable because each photograph is an interplay of techniques.

There is no right way or wrong way to make a photograph. I think it is for *you* to determine the photographic treatment that makes the best statement.

Our common goal is to produce better photographs. The book is designed with that end in mind. Most important to me, I hope this book is *fulfilling* for you. It represents what I had personally hoped to receive from that secretive photographer so many years ago.□

Light

The key to photographic quality rests in your ability to *see and control* light. This is regardless of the kind of illumination you're using and the nature of the subject matter. Light to the photographer is like crude oil to the automobile. Only through its proper refinement is it useful and beneficial. It's essential that you learn to manipulate light to serve your needs.

The commonly used terms *good light* and *bad light* have no meaning in photography. There are, however, successful or unsuccessful photographs—a determination made by your own evaluation. As a creator of images, you must constantly ask yourself whether you've produced what you had envisioned.

Lighting conditions can change in the middle of a photo session, particularly when you're working with natural light.

It is within your ability to control light in every situation, whether you are confronted with nature's unpredictability or the constancy of artificial studio light. Only this control makes possible personal interpretation and a singular approach to problem-solving that makes each photographer's vision unique.

STATE-OF-THE-ART CONTROL

Today's cameras, lenses, films, exposure meters and backup equipment provide flexibility and control for every conceivable lighting situation. Such foolproof photography allows the motivated photographer to consistently concentrate on the *ideal* shot.

Photography, at its most basic level, is a scientific phenomenon. It allows you to repeat procedures with totally predictable results. The mastery of photographic technique is like learning to speak. How we use the technique determines the level of communication.

Approach each new photographic situation with an open mind—the way a painter confronts a virgin canvas. This flexible thinking separates the snapshooter from the creative photographer. Like the painter, you should approach each image as a unique event. Evaluate the limitless variations and modifications at your command.

Such mental conditioning is built on strength, resulting from study, testing, application and confidence. Only when the control of your medium is as reflexive as blinking an eye are you truly free to create.

The photographer's passion is unique. It constitutes the desire to enthral ourselves and others with the fantasy of our imaginations. The photographic *language* is equally unique. When spoken eloquently, its appeal and understanding are universal.

As photographers, we have the ability to capture a singular moment in time with incredible detail—and preserve it for years, or even centuries. For this reason alone, dedication becomes its own reward.

PHOTOGRAPHING PEOPLE

I stated earlier that the success you achieve photographically is primarily a matter of personal evaluation. Only *you* know if the result justifies your original perception of the subject. The commercial photographer is not as fortunate. He has various masters to serve. It's with chagrin that I recall occasions when I relished the fruits of my labor, only to have the client view my efforts as a futile exercise.

Photography, whether viewed as an art form or business, is subject to a strict "law": Beauty and success are in the eye of the beholder.

The still-life or product photographer is in a unique position. He works with subjects that refuse to smile back

at him. Part and parcel of his craft is the limitless array of lighting effects and camera angles that he can use to photograph his subject. Try as you may, it is difficult to make an apple or bottle of cognac ugly—except, perhaps, by painting graffiti on it. This is not to belittle the effort and talent required for a product photograph. On the contrary, it is a tribute to those photographers who consistently arouse enthusiastic approval for their work.

The photographer of people is more restricted. Camera angles and lighting must be selected with care, to record a flattering representation of the subject. The viewer either likes or dislikes the result. When you photograph people, you lay yourself bare to scrutiny.

Never are people more critical than when viewing their own images. As the artistic servant to your subjects or clients—a cap you don from the moment you point a lens in their direction—you must be prepared for their evaluation. It is your subject, alone, who becomes judge and jury of your success or failure—and rightly so!

PHYSICAL PROPERTIES OF LIGHT

Photography is an art form based on physics and chemistry. There are certain intrinsic properties of light you must rely on. The two most significant of these are that *light travels in a straight line* and *light can be redirected by reflection.*

Apart from such basic laws of nature, I tend to detest *rules* in an art form. However, rules can be the springboard to a wealth of creative expression. They provide a foundation from which to begin, analyze and grow. In *that* context, they should be accepted.

NATURAL AND ARTIFICIAL LIGHT

It's important to appreciate the differences between using artificial light sources and natural light. You have total power when you work with artificial light sources because *you* control the direction of the light. If you don't like the way the light looks on your subject, change it. It's that simple.

As soon as you set foot outdoors, into Mother Nature's studio, you find yourself a slave to her every whim.

There are only certain times of the day, for example, when the angle of direct sunlight is appropriate for people photography without modification. And you can't move the sun as you can a light stand!

Consequently, you must move your *subjects* instead. You direct and position them in relationship to the light source until it is flattering to their faces.

LIGHTING ANGLE IS IMPORTANT

To flatter the subject, you must light the face properly. Whether you're photographing a head-and-shoulders portrait or a large group, facial lighting becomes the barometer for the entire shot. To determine the proper lighting angle for a face, look in the subject's eyes. The main light source should create a reflection on the surface of the iris of the eye. This reflection is called a *catchlight.* It is essential to your people photos, if the subject is to appear lively and vibrant.

Position the light—or move your subject—so the face receives light from the best angle. Generally, a face should be lit from an angle slightly above the height of the subject's eyes to an angle approximately 45° above the eyes, as shown in Illustration 1-1. The ideal lighting angle will differ slightly, depending on the subject. Exact placement is your personal decision. This is one of the factors making your photography a personal statement.

The Eye as a Clock—Imagine your subject's eye to be the face of a clock, with the pupil as the center of the dial. Proper portrait lighting creates a

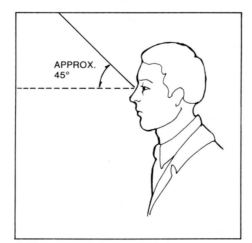

APPROX. 45°

1-1

catchlight between 9 and 12 o'clock, when the main source of light is to the left of the camera. When the main light is to the right of the camera, the catchlight will be between 3 and 12 o'clock.

Were the main light placed directly in front of the subject—and pointed horizontally to 45° downward—the catchlight would appear between the center of the eye and 12 o'clock. If the main light were *below* the level of the subject's eyes, you would emphasize the lines under the eye and the protrusion of the cheek—usually a most unattractive effect.

LIGHTING ANGLE AND HUMAN ANATOMY

Determining the lighting angle is not an arbitrary decision. All faces are different in terms of size and exact position of the features. For example, the width or length of the nose, distance between the eyes and thickness and length of the lips vary from person to person.

Basic facial anatomy, however, is remarkably similar in all faces. The structure of the human face contains one series of bones forming the forehead and a second series forming the cheek. Together, they create a crater of protection around the eye sockets. If your main light is too high or too low, it strikes the surrounding edge of the crater, causing a shadow to fall over the eye. No catchlight will appear.

I study two general areas of the face to determine the best direction for my main light. The first is the position of the catchlight in the eye. The second is the length of the shadow line between the nose and the top of the upper lip.

The effect of highlight and shadow created by the main light on the subject's face is known as *modeling.* Because all faces differ in structure, the modeling created by a specific main-light position on one face will appear slightly different on another. Modeling that enhances the masculine face, for example, may be unsuitable for the feminine face.

Shadow Line Below the Nose—When the main light strikes the face from above eye-level, you'll notice a shadow below and to the side of the subject's nose. If the main light is placed too high, the shadow lengthens to touch or cross the subject's upper lip. The lengthened shadow is accept-

able on the masculine face. This is because it falls within an area that is typically darker because of the natural "shadow" of the beard.

On the female face, the lengthened shadow makes the area immediately above and below the lip look dirty and misshapen. Lower the light—or raise the subject's head—to give a clean outline to the mouth.

All elements in photography should contribute to a balance. The shadow areas created by your lighting are as important as the highlighted areas.

Low Main Light—Is it possible to achieve dramatic results with the main light lower than the level of the subject's eyes? Definitely, but careful placement of the light is essential. If the main light is placed too low, you produce "monster" lighting. If you've never seen the effect, try shining a flashlight at your face from below in a darkened room while looking in a mirror. You won't soon forget it!

A low main-light position generally should be reserved for men, young women and children for the following reasons: The face of an adult male contains angular planes that can be enhanced by more extreme lighting angles. A younger face, because it has yet to develop the depth and angularity it will attain later, can also take this kind of lighting.

An extremely sensual look can be achieved with a young woman by lowering the mainlight, maintaining the camera position, and asking the subject to lower her head. Then ask her to look up at the camera. This brings the iris of the eye to the top of the lid. It emphasizes and apparently enlarges the size of the subject's eyes. It can be very dramatic.

A mature woman may be photographed with a low main light position if you compensate for it by changing the angle of her face to the camera. She must lower hear head so the light is effectively striking her from a higher angle.

This is also an appropriate corrective technique for the subject who has a narrow, thin face. By lowering the subject's head, while maintaining your camera position, you allow *perspective foreshortening*. This gives the appearance of a shorter, wider face.

Tilting the head slightly higher while maintaining camera position would also foreshorten the face.

However, the subject should be directed to *tilt* the head slightly to one side or the other, if a monster lighting effect is to be avoided.

DIFFERENCES BETWEEN LIGHTING MEN AND WOMEN

The inane double standard in life—women age while men develop character—has created a double standard in photography as well. There are, for example, certain lighting techniques we can use in photographing a man that would be totally unacceptable for a woman.

The differences between the sexes—as they apply to photography—become apparent the moment the subject enters the studio. It's not unusual for a woman's makeup and hair session—prior to beginning photography—to last as long as three or four hours. My male subjects never receive makeup, other than the camouflage of an occasional blemish or shaving cut.

Even though a staunch supporter of feminism, I have succumbed to this prevailing double standard. It's not because *I* find character lines in the maturing woman unappealing, but because *she* does. The question of retouching is usually broached by the female subject from the time a photographic session is planned. The typical woman is adamant about the elimination of lines and wrinkles when it's time to select display prints for her home. This is true even of the woman who is content with what she sees when she looks in a mirror.

There is no question that retouching is a helpful tool. However, using *lighting* well is the best way to minimize its need. I've resorted to retouching on only a few of the images in this book. Normally, my goal is to avoid retouching.

My aim is to fulfill the photographic needs of my subjects in a style I also find acceptable. *My* personal desires play a distinct role in the interpretation of *their* needs. I enjoy, for example, emphasizing and enhancing the character in the face of a masculine subject. I find equal enjoyment in softening the image of a woman to a dreamlike, exotic vision. It is a romantic concept, and one which the fairer sex unquestionably finds valid and desirable.

The photo books I've read deal with lighting very theoretically. They fail

to point out that the effect light has on a *cube* or *sphere,* used as a teaching aid, is different from the appearance of light on the human face.

Two factors control the appearance of light on a face: the *quality* of light and the *angle* of the light to the frontal plane of the face. The two are inseparably related.

LIGHT QUALITY

A light source that produces distinct, well-defined shadows gives *hard* light. This kind of light originates from a so-called *point source.* Direct sunlight on a clear day is an example of this kind of lighting.

Some other examples of small light sources are tungsten spotlights and all types of flash used with small reflectors. Unless aided by additional light sources or reflectors, hard lighting can create great subject-brightness differences that are also known as *high contrast.*

A light source producing less distinct, diffused shadows is a *soft* light. A soft light source, such as an overcast sky or hazy sunlight, causes the light to spread out. This creates more even illumination and soft shadow outlines. Midtones, between highlight and extreme shadow, become more apparent.

Other examples of soft lighting are window light without direct sunlight and light bounced from a white surface such as the wall of a building. The brightness difference between highlight and shadow areas is less extreme, creating *low* contrast.

LIGHT ANGLE

The second factor affecting the appearance of light on a subject is the angle of the light source in relationship to the camera's lens axis. As the angle of light deviates from a direct, camera-view approach, the surface texture and modeling of the subject become more pronounced. Conversely, light approaching the subject from camera position minimizes surface texture.

The combination of light quality and lighting angle provides an infinite variety of lighting possibilities for any subject. Let's apply the factors by looking at some specific photo situations.

Assume you are photographing an old Texas rancher. From working in the hot sun for many years, his face is

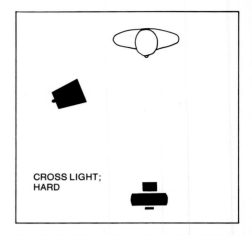

CROSS LIGHT;
HARD

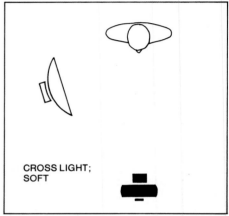

CROSS LIGHT;
SOFT

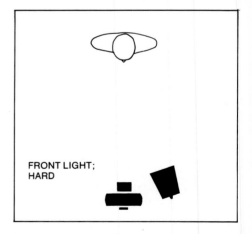

FRONT LIGHT;
HARD

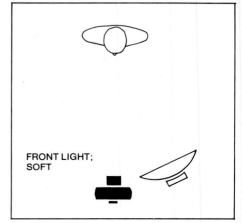

FRONT LIGHT;
SOFT

covered with leathery lines and wrinkles. This is a character trait you wish to emphasize in your photograph. The result you desire is easily produced by using a hard light source at an extreme angle to the camera's lens axis.

Let's look at another example. You are photographing a 60-year-old woman. You want to minimize the lines on her face. You can do this by using a soft, frontal light source.

The accompanying table indicates the control at your command, using the two factors that affect the appearance of light on a subject. You can achieve a great range of effects by varying the light quality and angles.

In controlling the effect of light on the subject, the angle of light is more critical than the quality of light. Let's look at an example to emphasize this important point. I am hired to shoot a photograph of a model wearing a pastel cotton dress. The client has requested an outdoor location. On the day of the shooting, it is clear and sunny. I position my model so the early morning sun strikes her at a 45° angle.

From camera position, I notice that the dress is badly wrinkled—and there isn't an iron in sight! The wrinkles will be far less noticeable if I change the camera position so the sun is behind the camera. This *frontal* light eliminates the textural shadows evident at the extreme lighting angle. I can then turn the model to retain the original pose and viewpoint in this new lighting.

Were I, instead, to move the model to a location with *softer,* more diffused lighting, without changing the *angle* of light on the subject, the wrinkles would still be apparent.

Lighting Equipment

As you know by now, my main aim in this book is to talk about pho-tographic technique and how it can be applied creatively. However, I can hardly avoid saying at least a few words about some important lighting accessories that can help you achieve your goals.

REFLECTORS, GOBOS AND SCRIMS

Some of the most important lighting equipment is non-electric. It includes photo reflectors, gobos and scrims—boards or screens used to modify the light from the source. You can make soft light appear harder and hard light softer by controlling the amount and direction of the light reaching the subject. The modified light illuminates the subject. I'll define the items separately.

Reflector— Any opaque surface used to reflect light to the subject. Reflectors can be matte white, producing soft and even illumination. They can also be silvered, to produce a hard, specular reflection. A silvered reflector is more efficient. Its surface doesn't absorb or scatter as much light as that of the matte white reflector. Reflectors can be flat or of various concave shapes. The shape affects the manner in which the light is redirected and the efficiency of the reflector.

Gobo— A dark or black board or panel used to selectively reduce or block light to the subject or the camera lens. The gobo enables you to change lighting contrast and eliminate lens flare.

Scrim— A screen made from thin fabric, translucent plastic or any other colorless translucent material that diffuses transmitted light. The scrim is placed between a hard light source and the subject to spread and soften the light.

The illustrations on the next page show the use of reflectors, gobos and scrims.

These accessories are as well suited for artificial-light photography as they

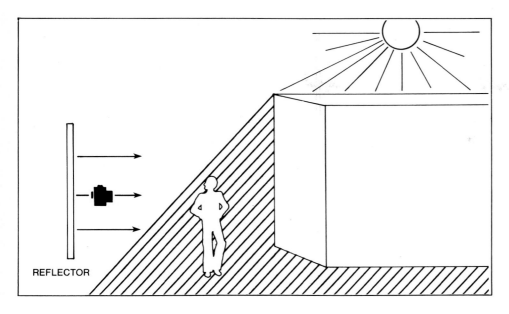

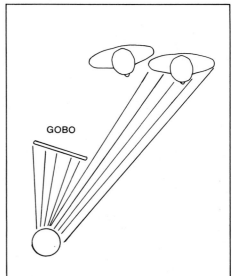

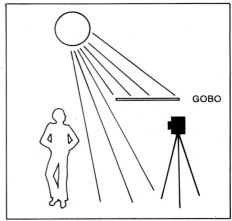

are for natural light. Available in an array of sizes, finishes and configurations, they can often do the job of secondary light sources at a fraction of the cost. Often, photographers spend needlessly on additional lighting equipment, when a simple reflector or diffuser is the answer. I'll discuss the use of reflectors more fully in the essay, *Light and Metering.*

ARTIFICIAL LIGHT SOURCES

When natural light is unavailable or inappropriate, we are forced to employ so-called *artificial* light.

Fortunately, the physical properties of light are the same whether the light is from a continuous source, such as tungsten photo floods or quartz-halogen lamps, or from short-duration electronic flash.

The purpose of lighting accessories

such as reflectors, umbrellas, snoots and barn doors is to modify the original lighting as it comes from the source. Most of this equipment is of standard design throughout the industry. For example, the umbrellas available are equally suitable for tungsten lighting and electronic flash.

Most of the images in this book were taken with either natural light or electronic flash. The lighting control discussed throughout the text, however, applies to all forms of artificial lighting.

In the final analysis, two factors contribute to quality lighting: the ability to envision the final result in your mind's eye and the knowledge and control to produce the effect on film.

Detailed descriptions of the practical use of light sources and lighting accessories are contained with many of the photos reproduced in this book. □

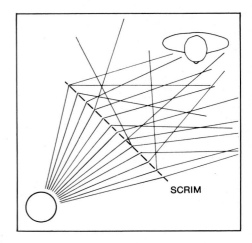

Light Meters

I remember my early days in photography, when I could look at a natural-light scene and determine correct exposure settings without the help of a light meter. At that time, I couldn't afford a meter. A camera containing its own metering system was no more than a fantasy for me.

Now, I no longer possess this exposure-assessing ability. Over the years, I've become dependent on light meters, falling prey to the appeal, accuracy, and expediency of modern photo-technology.

THE ABILITY TO SEE LIGHT

You must always remember that light meters do not *think* for you, as advertising hype would sometimes lead you to believe. The ability to discern the importance of brightness levels within a scene remains a human task. It is your responsibility to determine *exposure* from the *light reading* the meter provides.

The key to using light effectively lies in your ability to *see* variations in brightness and to understand their effect on the subject. Although experience is the critical factor here, there are certain intrinsic properties of light and film that help. First, you must be aware that your eyes see light differently than film.

The human eye adapts to variations in light brightness and contrast. Film can't adapt. That's why most films tend to enhance contrast. Photography is the art of recreating a three-dimensional entity on a two-dimensional surface. Therefore, it is important to achieve the desired rendition of highlight to shadow. Balanced lighting and accurate exposure are often the difference between an image possessing strong, graphic impact, and one that bores the viewer.

Types of Exposure Meters

There are three types of light-metering systems suitable for continuous-light sources. The *averaging meter* is often built into an SLR camera. It meters light through the camera lens. Alternatively, there is the handheld model. It is a separate unit, not built into the camera.

The *spot meter* is designed to read a very small area of the subject. The *incident-light meter* reads the light falling on the subject, rather than the light reflected from it.

Each meter type is capable of giving you correct exposure information for any given photographic situation. Each, however, is better suited for some continuous-light applications than the others.

Short-duration lighting—such as electronic flash—must also be metered accurately. An overview of the *electronic-flash meter* is included in the following section.

THROUGH-THE-LENS AVERAGING METER

The majority of 35mm-camera systems have through-the-lens (TTL) averaging meters. The metering system measures the average amount of light reflected by the subject. Most TTL systems are *center-weighted*. This means the meter is influenced primarily by the light from the part of the subject that appears in the center of the viewfinder.

My use of the TTL metering system is limited to the following photographic situations:

• Action photography in locations where the lighting tends to be variable. This includes candid photography of subjects moving quickly or sports photography in bright sunlight. The metering system lends itself to rapid evaluation of existing-light scenes. It allows the photographer to compensate quickly for lighting changes, with the camera at eye level.

• In a backup capacity as an averaging meter, to determine background daylight exposure for synchro-sunlight photographs. This is a technique that combines flash for a foreground subject with available light for the background.

• As an averaging system for vacation photographs and existing-light party pictures, when using a film capable of effective exposure compensation during development. This includes, for example, b&w negative film and E-6-type transparency films.

HANDHELD AVERAGING METER

The handheld averaging exposure meter operates in the same way as the TTL meter. It averages the amount of

light reflected by the subject. The angle of view—or angle of acceptance—of a meter can vary with different models and brands.

This type of meter is ideal for most scenic applications. However, it can easily be *fooled* in situations involving significant brightness differences between subject and background. A typical example is a brightly lit subject standing against a dark background.

The handheld averaging meter is ideal for determining background readings in synchro-sunlight photography. Shutter-speed and aperture combinations are always visible on the meter dial, indicating available exposure options.

SPOT METER

A spot meter measures reflected light from a small chosen part of the overall scene. It contains a lens and ground-glass optical system, allowing you to view an area larger than the part of the scene being metered. The actual *spot* being metered is outlined on the ground glass.

With a spot meter, it's easy to measure the brightest and darkest important subject parts to determine subject brightness range.

INCIDENT-LIGHT METER

This meter has a plastic hemisphere over the light sensor. It allows you to measure the amount of light falling on the subject instead of the light reflected by the subject. The meter is placed at subject position and the hemisphere pointed toward the light illuminating the scene.

In many respects, the incident meter is the most basic of the available-light metering systems. Its only function is to indicate the amount of light existing in a scene. It is for the photographer to determine proper *application* of the readings as they apply to each *specific* photo situation.

Most of the photographs in this book were metered with an incident-light system—for available light and electronic flash photographs. It is my choice because the incident meter is less susceptible to errors caused by flare and extraneous light.

FLASH METER

A flash meter is designed to evaluate short-duration bursts of light. The one I use is also capable of measuring continuous light in *f*-stops at 1/3-stop increments. Most flash meters use a plastic hemisphere over the light sensor for evaluating the amount of light reaching the subject. They are, basically, incident-light meters. Some are capable of metering ambient light together with electronic flash for syncho-sunlight applications. Some can also evaluate successive and stroboscopic flashes.

Practical Application

Before taking a photograph, determine the most critical part of the composition in terms of *lighting*. My concern is the photography of people, so subject lighting becomes the area of primary evaluation.

Accurate use of the exposure meter must take into account film speed and characteristics, the type of main-light source used and any auxiliary light sources affecting exposure.

FILM

Transparency and negative films are not metered the same way. With transparency film, meter for the highlights. This avoids *burnout* in the brighter areas and ensures proper color saturation. For negatives—b&w or color—meter for the shadows. It's important to have adequate shadow detail for a negative to print well. Illustration 3-1 on page 14 indicates how to take meter readings for transparency and negative films.

MAIN-LIGHT SOURCE

An infinite number of lighting variations is available. Your use of the light meter for one situation may be different for the next. A subject lit by quartz-halogen spotlight, for example, must be metered differently than one with overcast daylight as main-light source. Fortunately, the variations can be categorized, enabling you to apply past metering techniques to new applications with accuracy. I'll discuss this more fully in the next essay, *Light and Metering*.

AUXILIARY LIGHT SOURCES AFFECTING EXPOSURE

The more complex your lighting, the more critical your use of the exposure meter. Some studio photographs require the use of background lights, hair lights and rim lights, in addition to the main light source. It's not unusual for the auxiliary sources to be of *greater* intensity than the main light. Exposure accuracy depends on personal evaluation of the critical areas to be metered.

The accurate metering of scenes or sets using multiple light sources is often threatening to the photographer. It need not be. Here are some guidelines that may help.

It becomes easier to see subtle variations in light intensity when you squint your eyes. When your composition and lighting are set, view the scene in this way.

Often, rim and hair lights—also called *accent* lights—are of greater intensity than the main light. This can lead to dramatic results. However, there are also some dangers.

Because these accent lights are usually behind the subject and pointing toward the camera lens, beware of lens flare. The lens should never be exposed directly to the light source. Spill light is another hazard. This consists of unwanted highlight areas on the subject. It is caused by too wide a spill of light from the rim or hair light.

Proper viewing of accent lights is often made difficult by the brightness of the main light. To evaluate a rim or hair light, turn off the main light. This puts the subject in silhouette, leaving only the accent light. You'll see both the effect of the light where you want it and any spillage you don't want.

You can control accent lights with the use of small cards as baffles. Position the baffles so the light reaches only the areas you want illuminated. Spot grids are helpful in achieving the same end.

CONCLUSION

There are many sophisticated exposure meters on the market. Brand names are not as important as consistency in the use of the meter you select. I've emphasized that light meters do not think for you. It's important that you learn to use your meter correctly and interpret its readings accurately.

Help the meter serve you more accurately by *evaluating* a scene *prior* to the exposure reading. Observe the extraneous light and reflective elements surrounding the subject. They may affect exposure.

Contrast levels within the subject area and between the subject and background must be evaluated visually if you are to get a meaningful exposure reading from an incident-light meter. □

Light and Metering

The title to this essay may seem to be repetitive of the previous two. It really isn't. Let me explain.

EXPLANATION

My intention in preparing the essay portion of this book was to establish generic topics for discussion without *overlapping* material covered in more than one essay. Because a photograph is the result of an interplay of many related but different items, it was necessary to compose the essays concurrently—writing a bit on one, and then another—to maintain a balance of information.

There was no problem maintaining a separate approach throughout the entire manuscript, except in the previous two essays. In each case, I found it impossible to begin a practical discussion of one without reference to the other. You can't discuss the specific use of the light meter, for example, without reference to the quality of lighting. It is also impossible to discuss lighting application without reference to exposure and metering.

This resulted in this third essay. It provides specific, practical picture-taking techniques. The essay integrates light-evaluation and lighting placement with the proper use of the light meter to determine good exposure.

Good technique allows you to be a better photographer. It gives you the ability to record accurately on film what you find appealing in a subject. The success of your photographs, as perceived and appreciated by the *viewer,* depends on how *you* see.

It depends on your aesthetic refinement, your taste, your instincts.

This determines *what* you choose to photograph, *how* you choose to use technique, *which* lighting you find dramatic and *what* you choose to include or omit compositionally. In other words, it involves what you consider important aesthetically. Correct exposure is an essential part of this process.

Many of the world's most memorable photographs were not lit by man. They were lit by nature. Man was there, using his technique to record what he found appealing. He positioned himself in the right place at the right time. He worked intuitively. Photography is a way of communicating through images. If the viewer finds your images appealing, it's because he appreciates your personal vision and the way you interpret that vision on film.

How to Meter Light

Photographic technique involves scientific balance. It involves interrelationships between light intensity, film speed, shutter speed, lens aperture and film development.

EXPOSURE SETTINGS

Exposure is a matter of mathematical balance. The number of aperture/shutter-speed combinations for a given camera/lens system is fixed. Imagine a camera possessing nine shutter speeds, 1/4 second through 1/1000 second, and a lens possessing nine aperture settings, f-1.4 through f-22. The number of shutter-speed and full lens-aperture combinations for this example is 81.

This is determined by multiplying the number of shutter speeds by the number of lens openings.

For a given lighting situation, at most nine of the 81 possible combinations will provide an accurate exposure. For example, if the correct exposure for a given scene is 1/60 second at f-5.6, there are eight other aperture/shutter-speed combinations that will also produce a perfectly exposed picture—1/125 second at f-4, 1/30 second at f-8, and so on.

KNOW YOUR METER

The type of exposure meter you select is not critical to exposing a photograph properly. What is important is how you use it and how you *apply* the information received. You must have a basic knowledge of how your meter operates. The meter must be functioning properly.

The meter must interrelate with the characteristics of *your* camera lens, shutter and aperture settings. If necessary, the meter must be recalibrated for accuracy with your specific equipment.

Also, you must possess a basic understanding of the way light behaves. When all these conditions are met, any reliable light meter will do the required job.

EXPOSURE BRACKETING

Use the exposure indicated by the meter as a center point for bracketing a few additional exposures. For example, you may want to give one and two steps less exposure and one and two steps more exposure than indicated by the meter.

In evenly lit scenes, as found on an

overcast day, bracketing need not exceed one step in either direction. In more contrasty light, or situations in which reflections become a problem—like at the beach—it's sometimes advisable to bracket as much as three steps in both directions.

Using this system, you're almost bound to get one perfectly exposed photograph. Bracketing *seems* to waste a few frames of film. But if the result is a guaranteed good photo, it's hardly a waste.

I bracket most photographs I take, even with films allowing effective film-speed compensation during processing. I do this for several reasons, not the least of which is because I want to be certain that I've got one ideally exposed shot.

PERFECT EXPOSURE IS NOT ALWAYS NECESSARY

It's not unusual for a slightly overexposed or underexposed image to have greater value to you and the subject than a "perfectly" exposed image.

For example, you might be photographing an older woman who's concerned about her lines and wrinkles. You may find that a b&w image overexposed by as much as 1-1/2 exposure steps is more than just "printable." It may be *more* appealing to the subject than a properly exposed image, containing greater density and greater detail. Overexposure in this case provides its own method of retouching the human face.

In fashion photography, I must sometimes overexpose part of the image and accurately expose the rest. An example is a light-skinned model wearing an outfit of black, deep green or navy blue. Because of the great tonal difference between the face and the fabric, it is impossible to obtain proper exposure of the skin and detail in the outfit with most films.

Consequently, I add light to the garment to intentionally "overexpose" it. The camera exposure is determined by metering the subject's face. The additional light on the garment allows it, too, to register on film with detail.

SEE PHOTOGRAPHICALLY

It is important that you are aware of *all* the light present in a scene—not only the obvious main light. You should also be aware of the effect camera viewpoint has on the spatial relationship between subject and background. This can be important in

artificial light situations where the background is not lit separately.

Exposure must be related to the pictorial changes created by specific shutter-speed and aperture settings. Consider how a shutter-speed change will affect the image. For example, in dim light, don't risk a blurred image by using too slow a shutter speed. In such a situation, a faster film or a larger lens aperture may be the solution.

Learn how depth of field is affected by the lens aperture setting. Using a small aperture to compensate for high scene brightness may give you unwanted depth of field—and undesirable background detail. A faster shutter speed, or a neutral-density filter on the lens, may be a more appropriate way.

Technical ability frees you to record a scene with confidence, accuracy and consistency. The rest is a matter of personal taste and interpretation—based on aesthetics, compositional balance, subject appeal and your imagination.

You needn't sacrifice your aesthetic goals for technical considerations. Usually, you can record what you envision without technical compromise.

Natural Light

I've divided light into two basic categories—*natural* and *artificial.* In this section, I'll detail the use and metering of natural light. Natural light can be made to provide *hard* or *soft* illumination.

The basic source for all daylight photography is the sun. When unobstructed by clouds, it is a point source, producing hard light. When sunlight is diffused by an overcast of clouds, it becomes a soft source. Under those conditions, you no longer see the sun—only its diffused light coming from a large area of sky. This soft light produces gradual shadow outlines and low subject contrast.

I'll show you how you can modify the main light source to achieve certain effects. You'll see how a hard source can be made soft. Also, you'll learn how to meter different kinds of illumination for accurate exposure.

UNMODIFIED SUNLIGHT

Direct, hard sunlight is the most difficult form of lighting to use photographically. With artificial light,

we have the advantage of being able to move the source at will. We can position and aim lights so they flatter the subject. Sunlight can't be moved to obtain the lighting effect you want. You must move the *subject* instead.

In people photography, direct sunlight is usable as a main source only during the early morning and late afternoon hours. Only at these times is the angle of the light low enough to illuminate a face properly. The lower light angle provides illlumination for the subject's eyes, giving vibrancy and sparkle to the image.

To get the exact lighting effect you want, position the subject so the sunlight produces the wanted modeling on the face. In a studio, you would move your lights to achieve the same goal.

Direct sunlight creates high contrast between highlight and shadow areas, making accurate metering difficult.

Exposing Slides and Negatives— You must meter transparency (slide) films and negative films differently. Expose negatives for the shadows, to ensure adequate shadow detail. Meter transparency film for the highlight areas, to ensure saturated colors and avoid washed-out, colorless areas.

Incident-Light Metering in Sunlight—An exposure meter can be affected by both the subject and its background. The subject may have average tonality, while the background is light or dark in tone. The best way to avoid the background influencing the subject metering is to use an incident-light exposure meter. This meter records the amount of light reaching the subject, not the light reflected from the subject.

Make the reading from subject position, regardless of composition or the distance between camera and subject. The incident-light hemisphere of the meter should be pointed toward the camera.

Illustration 3-1 shows where to place the hemisphere of an incident-light meter for making highlight and shadow readings. When you make the shadow reading, you must be sure that none of the main light is permitted to strike the meter's hemisphere.

Does the incident-light reading preclude further thinking on your part? Hardly! You must take the specific photographic conditions into account. For example, were you photographing a subject with dark skin, it would be advisable to increase exposure by one

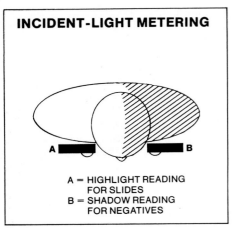

3-1

step (*f*-stop). To ensure optimum exposure under varying lighting and subject conditions, bracket exposures freely. In highly reflective areas, such as a beach or snow scene, bracket two or three exposure steps in each direction.

TTL Metering in Sunlight—If you're photographing a full-length subject against a background of medium tonality, an averaging TTL meter can be used with accuracy from camera position. If your subject were standing before a dark or light background, a direct averaging meter reading would not give optimum exposure for the subject.

Averaging camera meters are fooled by excessive tonal differences between subject and background. To get an accurate reading, move close enough to the subject to fill the frame with the important part of the subject. Use the reading you get from there when you return to your original camera position to take the picture. You will, in effect, have used your averaging meter as a spot meter by directing its sensor to the critical part of the subject only. When you make such a reading, be sure that you do not cast an unwanted shadow on the subject.

MODIFIED SUNLIGHT

With appropriate reflectors, you can modify and redirect hard lighting. Depending on its surface and placement, a reflector can either become a new main-light source or an additional secondary source, modifying the effect of the sun.

A reflector allows us, in effect, to move and redirect sunlight with almost the same ease as artificial studio lighting. Reflectors extend the hours during which you can use natural light. Overhead noon sunlight—unsuitable for portraiture on its own—can be harnessed by modification and redirection through reflectors.

Silvered Reflector—An efficient silvered reflector, used to bounce direct sunlight, produces point-source lighting similar in quality and intensity to that of the sun itself (Illustration 3-2).

The light remains hard. It is simply redirected.

White Reflector—A matte, white reflector redirects the sun's light uniformly from its entire area. Also, the light rays leaving the reflector are not parallel but go in different directions (Illustration 3-3).

These characteristics convert the hard sunlight into diffused, soft illumination. Shadows are softened and contrast is reduced. A noticeable proportion of the original light is lost through scatter and absorption by the reflector.

OVERCAST DAYLIGHT

Photo reflectors can be useful in overcast daylight, too. Clouds diffuse the sun's light into an even layer of illumination. This general overhead light can create unflattering shadows in a subject's eye sockets. The eyes then have no catchlights and no sparkle.

Silvered Reflector—With an efficient, silvered reflector, you can redirect skylight at will. The silvered surface adds catchlights to the eyes and gives life and vibrancy to the photograph.

You can make a close-up TTL meter reading of the light reflected from the subject. Or, take an incident-light reading from subject position, pointing the meter's hemisphere at the silvered reflector.

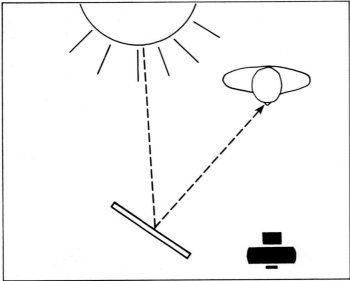

3-2

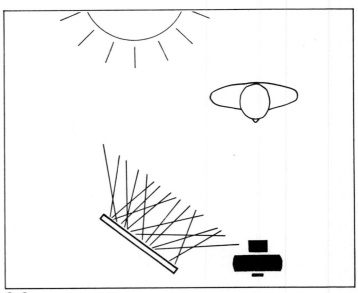

3-3

VISUAL EFFECTS OF REFLECTED LIGHT

The reflected light will always be less bright than the light from the original source. With a silvered reflector, the light loss may be barely noticeable. With a diffusing reflector, it will be considerably higher.

To achieve great illumination variations with daylight, you can use more than one reflector. Two reflectors can take the part of primary and secondary studio light sources.

High Sunlight Plus Silvered Reflector—When the sun is high in the sky and behind the subject, you can redirect it to the subject from a lower and frontal position. A silvered reflector will produce illumination very similar to frontal sunlight. Exposure will be no more than one-half step (half an *f*-stop) less than it would be in direct sunlight.

Edge lighting on a subject's head and shoulders, produced by the overhead sunlight, will be overexposed a half step. The result is a bright rim of highlight surrounding the subject. This effect can be very dramatic.

High Sunlight Plus White Reflector—A matte, white reflector redirects less light to the subject than a silvered surface. The amount of light received by the subject from the white surface is about two exposure steps less than the edge lighting from the sun. Thus, correct subject exposure will now produce more intense edge lighting.

The less efficient white reflector also affects background exposure. The required subject exposure is about 1-1/2 steps more than it would be with a silvered reflector. Therefore, an identical background will record 1-1/2 steps lighter when the white reflector is used for subject lighting.

METERING REFLECTED LIGHT

There are several ways of accurately metering reflected light. If you're using the TTL meter in your camera, move close enough for the subject's face to fill the frame. Remember, accurate exposure must be determined from the critical part of the scene. In a portrait, this is the face.

I prefer to use an incident-light meter in situations with reflected illumination. It allows me to make two critical readings from subject position—the amount of light redirected to the subject by the reflector and the amount of illumination reaching the subject's back and head from direct, overhead sunlight.

I begin by placing the meter next to the subject's face, pointing the incident-light hemisphere toward the reflector. It's important to shield the hemisphere with your hand from the harsh, overhead sunlight which would otherwise affect the exposure reading. For a second reading, I place the hemisphere near the subject's head or shoulder and point it straight at the sun.

Comparison of the two readings determines the relationship between the reflected main light and the direct edge light.

OTHER SOFT LIGHT SOURCES

Following are the most readily available forms of natural soft lighting: Sunlight diffused by a cloud overcast; light reflected from buildings and other surfaces; open shade providing skylight but not direct sunlight; gobos and scrims.

In each case, the effective size of the small light source is increased. Although the light can still possess direction and provide modeling, shadows and contrast are minimized.

METERING SOFT LIGHT

Averaging TTL camera meters are ideal in soft light. Because the scene contains limited contrast, it resembles the average scene for which the meter is designed.

Low Diffused Sunlight—Most lighting has *some* direction. Highlights and shadows are created. Consequently, subject modeling appears. When using diffused sunlight as main source, position and direct your subject to receive the angle of light you desire. From camera position, meter the subject through the camera lens or make an incident-light measurement from subject position. Give the indicated exposure and also bracket by one exposure step in each direction.

Open Shade—An area lit by skylight, but where the sun is obstructed, is called *open shade*. Illustrations 3-4 and 3-5 show two open-shade situations. The lighting produced in each example has similar qualities. A large area of sky gives soft illumination. The expanse of blue sky gives the subject an overall blue color cast, requiring the use of a *warming* filter to render skin tones and other colors normally.

For portraiture, there is one important difference between the two examples shown in terms of the usability of the light. A subject standing under the overhang of a tree will receive better facial lighting than a subject standing next to a building. This is because the skylight under the tree comes from a relatively low angle (Illustration 3-6). The high, unflattering light is blocked by the tree.

Because open shade is a soft light source, contrast is relatively low. A TTL camera meter will give consistently accurate readings in many situations. However, it's important to

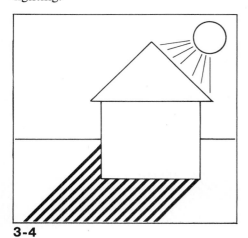

3-4

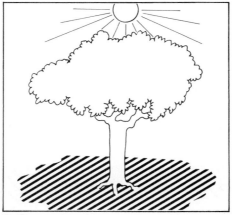

3-5

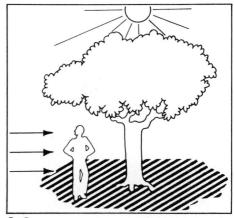

3-6

visually evaluate background tonality in relation to the subject before you take the picture. The following examples illustrate why.

Open Shade and Shaded Background—In Illustration 3-7, the subject is standing in open shade against a midtone background which is also in the shade. Illustration 3-8 shows the composition, as seen through the camera viewfinder. Because the entire scene is in the shade, lighting contrast is low. An averaging TTL reading will produce an acceptable exposure.

Open Shade and Bright Background—In Illustration 3-9, the subject is standing under the branches of a tree. The background is unshaded. It is lit by direct sunlight. The extreme brightness of the background would lead to extreme underexposure of the subject, if an averaging TTL meter were used. The camera would expose for the background, producing a silhouetted subject (Illustration 3-10).

In this situation, an incident-light meter would be a better choice. It evaluates only the light falling on the subject, regardless of background, ensuring proper subject exposure. To evaluate the same scene with an averaging meter, you would have to move in close, to fill the viewfinder with the most important part of the subject.

USING REFLECTED LIGHT TO BALANCE EXPOSURE

You can balance a shaded subject with a bright background by adding more light to the subject. You can do this with flash or with the use of an efficient, silvered reflector (Illustration 3-11). I prefer to use a reflector. It's easier, quicker and produces a

more natural-looking light. In addition, the reflector allows for visual evaluation of the lighting.

Electronic flash presents somewhat of a guessing game. You can't evaluate the lighting accurately until you see the processed film. A reflector also allows for rapid sequential exposures, whereas electronic flash requires a wait between exposures for recycling of the unit.

The efficiency of a silvered reflector allows maximum flexibility in lens selection. Most portable flash units lack sufficient power to be used with long lenses from camera position.

If effective subject and background brightness are fairly uniform, you can use an averaging meter. Or, use an incident-light meter, placing the meter's hemisphere at subject position and aiming it at the reflector.

GOBOS

A *gobo* is a device that enables you to block the path of light. Porches and overhangs from buildings represent excellent ready-made gobos, enabling you to block unflattering overhead daylight. Portable gobos, in the form of cards or special umbrellas, are easy to make or purchase and are versatile in use.

Illustration 3-12 shows an ideal gobo application. The sun is located above the subject. The awning forms a gobo. It keeps direct sunlight and most of the overhead skylight from the subject. The subject is lit by relatively low skylight.

Many of the commercially available photo reflectors can also be used as gobos to control the angle of the light striking the subject. In Illustration

3-13, a square photo reflector—similar to a Larson Reflectasol—is mounted to a light stand with a clamp. The light strikes the subject at a relatively low angle, the reflector blocking the unwanted overhead light. The altered lighting angle produces flattering facial modeling on the subject.

A portable gobo does much the same job as an awning. The advantage of the portable gobo is that you have total control of the shooting location and the placement of the gobo. For example, a portable gobo is ideal for photographing a subject in the middle of an open field. It allows proper facial modeling at any time of day, in a variety of natural-light situations.

Metering Gobo-Controlled Light—Gobos make subtly directional illumination possible. They can ensure good facial modeling and medium subject contrast. If you're using a TTL meter, move in close and meter subject detail. Incident-light metering is easier. Place the meter's hemisphere on the highlight side of the subject's face and point it toward the camera.

WINDOW LIGHT

For indoor portraiture, windows lit by skylight—but not direct sunlight—serve as wonderful main-light sources. They represent perhaps the most beautiful of all types of illumination for portraits. Window light is directional, yet relatively soft. The size of the window and its distance from the subject determine the light quality.

Illustration 3-14 shows the ideal position of the subject at the window. The subject is placed to face the window at an oblique angle.

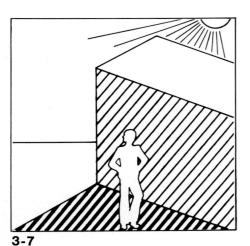

3-7

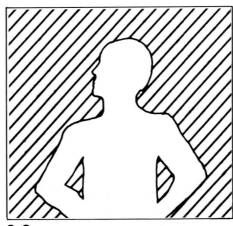

3-8

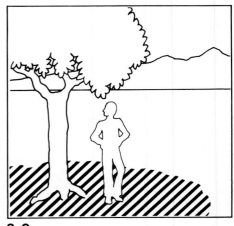

3-9

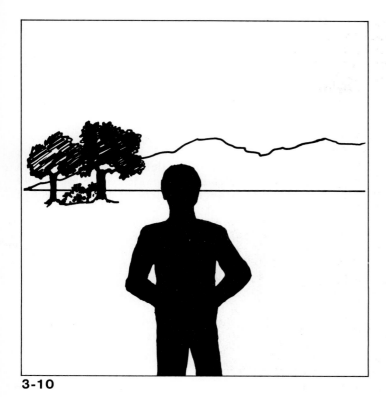

3-10

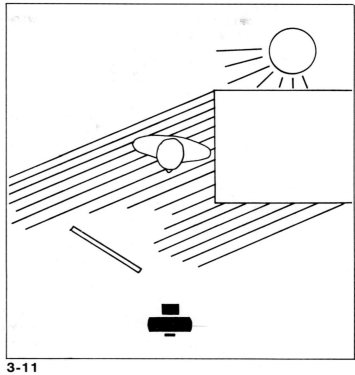

3-11

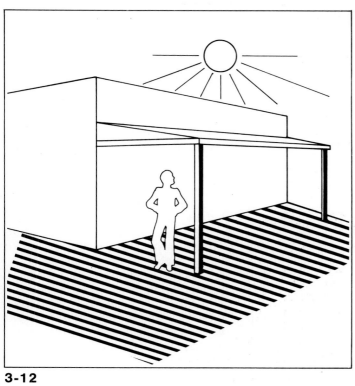

3-12

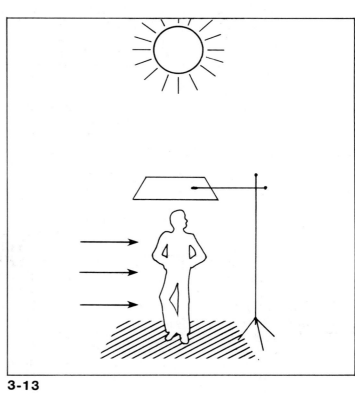

3-13

17

Window Light and Reflectors— Because window lighting is generally directional, contrast is apparent in the subject's face. I use a silvered reflector to lighten the shadows on the side of the face farthest from the light source. Illustration 3-15 shows the approximate location of such a reflector.

Background—The rapid falloff of light with increased distance from the window causes a rapid loss of background detail. Because the window is often a considerable distance from the wall behind the subject, it's advisable to use a portable background that can be placed closer to the window.

This is particularly important when you're photographing a subject with dark hair or in dark clothing. If sufficient visual separation between subject and background isn't provided, the dark hair or clothing will merge with the background and the subject will not be clearly outlined.

The background need not be sophisticated. A large sheet of paper, taped to a piece of wood and mounted on a light stand, will suffice. When I photograph portraits on location, I use a six-foot piece of 2x3 wood to which I've attached window-shade brackets. This device (Illustration 3-16) can hold a variety of hand-painted window shades in a multitude of designs and colors.

Think of the window as a large, diffused light source that isn't movable. To get the modeling you want, you must move the subject and, if necessary, the camera.

Metering Window Light—If you're using your camera's TTL meter, move in close and meter facial detail. Be sure to measure the highlight area of the face to determine slide-film exposure. For negative-film exposure, meter the shadow side.

An incident-light exposure meter is more appropriate for window light. When using slide film, place the plastic hemisphere at the highlight-side of the subject's face. Point the meter toward the window to measure the amount of light falling on the subject.

3-14

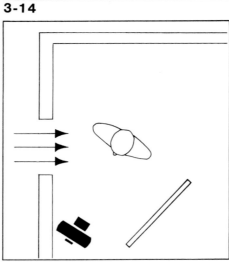

3-15

3-16

Artificial Light

Affordable lighting equipment suitable for the amateur is readily available. There are systems that are compact, portable and easy to use. Power output may be lower than would satisfy the professional, but all the essential components are there.

For example, ideally suited to the needs of the demanding amateur photographer is the ProStrobe 400 System. It offers studio-type flash in one compact package. The system incorporates a 400-watt-second power source and comes complete with flash heads, modeling lights and light-output control. Larson reflectors, umbrellas and stand clamps are also available for the system.

This kind of equipment widens your scope beyond daylight and hot-shoe flash photography. However, to benefit from all this, you must know how to use the equipment. And you must understand how to meter its light.

TOTAL CONTROL

In the realm of artificial light, photographic flexibility and control are almost unlimited. You are free to create and vary lighting balances. You can mix light sources of differing intensities and configurations with relative ease.

In the controlled environment of the studio, you can keep light intensity constant. This makes exposure control easier.

I use electronic flash almost exclusively in the studio. The great advantages of electronic flash are high light output for a very short duration. These characteristics are particularly useful in people photography.

In spite of my preference for flash, great similarities exist among artificial-light sources. Diffusers, reflectors and other accessories are used in the same way with tungsten lighting and flash. Light-to-subject distance has the same effect with each kind of illumination. The lighting patterns attainable with each are the same. Metering technique is also basically similar.

A single light source, if used properly, provides a multitude of lighting effects for a variety of subjects. The addition of second, third or fourth lights provides limitless control for any subject and scene.

LIGHT PLACEMENT

Earlier, I discussed the vast range of lighting effects possible with a single light source—the sun. The situation is not different with artificial-light photography. Most photographs can be taken with a single light source, if it's used correctly. Secondary light sources and reflectors serve to enhance the lighting. However, additional light sources can also bring additional problems.

The main light gives principal modeling to a subject's face and form. The advantage of studio lighting is that *you* decide where to place the main light.

LIGHT SOURCES

Studio lighting involves mixing and matching light sources of various configurations. For example, a source used to light a subject's face in one photograph may be used appropriately as an accent or background light in another photograph. Your creative flexiblity in the studio is unlimited. The quality of main-light sources is limitless. So are exposure choices and lighting and camera angles.

Let's look at some of the popular main-light designs available. I've divided the light sources according to the quality of the light received by the subject.

Light in Reflector—Illustrations 3-17 and 3-18 show standard bare flash heads to which reflectors are attached. The reflectors are interchangeable. Illustration 3-17 shows a standard-angle reflector. The light source is small, the light quality hard. The angle of coverage is between 50° and 60°. Illustration 3-18 shows a wide-angle reflector. It, too, gives a hard light. However, because of its shape it illuminates a wider angle—approximately 90° to 100°. Both lights produce high lighting contrast on the subject and cause distinct shadows.

Reflector and Grid Spot—In Illustration 3-19, a grid spot has been added to a standard reflector. The honeycomb design of the grid produces an almost parallel beam of light. This is, in effect, a spotlight, producing very hard illumination. Its principal use is as an accent or hair light or a background spot.

Pan Reflector and Silvered Umbrella—In Illustration 3-20, a pan reflector has been added to a bare flash head. In Illustration 3-21, a silvered

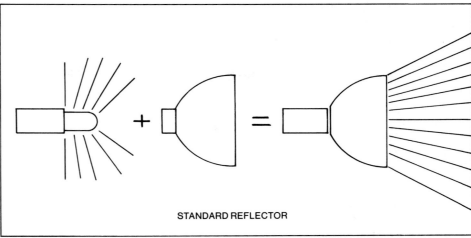

STANDARD REFLECTOR

3-17

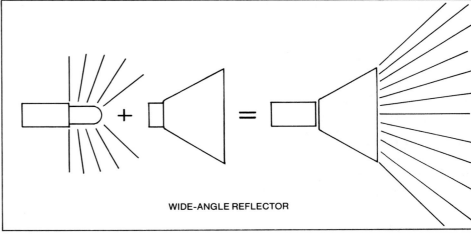

WIDE-ANGLE REFLECTOR

3-18

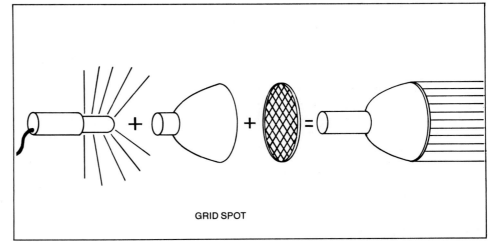

GRID SPOT

3-19

umbrella has been added. Both configurations produce medium-hard light with specular highlights and well-defined shadows. There are slight differences, however, in their use.

The diameter of most commercial pan reflectors is about 12 to 16 inches. By comparison, even a small umbrella has a diameter of about 32 inches. When used at the same distance from the subject, the larger umbrella yields a softer light and softer shadow outlines than the pan reflector. As the umbrella is moved farther from the subject, its light becomes more similar to that of the nearer pan-reflector light.

Translucent and Opaque Umbrellas—An opaque umbrella, as shown in Illustration 3-21, reflects light from its interior surface. The translucent umbrella (Illustration 3-22) is made of a thin translucent material that allows light to pass through it to the subject. Each source provides diffused, medium-soft illumination.

Softbox—Softboxes are becoming very popular. They are available from various manufacturers of lighting equipment. The softbox (Illustration 3-23) consists of a large, white reflector with a translucent diffusing material mounted to its front. It provides a very soft light, with low contrast and minimal shadows.

LIGHTING CHOICE

I rarely use soft light sources for the photography of people. The human face has too much vibrancy and personality to be photographed with excessively low-contrast lighting. To capture a personality with impact, it must usually be done with light sources that contribute to the pictorial strength and depth of the individual. This demands some degree of lighting contrast. Consequently, directional light sources are my principal tools for portraiture.

The proliferation of softboxes notwithstanding, I regard soft lighting largely as a tool of the inexperienced photographer. It can be a *cure-all* for inaccurate lighting. The simple reason is that mistakes are not as noticeable. Softboxes also make exposure metering, and therefore correct exposure, easier.

There are exceptions, of course, when soft lighting is needed. You'll see several examples as you look through the portfolio section of this book.

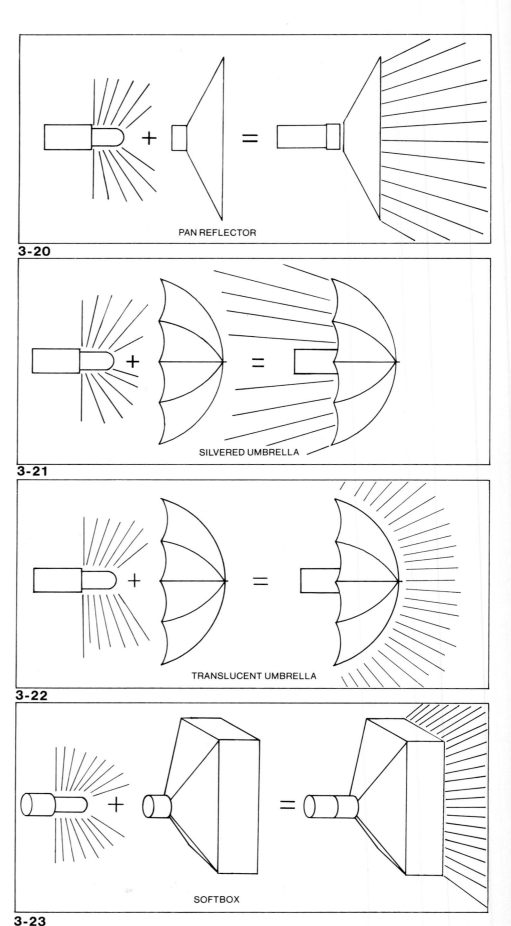

PAN REFLECTOR

3-20

SILVERED UMBRELLA

3-21

TRANSLUCENT UMBRELLA

3-22

SOFTBOX

3-23

METERING

Light metering does not involve simply measuring the intensity of light that's there. Metering is an essential tool that enables you to *control* every aspect of your lighting setup. The following imaginary studio assignment is a good example of how I use my meter to arrange lighting.

My subject is an elderly woman. Her face is slightly lined and pale in color. She is wearing a beautiful blue velvet dress, delicately tufted and embroidered with dark flowers across the bodice. An ornamental, highly polished sterling-silver broach is pinned to the dress.

Because of the subject's pale skin, I decide to use a neutral background. A warm background of brown or red would visually compete with her pale skin. I choose a medium-gray background. I decide to photograph the subject in a half-length standing pose, and begin to set the lighting.

I place a Larson Softbox a few feet in front of the subject. This gives even, flat illumination to the broach. I record an incident-light reading of *f*-8 on the broach. Every intricate detail in the broach can be seen. There are no irritating specular highlights typical of hard, point-source lighting. The softbox illuminates the subject's face, too, but at the wrong angle for proper facial modeling.

Main and Fill Lights—I add a second light, bounced from a silvered umbrella. This becomes the main light. It is placed to the subject's right. Its intensity at subject position measures *f*-11—one exposure step greater than the softbox. This light produces good facial modeling and specular highlights. The less intense softbox has become a fill light.

Unfortunately, the silvered umbrella has created unwanted specular highlights on the left side of the broach. A Larson Rocaflector, placed to shield the broach from the main umbrella light, eliminates the specular highlights from the broach.

Lighting the Dress—My next problem is how to record the detail on the front of the subject's dress. The exposure difference between the light reflected from her face and from the dark velvet dress is too great for the exposure latitude of the film. So I set a third light, with a grid spot, in front of the subject. It spotlights only the front of the bodice and meters between *f*-11 and *f*-16 on the incident-light meter. That's half an exposure step more light than is coming from the main light.

Camera exposure will be based on the light reading of the main light—*f*-11. This intentionally causes the front of the dress to be overexposed by half an exposure step to ensure good detail in the embroidered bodice.

Background—I search the studio for a roll of medium-gray background paper but find only a roll of pure white. Realizing this will have to suffice, I use it about 10 feet behind the subject. An incident-light reading of the background indicates an exposure of *f*-4. In order to produce a medium-gray background, I require a differential of two exposure steps between main light and background.

I use two background lights, bounced from white umbrellas. The output of the lights is set to give an *f*-5.6 reading uniformly over the background. The two-exposure-step difference will produce an even, medium-gray background with the white paper.

Edge Light—On viewing the composition from camera position, I notice the need for accent lighting. It will add interest and excitement to the image by edge lighting the subject. It will also graphically separate her blue outfit from the gray background.

I place a light with a wide-angle reflector on a boom stand and position the light above and slightly behind the subject's head. It is set to give a reading between *f*-16 and *f*-22. It adds hard, directional light around the top of the subject's head and shoulders. The overexposure of this light will record on film as a fine halo around the subject.

Background Spot—To add a final creative touch to the photograph, I place another light with a narrow-angle reflector on the floor behind the subject. It is directed toward the center of the background, throwing a circle of light just behind the subject. The reading for this light is *f*-16. This means that the circle of light will give one step more exposure to the background than the main light will give the subject. The appearance of this bright spot in the photograph directs viewer attention toward the center of the composition.

I recommend that you approach each new photo session in the manner outlined here, using your meter as an essential tool. If you do, you'll find your photography not only more enjoyable, but better and more rewarding. In addition, your subject benefits from such dedication in the form of better photographs.

In the portfolio section, many similar problem-solving techniques are discussed. Apply those examples to your own photo situations. With time and patience you'll gain the experience necessary for total control of any photographic lighting situation. □

Four

Cameras, Lenses and Film

For the sake of brevity, and to suit the vast majority of photographers reading this book, I confine my discussion of cameras to 35mm and medium-format cameras. The latter usually make pictures in the 2-1/4-inch-square format. However, some medium-format cameras are designed for other formats on 120-size film.

Roll-Film Cameras

The decision to exclude the larger formats is not an arbitrary one. Never before have the small roll-film formats been so readily accepted—not only by professional photographers, but by major clients as well. In the past, only sheet-film originals provided the quality necessary for commercial reproduction. However, there have been dramatic changes in equipment and film and in the attitudes and aesthetics of the users of photographs.

One reason for this change is the remarkable resolution obtainable with today's optics in combination with high-resolution films. Another reason is that the last 15 years have seen a dramatic transition from static and often overly studied photographic treatment to one of increased spontaneity and naturalness. This trend lends itself to the use of smaller and more responsive camera equipment. Another factor that caused the change is the increasingly prohibitive cost of shooting sheet-film for people-related assignments. Many exposures are usually necessary to capure the one ideal expression.

Today's 35mm and medium-format cameras are highly sophisticated. They avail the photographer of every conceivable form of picture control for total command of the medium.

SLR OR RANGEFINDER

Accurate image composition is critical in photography. I use single-lens-reflex (SLR) cameras. They enable me to view the entire frame through the lens of the camera. With a rangefinder camera, parallax error is always a possibility. This means you don't see through the viewfinder exactly what you'll get on film.

Accurate image framing is imperative to the advertising photographer, who must conform to *layouts*. These are designs produced by the ad agency, indicating the required location of elements within the picture. A layout ensures that headlines, copy and logos can be added where they are wanted. I don't want any unpleasant surprises when the processed film comes back. Neither do my clients!

MEDIUM FORMAT

The medium format provides the same range of control and backup equipment available to the 35mm owner. The differences between the two formats is minimal in most amateur applications. For the professional and the advanced amateur, however, the medium format provides several distinct advantages for certain types of photography.

The portrait photographer, who shoots originals on color or b&w negative film, has greater retouching flexibility with the larger image. The commercial photographer is often asked to use a medium-format camera on b&w assignments because the larger images, when contact-printed, are easier to see and select from. Many people also think that the 2-1/4-inch-square format allows for greater compositional freedom *after* the session has been photographed, if there are design or layout changes.

Some assignments will specifically call for square-format composition. Among them are many of the point-of-purchase displays used in retail stores. Another obvious application is making photos for record-album covers. In such cases, a 35mm image would be reduced to a miniscule 23x23mm original, making quality reproduction difficult.

SYNCHRO-SUNLIGHT PHOTOGRAPHY

When you want to combine electronic flash with daylight, some medium-format cameras allow greater freedom than the 35mm. The technique often requires the use of flash-sychronization speeds faster than 1/60 or 1/125 second—the maximum for most 35mm cameras. This is to give more control of the ambient-light exposure. Electronic flash can be used with the leaf shutters in medium-format cameras at *any* shutter speed up to 1/500 second.

Portable Electronic Flash—Battery-operated portable flash units are ideal for synchro-sunlight photography. These units are lightweight and relatively inexpensive. They don't impose the restrictions of studio flash, which needs AC power. Like other electronic flash, portable units give light of approximately the color temperature of average daylight.

The manual flash setting is preferable to the automatic for synchro-sunlight use. In the automatic mode, flash duration is determined by a sensor on the flash unit. The duration is dependent on the film-speed setting and on the flash-to-subject distance. In the manual mode, flash output is constant. This allows for greater personal control of the precise lighting effect you want to achieve.

My primary use of electronic flash in this manner is indoors, against the background of a window or door. Direct sunlight is rarely involved so that a more appropriate name here might be *synchro-daylight*.

How to Balance Flash and Daylight—The following steps outline the procedure for producing a balance between daylight and flash illumination. The flash should be in the manual mode:

1) Set the film speed on the flash calculator dial.

2) Focus on the subject in the normal way. Note the distance indicated on the lens scale.

3) With a handheld or through-the-lens meter, determine the available-light exposure for the background.

4) Set the available-light exposure. Two requirements must be satisfied: First, the shutter speed setting must synchronize with the flash. Second, the aperture setting must be compatible with subject distance and flash power, so that the next step can be taken satisfactorily. The shutter-speed and aperture combination must give proper background exposure.

5) Adjust the flash-to-subject distance to give correct flash exposure for the subject at the aperture you are using.

Be Creative—The ratio of daylight exposure to flash exposure can be changed easily. This enables you to achieve a wide variety of effects. You can add more light to the main foreground subject and get the background darker. Or, you can underexpose the foreground subject and brighten the background.

The flash can be used on-camera or, to achieve specific modeling, off-camera. Single or multiple flash can be used.

Lenses

As you walked out of the store after purchasing your first interchangeable-lens camera, you were probably already contemplating the *additional* lenses you were going to buy. You were not alone. Equipment and gadgetry appeal to most photographers—amateur and professional alike. The problem is that many photographers buy lenses for the wrong reasons. Having numerous lenses

does not automatically lead to increased photographic expression. Understanding their use does!

STANDARD LENS

It's important to use each lens to its full capability. This can prevent your buying equipment needlessly. It can also help to strengthen your control of the medium.

Most frequently, negatives are enlarged to 8x10 or 11x14 inches. Normal viewing distance is about 15 inches. An enlargement from a negative made with a *standard* lens will yield approximately the perspective seen by the photographer at the scene. If a wide-angle lens is used, the enlargement will have exaggerated perspective at normal viewing distance. If the camera lens was a telephoto, perspective will be foreshortened.

A 50mm lens is standard for the 35mm format. An 80mm lens is standard for the 2-1/4-square format.

No focal length provides greater versatility than the standard lens. It is sufficiently long to be used for head-and-shoulders portraiture. Its angle of view is also wide enough for group photos or to take in a generous amount of background. The *speed*—or widest aperture setting—of the standard lens makes it ideal for dim available-light photography.

The versatility of the standard lens can be a double-edged sword because its misuse can create problems.

Distortion—The standard lens can lead to a distorted image when used too close to the subject. The effect is particularly apparent in a head-and-shoulders portrait. The distortion may not be obvious through the viewfinder, but it is unmistakable on the photographed image.

There are two basic types of distortion. One is caused by different features being at substantially different distances. This leads to long noses and prominent chins. The other kind of distortion is due to the fact that, as you get closer to a spherical or oval shape, you see less *around* it. The effect is to make ears disappear behind the head and eyes move to the outer edge of the face. As you move your camera farther away from the subject, normal perspective returns.

Use Lenses Creatively—Distortion is not necessarily good or bad. You should be aware of the condition and

use it to your photographic advantage. The distortion caused by a standard lens used close to the subject can enhance a small chin, nose or forehead.

Distortion is most apparent in the features closest to the lens. The intentional use of the lens at closer than normal distances will cause weak features to appear larger on film than they do in reality. For this touch of instant cosmetic surgery, your subjects may be forever grateful!

Your lens selection should be determined by the photographic statement you wish to make. I'm often asked to photograph corporate executives in their working environment. For this, the standard lens provides a good compromise. It enables me to record the subject with detail and also to get an adequate background area into the picture.

TELEPHOTO LENS

The telephoto lens is perhaps the portrait photographer's most valuable tool. Because of its limited depth of field, as compared to shorter lenses used at the same aperture, it gives good selective-focus control. You can keep important image elements in sharp focus and have less important elements remain soft. This technique directs the viewer's attention to the area you determine most important in the photograph.

Subject Distance—A subject does not feel comfortable when the camera is very close to him. The telephoto lens allows you to work at a distance close enough for easy verbal communication, yet far enough away for the subject's ease and comfort.

When I use various lenses during a session, I usually begin with the telephoto. As the subject gets used to being in front of the camera, coming closer becomes easier.

For portraiture with a 35mm SLR, 85mm, 105mm 135mm and 180mm telephoto lenses are most useful. For the 2-1/4-square format, 120mm, 150mm and 250mm lenses provide a similar range.

Use a Tripod—When using a slow shutter speed, remember that camera shake is more evident on film when a long lens is used. This is because the movement is magnified along with the image. I like to use a tripod with telephoto lenses, especially at shutter speeds of 1/60 second or slower, to be sure of an unblurred image.

Close-Ups—The telephoto lens is useful for detailed close-up portraits. It allows for critical scrutiny of a face without the distortion of features resulting from a close viewpoint with a shorter lens.

WIDE-ANGLE LENS

The wide-angle lens is useful for group photography and for shooting in confined areas. Always remember, however, the tendency of the wide-angle lens for distortion. Objects closest to the camera become excessively large and elements farther away appear abnormally small.

Depth of Field—The extensive depth of field inherent in wide-angle lens makes it ideal for environmental portraiture. For example, a wide-angle lens would be an ideal choice for photographing a surgeon in the operating room. The lens gives a *wide* view and detail in *depth*.

Edge Distortion—Image detail near the edge of the film frame tends to be distorted when a wide-angle lens is used. This can be particularly evident in group photographs. Subjects placed close to the picture edge tend to record with an unpleasantly distorted head. The only way to avoid this is to not allow the group to extend to the edge of the frame.

Film

There are color transparency films, color negative films and b&w negative films. In addition to these obvious distinctions, different film types have different characteristics. Some of these traits can be used as creative elements in the making of a photograph. Film selection is as important as lens and lighting selection or choosing a camera angle.

There is no such thing as a *right* or *wrong* film. Selection must remain a matter of personal preference. However, you must be familiar with films and be able to choose wisely, if your photography is to be successful.

Rather than list the dozens of films available, I'll discuss the main film groups of interest to the people photographer.

FINE-GRAIN B&W FILMS

Slow, fine-grain films, used in combination with modern high-quality lenses, provide almost unlimited potential for image resolution. A 35mm image on such film can be greatly enlarged without any visible loss in image detail. With a larger film format, the enlarging potential is proportionately greater.

High resolution is important in group photographs, where detail and quality is to be retained in individual faces. The same is true of full-length portraits, for the same reason. In individual head-and-shoulders portraits, the detail reproduced is often almost excessive.

My favorite fine-grain b&w film is Kodak Panatomic-X, rated at ISO 32/16°. However, I use it selectively. It's fine for the face that has attractive character lines and good skin texture, or for the smooth-skinned baby. I avoid it with subjects having less than near-perfect complexions.

MEDIUM-GRAIN B&W FILMS

These films are usually in the speed range of ISO 125/22° to ISO 400/27°, when processed normally. Their grain structure is just prominent enough to conceal minor facial blemishes. The films have good exposure latitude and are capable of producing a full range of tones. Extended development leads to coarser grain and higher image contrast.

COARSE-GRAIN B&W FILMS

These films have two major attributes. They are fast and, therefore, ideal in low-light situations. They also have coarse grain that can be very attractive and effective in some types of photographs. In the 35mm format, Kodak 2475 Recording Film, at a speed of ISO 1000/31°, features a beautifully sharp grain structure that is very evident in enlargements. In 120-size film, Kodak Royal-X Pan, rated at ISO 1250/32°, has similar grain characteristics.

COLOR-TRANSPARENCY FILMS

This film type produces positive color transparencies or slides, suitable for viewing by projection or for photomechanical reproduction.

I like to use film that gives the highest image resolution and the best color balance and saturation. With this basic tool, I can always add a diffuser or filter to modify the image or achieve a special effect. As you see from the data provided with the photographs in this book, I do most of my color photography on Kodachrome 25. It is capable of yielding exceptional sharpness, color rendition and image contrast.

Other films have their own specific characteristics. Some offer higher speed. Some you can process yourself—which you can't do with Kodachrome. Some offer a granularity you may find attractive for certain applications.

COLOR-NEGATIVE FILMS

Color-negative film produces negatives from which color prints can be made. With the amateur snapshooter, this is currently the most popular kind of color film. Its main assets are easy reproducibility in any desired quantity and size and ease of viewing, without the need for projector or viewer.

There are also certain disadvantages. One is particularly disturbing: Unless you pay a special price for custom-made enlargements or prints, color balance tends to leave much to be desired. This is best illustrated by comparing identical images printed at different times. The color rendition will often be extremely dissimilar—even when the prints were made by the same lab. If you intend to use color-negative film for serious photography of people, I strongly recommend you either make your own enlargements or have them custom-made by a reputable lab.

The commercial photographer does most of his work on transparency film. The image viewed by transmitted light has an inherently wider tonal range. This is evident both when viewing the projected image and when scanning it for photomechanical reproduction.□

Five

Composition and Posing

Composition involves arranging elements in an artistic form. As photographers, we have command over many elements. The two that play the most important role in good composition are the *position* of the various elements and *tonal balance.*

Position involves the placement of positive elements—known as *subject matter.* This placement occurs in relationship to a negative element—the *space* where there is no subject matter. Tonal balance involves the visual balance between light and shade.

It is for you to decide what parts of a composition you wish to emphasize and which parts you consider less significant. By de-emphasizing certain areas, you can give added emphasis to others.

Position

The decisions you make regarding composition can either enhance or detract from the effect you hope to convey to the viewer. In the final analysis, the procedure is a matter of personal taste. There are, however, certain guidelines that may help you avoid problems.

THE GOLDEN MEAN

Philosophizing about composition is as old as art itself. My earliest recollection of the term was during grammar school art class. My teacher went to the chalkboard to diagram what she termed the *golden mean.* Years later, when I was an undergraduate at Penn State, my architecture professor made reference to the *golden rectangle* theory during a lecture on spatial

proportions. The theory refers to the use of basic geometry to locate specific points of interest in a rectangular form.

The basis of the theory is that the strongest point of visual interest in a rectangular form with adjacent sides of unequal length *is not at the center.* It is at four specific locations. You can find these in the following way: Draw two lines to divide the rectangle vertically into three equal parts. Then draw two lines to divide the rectangle horizontally into three equal parts. The four points where the lines cross mark the locations of strongest visual impact in a picture. Illustration 5-1 shows the golden rectangle.

EYE PLACEMENT IN THE GOLDEN RECTANGLE

Good composition is a matter of placing critical subject elements in an area of the photograph where they receive the greatest viewer attention.

You must determine the element of greatest importance within the scene.

With the exception of some advertising photographs—in which a model may be holding an important product—*subject* placement is the primary concern. The most vital part of the subject is the eyes. They, above all else, capture the life and vibrancy of the individual. They constitute the part of the face the viewer looks at first.

As you look through the images in this book, you'll notice the eyes are usually placed in one of the four strategic locations indicated by the golden rectangle. Notice that the rule works, regardless of subject cropping. It's as appropriate for full-length photos as for extreme close-ups.

If you draw a line through the upper two points of the rectangle and another through the lower two points, you divide the frame into thirds. The upper and lower thirds—in the case of

5-1

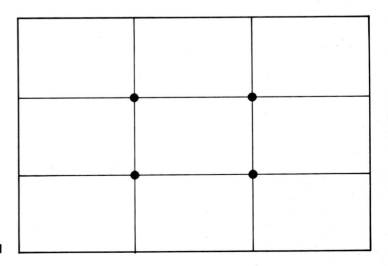

a vertical image—are the areas of greatest impact.

This formula is nothing more than a guideline for good composition, but it works most of the time. You can test the theory with photographs you've already taken. Try re-cropping your prints with two L-shaped pieces of cardboard. Be sure to relocate the eyes according to the golden-rectangle rule. You'll see that it can make a dramatic difference in picture impact.

EXCEPTIONS TO THE RULE

There are exceptions to most rules, including this one. The most significant one is in the photography of children. When children occupy too much of the picture area, they tend to appear too large—and sometimes almost grotesque.

The effect is most apparent in studio situations with seamless paper as background. This environment offers no objects to act as a scale of reference to the child. To make a child look like a child, provide extra background area, particularly above the child's head. In doing so, you allow the child to occupy a smaller part of the picture area and thus give him less prominence.

There are other exceptions to the rule. They are determined by the specific statements you might wish to make photographically. If, for example, you want to photograph an old farmer in his natural environment, or a famous architect in front of his latest high-rise creation, you might elect to compose the subjects smaller in the frame.

You'll want to allow for an expanse of countryside behind the farmer and a maze of concrete and steel behind and above the architect. In the final composition, the subject's eyes may be positioned close to the center of the print. This departure from the rule is justified because you consider the background to be an important part of the picture.

Tonal Balance

The second way to add compositional strength and subject emphasis is by selectively varying tones within the photograph. The human eye is attracted to *contrast*. A light object on a dark field draws viewer attention, as does a dark object on a light field. Just as you must be careful to place the subject in

the strongest area of the frame, so you must also take care to place the subject against a complementary background tone.

A photograph is sharp if it has good resolution of image detail. A photo can also be made to *appear* sharp through the skilled use of contrast.

Subject Control and Posing

I much prefer the term *subject control* to *posing*. When I hear the word *posing*, I imagine an individual firmly planted in a predetermined position for an indefinite length of time. In the context of this essay, a *pose* is the position of the subject at the moment of photography.

In the early days of photography, there was a reason for standard poses. It was not unusual for a photographic exposure to last a minute or even longer. It was imperative for the subject to be placed in a secure, yet appealing, position that could be sustained for the duration of the exposure.

Constrictive posing is a relic of the past. There's no need for it any longer. Today's state-of-the-art camera/lens systems, in combination with fast films, avail the photographer of short-duration exposures. This gives you almost limitless subject control.

Such flexibility can be a double-edged sword. It requires expertise beyond the technical to exercise continuous effective control over both body and mind *while* you're shooting.

The subject must feel comfortable mentally with a pose if the photograph is to be successful. There's a difference between mental and physical comfort. A pose need not always be physically comfortable to produce a successful result. In the medium of photography, the end result usually justifies the means of achieving it.

For example, it is normal for lines, wrinkles and loose skin to develop on the neck and under the jawline of mature adults. This condition is of equal concern to the subject and the photographer. To de-emphasize the condition, ask the subject to stand and place one foot up on the seat of a chair or on a railing. As the subject turns to confront the camera, have him lean toward you, stretching his neck.

From camera position, the pose looks perfectly normal. And there's an unquestionable improvement in the line of the neck and jaw. The subject, however, may feel discomfort if he attempts to hold the position too long. Discuss the situation with him prior to asking him to pose. Tell him to let you know if the position becomes uncomfortable, so he can take a break.

I begin most photo sessions by posing *myself*. I take the position I would like my subject to assume. I explain the reason for the position. For example, I may say, "This pose produces a cleaner line along the neck."

Remember, you and the subject have the same goal—to produce a successful, flattering image. Achieving success is the responsibility of both of you. Don't expect subject participation and total involvement if you exclude the subject from your thinking.

Like lighting and camera angle, body position must be tailored to the individual. For example, a position that suits one woman may be unsuccessful with another. The position enhancing the look of a child will certainly be inappropriate for an adult man.

I begin analyzing potential poses from the time I meet the subject. Watch your subjects as they sit, speak, turn their heads and move. The best subject positions are those assumed *naturally*!

Some exceptional subjects have a natural ability to work with ease in front of the camera. Their every movement becomes a thing of beauty. Many, however, seem to be totally lacking in muscular control and basic bodily coordination. Fortunately, there are some ground rules. When all else fails, return to the basics.

There are guidelines for posing men and women that should be viewed as a foundation—a basic starting point. Familiarize yourself with them. Then experiment and refine as you consider necessary. The guidelines are as appropriate for posing the head shot as the full-length photograph. In the remainder of this essay, I'll discuss and illustrate the principles of classic portrait posing.

MALE PORTRAITURE

Illustrations 5-2 and 5-3 show how a male portrait should be posed and how body weight should be distributed.

Illustration 5-2 was taken for Fabergé to promote a man's cologne. The model is positioned in a classic masculine pose. Notice that his head and body face in nearly the same direction. His head is squared on the shoulders.

It is important that the subject appear comfortable and balanced. If he is standing for a full-length or 3/4-length photograph, ask him to place one foot toward the camera. Then direct him to allow most of his weight to fall on the rear foot. The resulting pose will look natural and comfortable. The shoulder on the side of the rear foot will usually be a little lower than the other shoulder.

The position looks totally natural from camera position because normal perspective accounts for the near shoulder appearing higher than the far shoulder. The most comfortable and attractive position for the man's head is achieved by asking him to tip the head slightly toward the lower shoulder.

Illustration 5-3 of actor Lee Majors was taken for Diet-Rite Cola. Although he is seated, Lee's weight is mainly to his left side, away from camera position. His head—nearly squared on his shoulders—is tipped toward the lower shoulder.

FEMALE PORTRAITURE

In order to pose a subject properly, it's important that you understand

and *feel* the body positioning yourself. Only then can you effectively direct your subject.

Stand in front of a full-length mirror. Assume the classic masculine pose, as described in the preceding section—left foot forward and weight on the right foot. Tip your head slightly, allowing it to be approximately perpendicular to your shoulders. Notice that the compositional lines created by the intersection of the head and shoulders are angular. Such angularity in composition and posing is uniquely masculine.

Remain standing in front of the mirror. Without changing your body position, change the position of your head, tipping it toward the higher shoulder. An interesting and remarkable change occurs. The rugged and angular compositional line of head and shoulder in the masculine pose is replaced by a soft "S-curve." Your appearance becomes distinctly "feminine."

The slight change of head position in relationship to the placement of the shoulders is the main difference between classic masculine and feminine posing.

Illustrations 5-4 and 5-5 illustrate a difference between classic masculine and feminine posing. Illustration 5-4 of talented Ben Vereen shows a casual approach to classic masculine posing. Although seated on the floor, Ben has shifted his weight to the rear and

tipped his head toward the lower shoulder in classic masculine fashion.

Illustration 5-5 is part of an advertising series produced for Conair, Inc. The model is also positioned on the floor, but she has turned and tipped her head to the higher shoulder. The relationship of her head and body creates a beautifully feminine curve.

The classic feminine pose is further evident in Illustration 5-6, taken for Fabergé Cosmetics.

EXCEPTIONS

Does the foregoing mean that a woman can't be photographed in a "masculine" pose and a man can't be photographed in a "feminine" pose? Not at all. Rules may be broken to achieve a specific result. A visually *pleasing* pose is a *good* pose. In Illustration 5-7, for example, actor Jack Scalia has not squared his head and shoulders. His head is tipped to the higher shoulder, but his appearance is unquestionably masculine.

Illustration 5-8 of legendary model Wilhelmina was made for the cover of her book, *The New You.* Notice that she tips her head to the lower shoulder, as with classic masculine posing. Her head is almost squared on the shoulders. Nonetheless, the image is very feminine. In Illustration 5-9, Wilhelmina returns to the classic feminine pose.

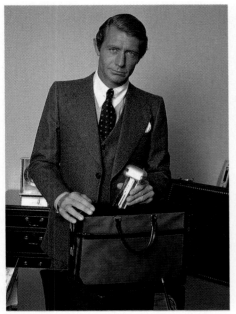

5-2

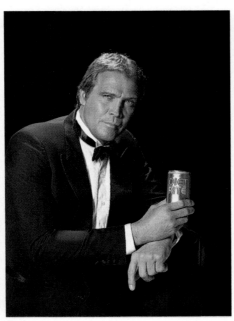

5-3

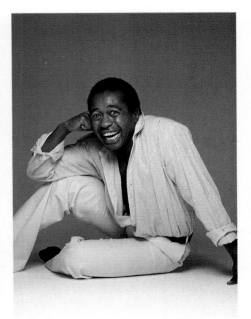

5-4

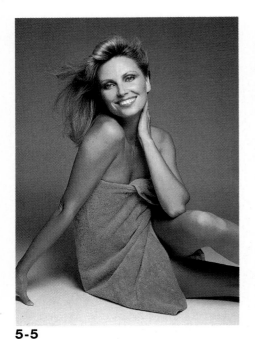

5-5

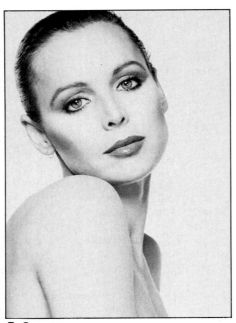

5-6

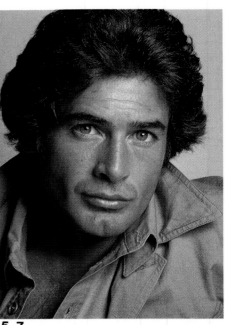

5-7

These photos of Jack Scalia and Wilhelmina show that the personality and mental attitude of the subject play a far more significant role in overall appearance than restrictive posing.

SEATED SUBJECT

The classic masculine and feminine poses are appropriate for seated subjects, too. To pose a subject on a chair or sofa, I begin by directing the subject while he or she is standing. I then ask the subject to slowly be seated without altering the position of the feet. The body easily assumes a

perfect, classic position for the seated photograph. If the subject sinks too low into a soft chair or sofa, try placing some books or a two-inch board below the seat cushion to raise the body.

MALE AND FEMALE TOGETHER

The classic poses lend themselves ideally to a harmonious interplay of forms when combined. Illustrations 5-10 through 5-14 show variations in which the blend of masculine and feminine posing combine as naturally

as adjoining pieces of a puzzle.

Illustration 5-15, taken for a European shirt manufacturer, shows an interesting combination of masculine and feminine poses.

Be flexible in your posing. If a subject is having trouble positioning his body according to your verbal direction, assume the pose for him. *Show* him the pose you want. I ask the subject to assume my position behind the camera, so he can see the effect as it will appear on film.

Don't be surprised if a subject sometimes has difficulty assuming a

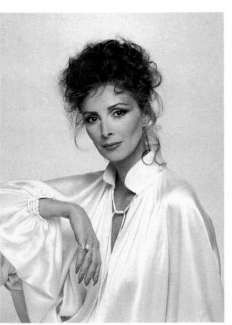

5-8

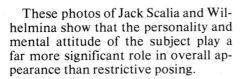

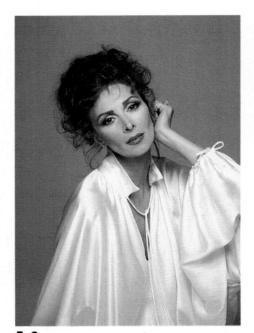

5-9

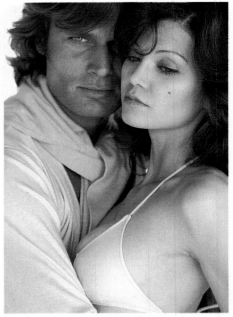

5-10

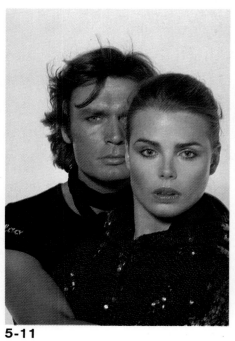

5-11

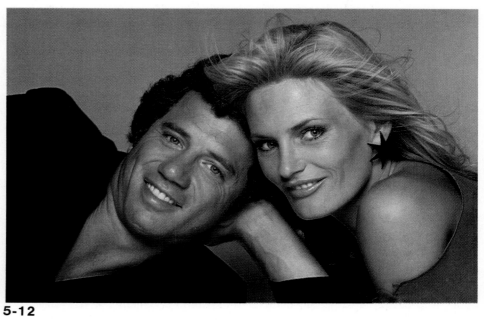

5-12

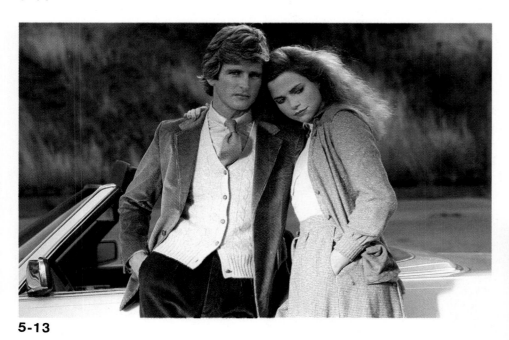

5-13

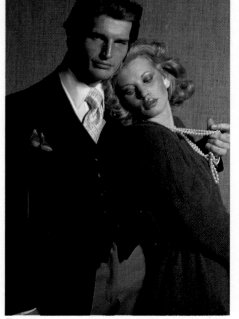

5-14

pose even after having been shown. Poses must be designed with the individual subject in mind. A position that worked on one subject won't necessarily be successful on another. Be prepared to experiment. There are always alternative methods for achieving the desired effect.

GROUPS

Many years ago, I studied classic portraiture. I remember my instructor saying that "posing a group is like arranging flowers." Place the first flower and then add to the bouquet, one at a time. I can't improve on this advice. Posing groups is a uniquely visual talent. Success depends on your ability to compose a pleasing blend of shapes and sizes within the frame of the photograph.

In the group photograph, all subjects must register in the final composition with equal importance. Spacing, lighting and compositional areas must balance. Graphic elements must appear to flow in a continuous path, leading the viewer on a *visual tour* of each subject.

The thought of group photography intimidates many photographers. I like to look at it as an opportunity for limitless graphic expression. The group photograph must be approached with an open mind. Regard it as graphic creation, using the human form as your medium.

Special technical precautions must be taken in the photography of groups. Whenever possible, shoot at small lens apertures to ensure sufficient depth-of-field. Faces must record with equal sharpness. Position your subjects as close to the same plane perpendicular to the lens axis as possible. This minimizes depth-of-field problems in low-light situations requiring large apertures. It also ensures accurate perspective rendition of the subjects.

Illustration 5-16 was taken at Vassar College for a fashion issue of *Sport* magazine. It shows a formal approach to group posing. Notice that each man is in a classic masculine pose. Both women are in a typical feminine pose.

Illustration 5-17, of *The Village People,* for Jean-Paul Germain's *Winners,* shows the freedom at your command in group posing.

Photography is a medium without limitations. Group photography is no exception. Make sure you follow the basic rules of good composition and the technical requirements for a good photograph. Then let your imagination be your guide.□

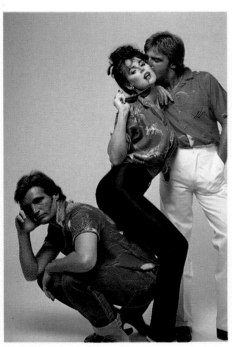

5-15

5-16

5-17

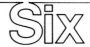

Six

Psychology

Except for the experienced professional model, I've yet to meet the subject who's comfortable in front of the camera. And I've been a professional photographer for more than 17 years. Regardless of the attractiveness or success of the subject, something strange takes place the moment he or she confronts the camera.

Faces become contorted. Expressions and attitudes change. The subject's overall energy level sometimes even seems to dissipate. The subject is filled with a multitude of emotions and apprehensions. To a great extent, this mental state is not without foundation.

EFFECTS OF SOCIETY AND THE MEDIA

Society and the media are largely responsible for our insecurities. None can deny the importance placed on youth, on looking good and on being slim. This is not new. We've all lived with it for years.

Beauty and glamour magazines, physical-fitness and self-help publications, television and advertising all affect our lives daily. The more permanently engrained this "brainwashing" becomes, the more apparent are our fears. Most people do not face a camera on a regular basis. A photo session is rare, whether the photographer is a professional or a next-door neighbor with a new Instamatic. The subject is suddenly on stage, facing the moment of truth . . . alone!

INFLUENCE OF PHOTOGRAPHER

I believe that, to a large extent, we professional photographers are responsible for the fears of the subject confronting the camera. For the moment, place yourself in the role of the subject. Your earliest recollections of being photographed by a professional were probably for school pictures. You entered the cold, makeshift studio set up in the school cafeteria. You were told you were allowed six exposures and no more.

This limitation was the start of the negative attitude toward portrait sessions. You realized you had "only six shots"—six opportunities to look your best! You had to look good in at least one of them.

The production-line approach to photography was enforced through childhood and into adulthood. Perhaps, in subsequent years, you encountered the finest portraitist in your home town. However, his approach was probably not dissimilar. He required performance on demand, lest you ruin your six or eight shots!

Unfortunately, the majority of professional photographers have yet to learn one basic lesson: Film is an expendable item! Its cost is insignificant when compared to the importance of preserving a comfortable expression on a special subject. And *all* subjects are unique and significantly special! To capture that unrepeatable moment and expression, start by eliminating subject apprehension and insecurity.

START OF SESSION

When I start a portrait session—whether it's with a celebrity or a grandmother from Waukeegan—I tell the subject I'll be shooting a lot of film. I emphasize the expendability of my supplies. I assure my subject he's paying for my efforts and skills—not my film costs. Your approach should be basically the same.

Let your subject know you'll try many different poses, expressions and lighting effects. Your aim is to get that *one ideal* image. It's the one the subject, his relatives and friends will cherish forever.

People can sense honesty. They also appreciate dedication, concern and empathy. It is to your advantage to care for your subject. You will see the results of the extra effort when your film is processed.

Shutter speeds and lens apertures are, indeed, part of the photographic process. However, all the technical knowledge and skill in the world is meaningless, if the subject looks less than spectacular—by *his own* standards—in the finished photo.

SUBJECT'S ATTITUDE

Most subjects do not understand, nor do they care about, the technical aspects of photography. Just like the professional advertising client, they judge the success or failure of an image by its *impact* alone. David Ogilvy, a prominent advertising executive, said many years ago, "It's not creative unless it sells!"

As a photographer of people, you have to *sell* the subject on his own image. Sales technique alone is of no value, once the session is complete. You can't talk someone into liking an image he considers less than appealing. The *photograph* must do the selling for you. The finer your technique and understanding of the medium, the greater your chances for pleasing the subject. In the final analysis, the subject is the judge.

PHOTOGRAPHER'S ATTITUDE

All people are beautiful. If you are able to capture that beauty, your subjects will be eternally grateful. It requires the proper state of mind on your part to influence the subject's spirit. His mental attitude is apparent in the eyes. They are the windows of the soul, telling all.

Look at the portraits you've taken, or those you find in magazines and books. The relationship between the subject and the photographer at the moment the shutter was released is apparent in the subject's eyes. You can see confidence or the lack of it. You can see strength or weakness, happiness or sadness.

As photographer, I must be able to influence my subject's emotional state while he's in front of my camera. The subject should respond to my direction as an actor responds to a director. However, the response should be spontaneous and natural.

PHOTOGRAPHER-SUBJECT RELATIONSHIP

The photographer and the subject have mutual responsibilities. You can't demand a higher energy level or more involvement from your subject than you are contributing yourself. I expend a tremendous amount energy during every photographic session—regardless of the subject or my mental and physical condition at the time. The subject's awareness of this give-and-take is essential. Your subject must be made to realize that he, too, will be working to produce a successful photograph.

In the high-pressure world of advertising photography, it's the norm to have a multitude of spectators in the studio, watching every move. In this environment I have learned the importance of maintaining total control over the model's emotion and attitude. It's imperative that the model's attention be directed only to

me. Otherwise, she is likely to become confused and unable to perform her task to the best of her ability.

The sensitive and experienced client is aware of the subject's frailty and the tenuous relationship between photographer and model. When he has thoughts or comments relating to the session, they are tactfully whispered to the photographer as an aside. This maintains the photographer's integrity and his control of the photo session.

A private portrait session should be no different. Subject control is your responsibility from the moment you get behind the camera and ask an individual to pose for you.

Never forget your ultimate goal—to capture and preserve the individual's personality in a way appreciated equally by you and the subject. Use whatever technique is necessary to capture the unique expression of the subject, regardless of how fleeting the expression may be. It need only exist for a moment to be captured forever.

THE ART OF FLATTERY

One distinct advantage for the photographer of people is that all individuals want to feel beautiful. Women, men and children all love to be flattered. As we go through life, the unfortunate truth surfaces: Society is not always generous with compliments. The recent proliferation of self-help books is an indication of the abundant insecurity of our society.

It is imperative that you give support and encouragement to each of your subjects from the time the photo session commences. You can do this in several ways. Each photographer must determine the methods that work best for him.

From the moment my subjects are within earshot, I begin to use flattery. I tell each how uniquely wonderful he or she looks. Is it always the truth? No, not at *that* moment. Does that make me dishonest? Perhaps, a bit—but it's only a momentary half-truth. Like magic, as the session progresses, the subject's attitude and appearance begin to change!

Appreciate the most essential factor in producing successful photographs of people: When people *feel* beautiful, they *look* beautiful. Their faces begin to change—even the tonality of their skin. And most assuredly that special look in their eyes. Scientists may not be able to substantiate this philo-

sophy, but it can be proved on film. Believe me!

BEGINNING TO PHOTOGRAPH

Flattery is the initial approach to instilling subject confidence. The second step begins with the photo session. Because part of the subject's insecurity is a result of forced performance within the span of a few exposures, it's important to make clear that a session with *you* will be *different.*

My kind of portrait session is a new and unusual experience for most subjects. They are given restrained direction and get constant approval for their efforts. As soon as a subject is in place, I indicate that I will *not* be giving directions after each exposure, if I like what I see. I'll give additional direction *only* if I think there is a way to improve upon what I am seeing.

This lets the subject know that there's no need for continuous flattery and encouragement, if he's performing admirably in front of the camera. Nonetheless, I'll be talking a lot—non-stop, most likely—to maintain a close rapport with the subject.

I will *not* alter the subject's attitude or correct posing problems within the first 10 to 15 exposures. Remember, film is expendable and the subject's security and confidence are not. It's important that the subject begin feeling the *pace* of the session. I want him to be familiar with the sound of the shutter, the speed at which I shoot and the amount of film I shoot. I want my subject to feel self-assured in front of the camera from the onset of the session. To begin a session by correcting every movement and attitude would be inhibiting and destructive.

During this break-in period, I give encouragement to the subject with, "That's beautiful! That looks great! Perfect!" This shows my satisfaction. The subject quickly begins to gain confidence and may experiment with different poses and attitudes. If I like the changes, I continue to shoot while giving verbal encouragement. If I prefer a different attitude or pose, my response might be, "That's nice, but try turning your head a bit more toward me."

Before making corrections, always assure your subject that he's doing well. Make this a basic rule: The subject can never do wrong!

Not all subjects will respond in the same way. However, you'll be sur-

prised at the consistency of their performances, when you deal with them thoughtfully. The change in a subject's confidence by the end of the first roll of film will amaze you!

COUPLES

In terms of subject control and psychology, two subjects make your task easier. They give support and encouragement to each other. Their fears are lessened because the experience is shared. As a result, they tend to be less tense. As photographer, you maintain your directorship, but with one more player in the scene.

I particularly enjoy working with loving couples—as distinguished from business and sibling relationships. The intimacy and physicality of the romantic couple offers more variety of expression. The basic, emotional reaction to tactile sensations—a touch, a squeeze or a tickle—begs to be captured on film.

It's not unusual for one of the pair to be more demonstrative than the other. It is important, however, that a balance exist between the attitudes of the two. You should direct and encourage them equally. For one to be smiling as the other remains pensive may be realistic, but photographically it rarely works.

Be aware that one subject may not see the other's expression. So, let each know what the other is doing. Talk to your subjects. Don't be afraid to tell them what you're looking for. You are the director. They are your actors. Have confidence in your subjects—they won't let you down.

The same confidence-building techniques used for the individual must be applied to couples and small groups. Begin the session by shooting continuously, giving constant verbal encouragement. When you get a pose or attitude that obviously doesn't work, break from it. Don't belabor the inappropriate.

It's natural for a photographer to predetermine the best attitude for a subject. Resist this temptation and try a variety of expressions and poses.

CHILDREN

I'm at my most frivolous when photographing children. I live by the credo, "It matters not how you act, in order to get a child's expression on film."

A child, in all his frailty, possesses an uncanny ability. He can make a mature photographer bark like a dog and scratch like a monkey, to elicit a wonderful expression. The tables have suddenly been turned on you. It is *you* who must perform. It is *you* who must emote with reckless abandon—often in the presence of strangers—all for the sake of capturing a twinkle in the eye.

There is a reason why small children respond to physical display and scoff at the logical. They're innocent and innately honest. They display only that which they *feel*—and respond to only what is genuinely *felt*. They've yet to be shaped by society, which *demands* "spontaneous" performance and *encourages* contrived attitudes.

I believe that you must truly love children to photograph them successfully. You have to respect them and their purity. You must also strive to gain their confidence. If they trust you, a million galleries may be filled with their range of expressions and attitudes. They'll work harder than any other subject to please you. If you truly care, the twinkle will appear!

GROUPS

Photographic ineptitude has no place in group photography. Although family members and other close-knit coteries may have the patience of saints, a group of strangers will not. Only an adept and communicative photographer is consistently successful when working with groups of people.

In group photography, each subject is of equal importance. Just as the single subject must be recorded well, so must each individual in a group. Groups as collective units respond intuitively to competency. They seem to have a collective sixth sense, capable of detecting a photographer's insecurity, ineptitude or indecisiveness.

It is important that you *know* what you want photographically and how to achieve it. If you don't, you'll lose their attention and cooperation. The attention span and patience of a group tends to be less than that of an individual.

If I'm working at an outdoor location with a large group, I take an electric bullhorn with me. If the subjects can't hear, they can't respond and follow direction. I'm more verbal and more demonstrative during group sessions than in an individual portrait session. There are more people to be motivated—more personalities to be captured. The picture is not successful unless each individual looks his best.

I start by explaining to the group my concept for the photos. I assure them of my dedication to producing a successful image. I explain what their individual and collective responsibilities will be. When I have placed an individual in a pose, he should remain in position until each other person in the group is posed. The relationship of each individual to the others is critical to the success of the photograph.

The group is told that I cannot watch everyone's expression and attitude at the same time. Each person must be responsible for his own expression and pose.

Excitement and dedication are contagious. That's true whether you are photographing a couple or a group of 20. Make the photo session an enjoyable experience for your subjects. Show them that your desire is to produce an image they will love. Let them know that you'll be satisfied only with an image that captures the beauty of their faces and the essence of their personalities. Make them realize that you're out to produce a *lasting* image.

Your understanding and technical control of the photographic process should be second nature. This makes you free to devote your total energy to the subjects. You'll find that each group member will echo your confidence and respond to your desires.

It seems increasingly rare for individuals to meet and find themselves with a common goal. However, such a common goal can be found in a group of people when they're directed by a competent photographer.□

Seven

Portfolio

1

Subject: Professional model
Location: Beverly Hills, California
Camera: Nikon F3
Lens: 85mm ƒ-1.8 Auto-Nikkor
Lighting: Direct late-afternoon sunlight
Light Control: Two black Rocaflector panels
Film: Kodachrome 25
Exposure Metering: Through-the-lens, center-weighted, automatic mode
Exposure: Automatic (not recorded)

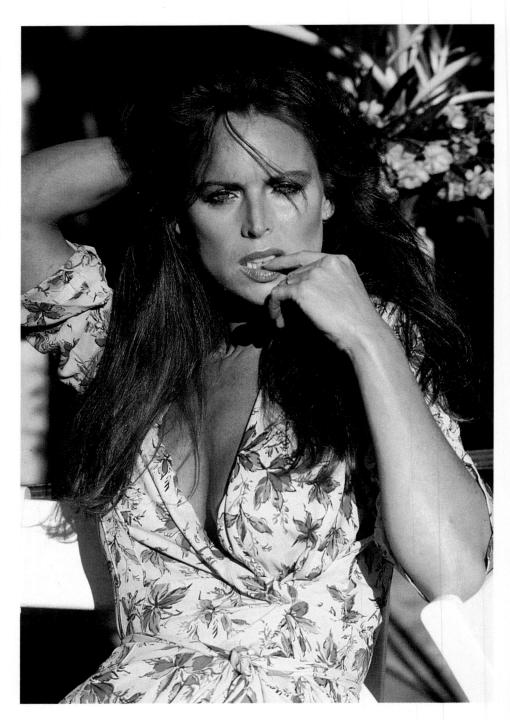

The direction of the low afternoon sunlight was frontal to the model's face. It reveals minimal facial texture but emphasizes the facial outline. Two seven-foot black Rocaflectors were positioned on either side of the model. They helped to eliminate light from the side and further emphasized frontal illumination.

Normally, brunettes should not be photographed against a background having the same tonality as the hair. It causes the subject's head to apparently end at the hairline because hair and background tend to merge. In this photograph, however, the tonal similarity was compensated for by selective placement of background elements. They included flowers and branches on one side and the model's arm on the other.□

Subject: Professional model
Client: The Palm Beach Company, Inc.
Art Director: Ceci Murphy
Location: Nyack, New York
Camera: Nikon F2
Lens: 105mm *f*-2.5 Auto-Nikkor
Lighting: Daylight, overcast
Light Control: 27-inch silvered Reflectasol
Film: Kodachrome 25
Filtration: Skylight filter
Exposure Metering: Gossen Luna-Pro, incident-light mode
Exposure: 1/30 second at *f*-4

It was an overcast day in New York when this photograph was taken. The model was positioned under the overhang of a porch. The overhang blocked the diffused light from above, allowing lower light to strike the model's face at a flattering angle. I used a silvered reflector to the left of my camera, adding modeling to the face and sparkle to the eyes.

I took an incident-light reading from the model's face, pointing the meter toward the reflector. A skylight filter was used on the lens to eliminate the blue cast inherent in open shade.

Notice the placement of the model. The white wood blends with the model's sweater. Dark elements are placed to either side of the subject, enclosing and framing her in the composition.☐

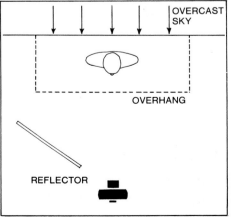

Subject: Gladys Knight and the Pips
Client: Jean-Paul Germain, Ltd.
Location: Hollywood, California
Camera: Nikon F3
Lens: 55mm ƒ-3.5 Micro-Nikkor
Lighting: Four 1200-watt-second electronic flash units
Light Control: Silver Rocaflector
Film: Kodachrome 25
Exposure Metering: Minolta Auto-Flash III, incident-light mode
Exposure: ƒ-11 (shutter at 1/60 second)

Energy and excitement are contagious. They exude from this photo of recording legends Gladys Knight and the Pips. The subjects' attitude was one of confidence and we had a wonderful rapport.

When you're working with a group of people, you must be able to work fast and make instantaneous decisions. You must be able to control your *lighting* with ease and speed. This is not easy, when you have four different subjects to consider. You must also be decisive and quick with the *posing*.

While the group was getting ready for photography, I marked a small X on the white seamless paper to indicate the group's position on the set. I made light-meter readings in advance, estimating the approximate position of each group member.

Four lights were used. Two were umbrella-reflected background lights. The main light was reflected from a six-foot silvered umbrella, to provide uniform illumination over the four faces. A rim light, fitted with a grid spot, was used to highlight the heads of the two members at the rear. I placed a seven-foot silver Rocaflector on the floor in front of the group. It provided the secondary catchlights in the eyes. It also directed some light into the shadow areas.

Individuals in a group photograph should be arranged like flowers. Carefully place one, then the next, and then the next—until the *bouquet* has balance. I pose subjects by first taking their position in front of the camera myself. I have them copy what I do. I started by posing the two subjects in the front. Next, I added Gladys.

Finally, I brought in the fourth member behind Gladys.

I explained to the group that I would like their faces as nearly the same distance from the camera as possible. This was important. It ensured that all heads appeared about the same size. The member at the rear strained a bit to come forward far enough.

Your eye should be drawn first to Gladys. She was placed at the most dynamic point in the image, as described in the essay on *Composition and Posing*. Her white sweater also makes her the center of attention. Notice that each individual is at a slightly different height in the frame. This gives the group a casual, candid appearance.

I had to use a lens aperture that ensured adequate depth of field. In this requirement, I had to include the possibility that the members may need some readjustment during the session.□

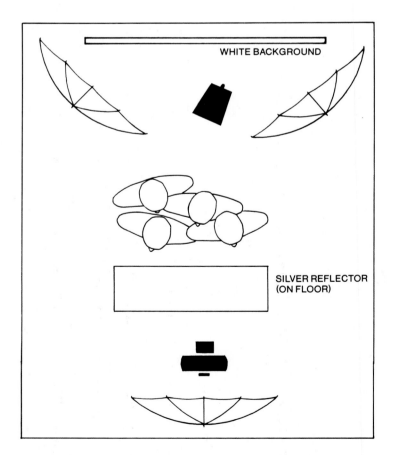

WHITE BACKGROUND

SILVER REFLECTOR
(ON FLOOR)

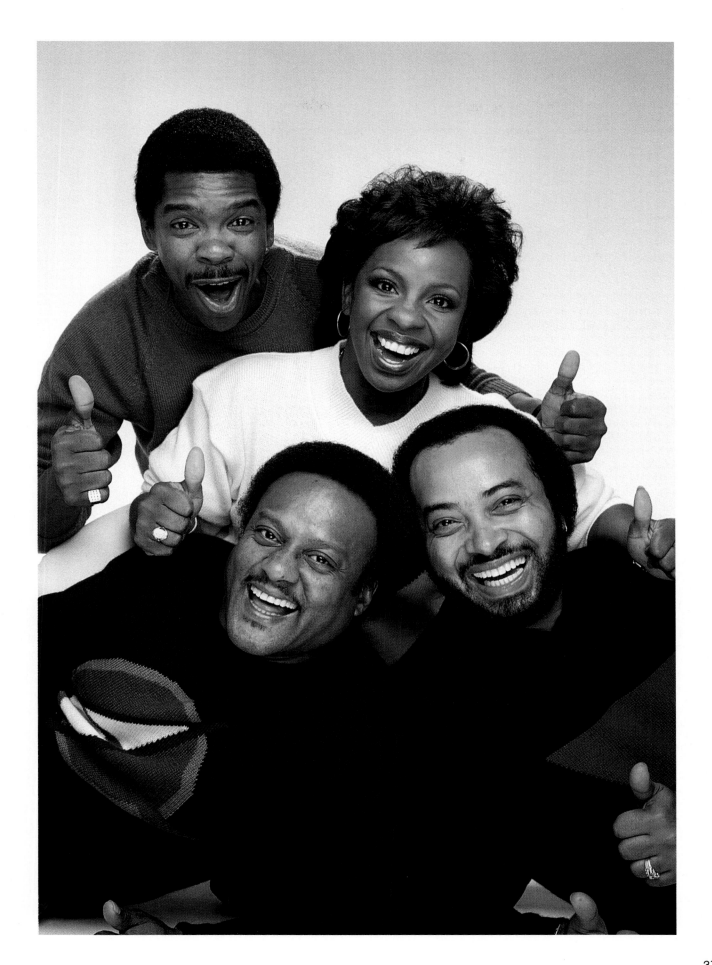

Subject: Professional model, for a retail poster
Location: Beverly Hills, California
Camera: Nikon F3
Lens: 105mm *f*-2.5 Auto-Nikkor
Lighting: Midday sunlight, redirected
Light Control: Rocaflector with silver surface
Film: Kodachrome 25
Exposure Metering: Minolta Auto-Flash III, incident-light mode
Exposure: 1/250 second at *f*-5.6

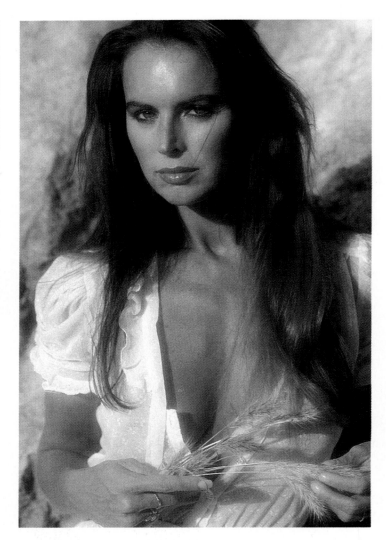

This photograph was taken at noontime on a bright, sunny day. The subject was placed against a steep hillside, shielded from the direct sun. At midday, the sun is too high in the sky to be usable as main light for portraiture. It has to be modified. I used a large, silver-surface Rocaflector to bounce the sunlight back into the model's face.

The highly efficient reflector redirected the sunlight without changing its specular and directional quality. This is shown by the distinct shadows and high contrast between highlight and shadow areas. I redirected the light so the model was lit frontally. This kept facial texture to a minimum. The end result is both flattering and dramatic: The face appears soft but its outline is emphasized.

When you meter a scene lit in this way, the *redirected* light effectively becomes the *main* light. I placed the meter at the subject's face and pointed the incident-light hemisphere toward the *reflector.*

Looking directly at a silvered reflector can be difficult for some subjects. Like direct sunlight, it can cause squinting. I tell the subject not to look directly at the reflector until the moment I'm ready to shoot. Sensitive eyes may not be able to look at the reflector at all. In such a case, I compromise. I *angle* the reflector away from the subject slightly. I compensate for the slight light loss when I expose. □

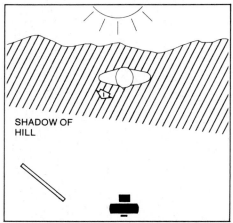

SHADOW OF HILL

⬇ INCIDENT-LIGHT METER READING

The only illumination for this intimate scene came from the tungsten modeling lights of two electronic flash units. These lights have a color temperature of 3500K. That's very close to the tungsten-light balance of the 3M 640T film I was using.

I used grid-spot attachments on both modeling lights to concentrate the illumination where it was needed. I wanted to highlight the faces and rim light the subjects' heads. The lamp that provided the rim light for the hair was on a light stand immediately behind the seat. The main light was to the right of the camera.

There are many ways to generate an ambiance photographically. In this case, I *softened* the entire image by using a characteristically grainy film. To make the image even grainier, I exposed the film at double its advertised speed of ISO 640/29° and had the lab *push-process* it. The resulting image is highly granular, giving the photograph a candid mood.

My incident-light meter indicated an aperture setting of *f*-8 for the rim light and *f*-5.6 for the main light, with the shutter at 1/60 second. I exposed at *f*-5.6. The exposure was also appropriate to record the candle flames in the foreground.

The subjects are involved with each other, not the camera. Although both models were carefully directed, the photo appears candid and spontaneous. Notice that the woman is looking just past the camera without indicating any awareness of its presence. □

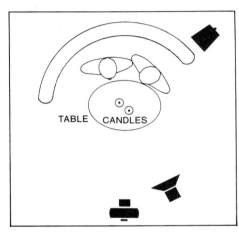

TABLE CANDLES

Subject: Professional models
Client: Pisces Restaurant, Carlsbad, California
Art Directors: William Randall and Russ Heinze
Location: Carlsbad, California
Camera: Nikon F3
Lens: 85mm *f*-1.8 Auto-Nikkor
Lighting: Quartz-halogen modeling lights from two electronic flash units
Film: 3M 640T film
Exposure Metering: Gossen Ultra-Pro, incident-light mode
Exposure: 1/30 second at *f*-5.6

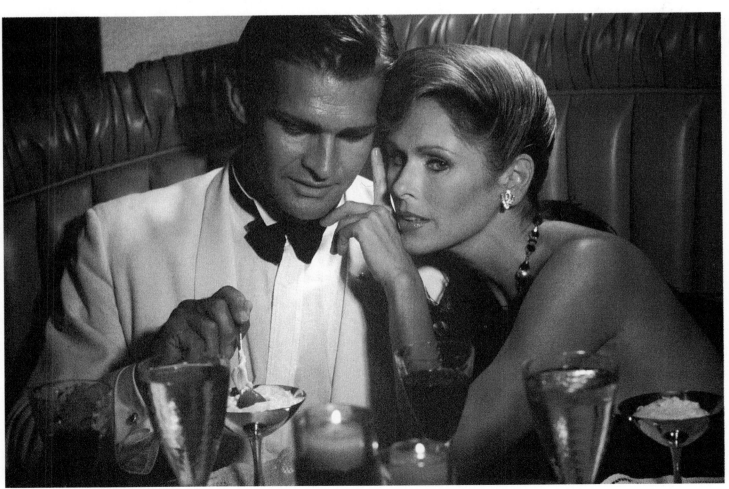

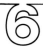

Subject: Natalie Cole
Client: Posner Cosmetics, Inc.
Ad Agency: Hicks and Griest, Inc.
Art Director: Ralph Parenio
Location: Los Angeles, California
Camera: Nikon F2AS
Lens: 105mm *f*-2.5 Auto-Nikkor
Lighting: One 1200-watt-second
electronic flash unit
Film: Kodachrome 25
Exposure Metering: Minolta
Auto-Flash II
Exposure: *f*-5.6 (shutter at 1/60
second)

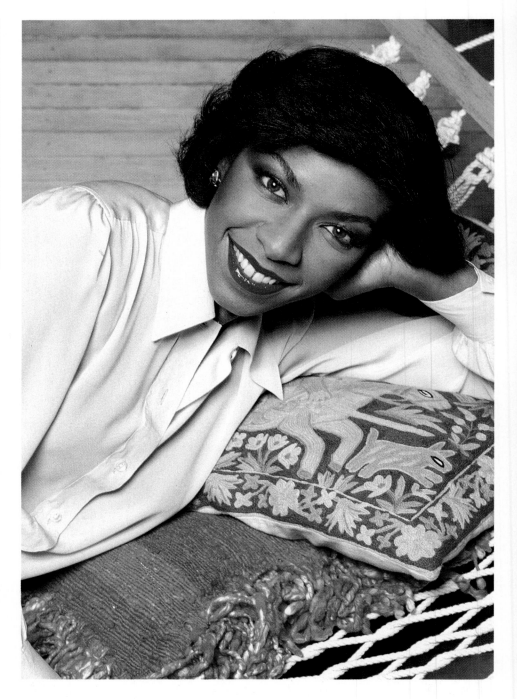

An example of one-light portraiture with talented Natalie Cole as the subject. A special set consisting of a planked deck and a hammock was constructed for this national cosmetic ad.

With Natalie in the hammock, it was difficult to obtain a pose that looked comfortable from a normal, eye-level camera position. So I shot down from a ladder. I asked Natalie to turn on her side and look up toward the camera. In the photo, she looks natural and comfortable.

As a subject's body position changes, so must the lighting angle. To achieve frontal lighting on Natalie's upturned face, I had to place the light source high. The 1200-watt-second flash with 32-inch silvered umbrella was mounted on a boom stand slightly to the left of my high camera position. The lighting was metered with a Minolta flash meter and incident-light hemisphere. I pointed the sensor straight up, toward the light source.

Notice the placement of Natalie's head in the composition. It is at one of the four points of major impact in the rectangular frame; see page 25. □

Subject: Child (Sixth birthday portrait)
Location: Gary Bernstein Studio, Los Angeles, California
Camera: Nikon F3
Lens: 85mm *f*-1.8 Auto-Nikkor
Lighting: Four 600-watt-second electronic flash units
Light Control: Silver Rocaflector
Film: Kodachrome 25
Exposure Metering: Gossen Ultra-Pro, incident-light mode
Exposure: *f*-8 (shutter at 1/60 second)

Low main lighting can bring a special glow to a child's face. It emphasizes subtle features that might otherwise go unnoticed.

The low main light was reflected from a silvered umbrella. Below the camera and to the subject's right I placed a silvered reflector. This bounced additional light into her face and added a secondary catchlight to each eye.

I painted the mottled gray background myself on a large piece of canvas. I applied gray, black and white latex house paint with a sponge. The result provided a variety of possible background effects, depending on the lighting used. For this photograph, I used two background lights in umbrellas, one on each side of the background. A fourth light, on a boom above the subject's head, was used to highlight the hair.

Notice my young subject was positioned low in the frame. The extra space helps give her proper scale in the composition as a small child.□

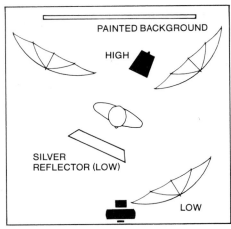

Subject: Christopher Atkins
Location: Gary Bernstein Studio, Los Angeles, California
Camera: Nikon F3
Lens: 105mm ƒ-2.5 Auto-Nikkor
Lighting: Rollei 1250 Electronic Flash
Light Control: One 14-inch pan reflector for the Rollei flash head. One 36-inch silver-surface Larson Reflectasol
Film: Kodachrome 25
Filtration: Amber gelatin filter
Exposure Metering: Minolta Auto-Flash III, incident-light mode
Exposure: ƒ-11 (shutter at 1/60 second)

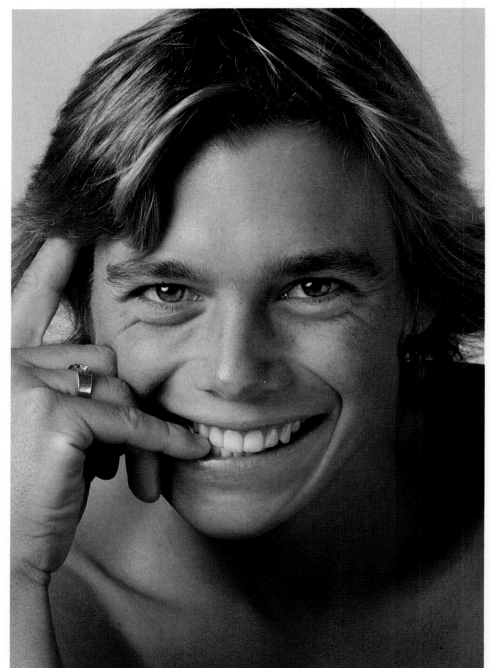

Facial character develops with maturity—and, therefore, age. To emphasize the all-American good looks of actor Christopher Atkins, I used an extreme lighting angle. It revealed subtle lines in his face.

Side lighting created heavy shadows on the left side of the face. As the diagram shows, I used a square, silvered Larson Reflectasol to fill the shadows and reduce contrast.

Hands can have character of their own. Also, a subject generally feels more comfortable when his hands can become a meaningful part of the photograph. He can lean on them or use them in some believable way.

Chris' expression in this photo is genuine. I remember that during the shooting session we were talking about girls. A pleasant subject—and it produced the right shot!

Adding an amber gelatin filter over my Rollei main light gave an extra bit of warmth—typical of a day in the sun at *The Blue Lagoon.*☐

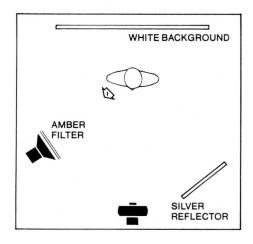

WHITE BACKGROUND

AMBER FILTER

SILVER REFLECTOR

Subject: Professional models
Client: Gant Shirtmakers, Inc.
Ad Agency: Waring and LaRosa, Inc.
Art Director: Howard Title
Location: Mill Valley, California
Camera: Nikon F2AS
Lens: 85mm ƒ-1.8 Auto-Nikkor
Lighting: Window light
Film: Kodachrome 25
Filtration: Skylight filter
Exposure Metering: Gossen Luna-Pro, incident-light mode
Exposure: 1/125 second at ƒ-4

This ad for Gant Shirts illustrates the directional quality of window light. The table was set in front of a large window facing open sky. Using the incident-light mode on a Gossen handheld meter, I determined the highlight exposure for transparency film. An aperture of ƒ-4 was selected to allow critical focus on the subjects while the food and background recorded as a soft blur.

Window light falls off rapidly. Exposing for the highlight value of the subjects caused the restaurant to record dark. I liked the drama created by the effect. However, I didn't want the subjects' dark hair to blend with the background. So I chose a camera position that placed the brightly lit back door of the restaurant behind the subjects' heads. □

DOOR

TABLE

WINDOW

Subject: Kenny Rogers
Client: Kenny Rogers Western Wear
Ad Agency: Roadrunner, Inc.
Art Director: John Coulter
Location: Burbank Studios, Burbank, California
Camera: Nikon F3
Lens: 300mm *f*-2.8 Auto-Nikkor
Lighting: Morning sunlight, redirected
Light Control: One silver-surface Rocaflector and one Larson Gobosol
Film: Kodachrome 64
Exposure Metering: Gossen Luna-Pro and Minolta Auto-Flash III—both in incident-light mode
Exposure: 1/250 second at *f*-4

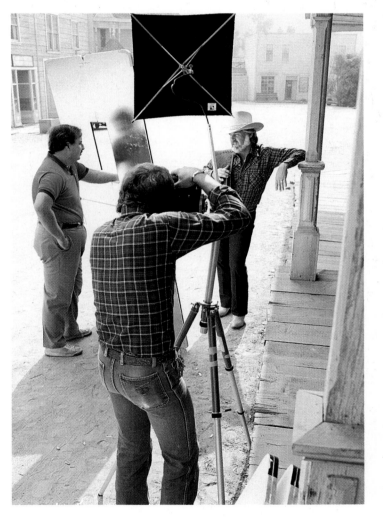

The best times for using direct sunlight for portraiture are the first few hours after sunrise and the last few hours before sunset. Only then is the light angle low enough to create the modeling desirable in a face. Once the sun is higher than about 45° from the horizontal, harsh shadows begin to appear on the face and the subject's eyes fall into shadow.

This photograph was shot in the morning. The sun would have been an appropriate direct main-light source. However, I wanted to create a rim-light effect on Kenny's hat and shoulders. So I turned Kenny's back to the sun, using the sun as a secondary light source to accent the hat and shirt.

I placed a large silver reflector in front of my camera to redirect the sunlight back into Kenny's face. I metered the sunlight on Kenny's shoulders and hat and the light reflected onto his face. Lighting and exposure were balanced to ensure overall detail.

Flare is always a potential problem when shooting into a low sun. I mounted a Larson Gobosol on my tripod and placed it so it shielded the camera lens from the sun.

Good technique ensured a technically good photograph. The great face of Kenny Rogers did the rest! □

Subject: Professional model (Test session)
Location: Gary Bernstein Studio, New York City
Camera: Nikon F2AS
Lens: 105mm *f*-2.5 Auto-Nikkor
Lighting: 1250-watt-second Rollei flash with pan reflector
Film: Kodak Plus-X Pan
Exposure Metering: Minolta Auto-Flash II, incident-light mode
Exposure: *f*-11 (shutter at 1/60 second)

The model was positioned close to a white background. The pan reflector on the flash was relatively large. However, the flash was nearly 15 feet from the subject. This made the light behave like a small source. The dark shadows and high image contrast are a result of this point-source lighting.

The farther the light source is from the subject, the less the brightness on the subject changes as she moves forward or backward. This allows for greater subject spontaneity during shooting.

The shadow on the model's right forms an intentional part of the overall composition, accentuating the shape of her body.

This photo is an excellent example of single-light photography. Properly placed, one light can often be more effective than a battery of lights. Simple lighting also frees the photographer to concentrate on the subject.

To give the print its apparent texture, the negative was printed through an etching screen. □

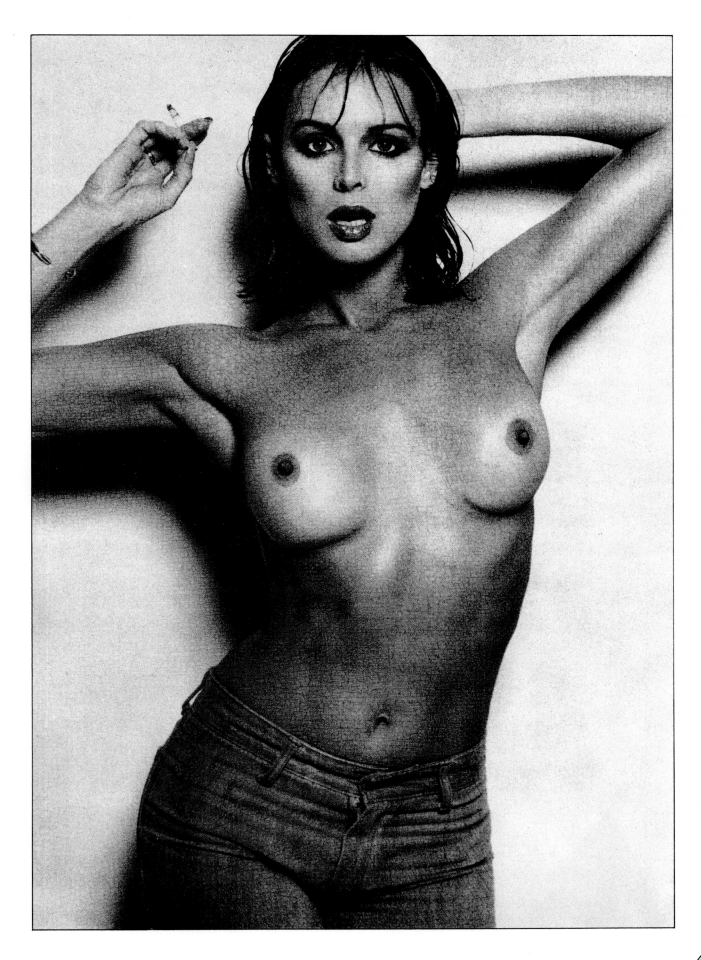

12

Subject: Lee Majors and a professional model
Client: Los Angeles Magazine
Art Director: Bill Delorme
Location: Gary Bernstein Studio, Los Angeles, California
Camera: Hasselblad EL/M
Lens: 150mm *f*-4 Zeiss Sonnar
Lighting: Six electronic flash units
Film: Ektachrome 64 Professional
Exposure Metering: Minolta Auto-Flash III, incident-light mode
Exposure: *f*-16 (shutter at 1/250 second)

This was an outtake from a *Los Angeles Magazine* cover session with Lee Majors. The theme was *Valentine's Day.* Four 600-watt-second lights, bounced from umbrellas, were used to produce an even, rich-gray background.

Bill Delorme, talented design director for the magazine, wanted the gray deep enough to allow for light type. The exposure difference between the subjects and the white paper background was two steps.

The main light was a 1250-watt-second Rollei flash in a pan reflector. The edge light striking the top of Lee's head, the model's shoulder and her hair was produced with a sixth electronic flash unit with a narrow grid spot. The edge light was adjusted for one step more exposure than the main light.

My two subjects were real troopers. The pose was not a comfortable one. In fact, it was almost back-breaking—graphic proof that a *good* pose isn't necessarily a *comfortable* one. In photography, the end justifies the means.□

WHITE BACKGROUND

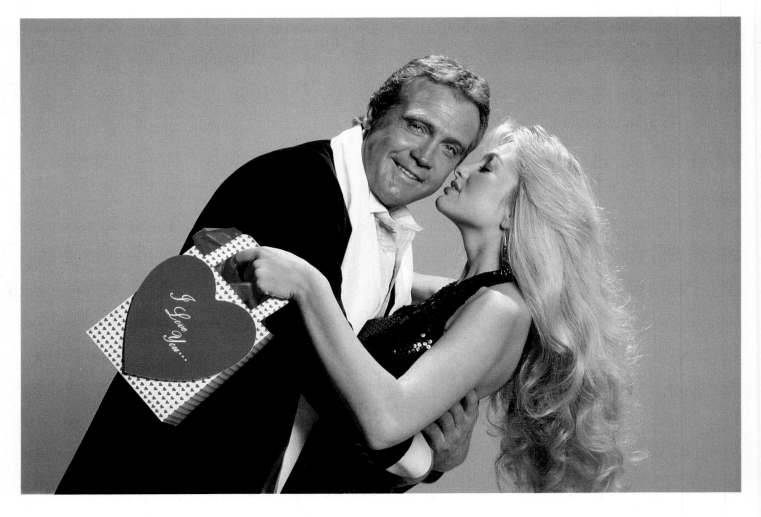

This half-length portrait of Lawrence Rodberg, Chairman of Burlington Northern, Inc., was taken as part of a national ad series. In each ad, Rodberg commented on what had been learned from the economic recession. It was imperative that his attitude appear professional and commanding, yet not intimidating.

Because of his busy schedule, I couldn't choose the time of day for the photography. The photo was taken with the sun high in the sky. I was careful to avoid direct sunlight on Rodberg's face, using a reflector as main light source for the face. I also placed the subject so his lower half had the shadow of the plane for a background. I used direct sunlight to highlight hair and arm.

An ultra-wide-angle 20mm lens was used, placing the subject within *three feet* of the camera! Wide angle lenses may be used for dramatic portrait results if the subject is located close to the center of the frame. Near the frame edge, distortion would make a portrait unacceptable.

The background—a small corporate jet—does show signs of distortion. However, the aircraft graphically directs viewer attention to the subject.

A 30-inch Larson Super-Silver reflector was taped to the wing of the jet, just out of camera range to the subject's right. It subtly redirected the overhead sun into the subject's face.

Exposure was determined by locating my Gossen Ultra-Pro meter at the right side of Rodberg's face to meter highlight values. The incident-light hemisphere was pointed toward the reflector. □

Subject: Lawrence Rodberg, Chairman, Burlington Northern, Inc.
Client: Burlington Northern, Inc.
Ad Agency: Haller Schwarz, Inc.
Art Director: Tony Haller
Location: John Wayne Airport, Orange, California
Camera: Nikon F3
Lens: 20mm *f*-3.5 Auto-Nikkor
Lighting: Redirected midday sunlight; direct sunlight for rim lighting
Light Control: Larson Super-Silver Reflectasol
Film: Kodachrome 64
Exposure Metering: Gossen Ultra-Pro, incident-light mode
Exposure: 1/125 second at *f*-11

14

Subject: Professional models
Client: Munsingwear, Inc.
Ad Agency: Haller Schwarz, Inc.
Art Director: Tony Haller
Location: Malibu, California
Camera: Nikon F3
Lens: 105mm *f*-2.5 Auto-Nikkor
Lighting: Daylight, overcast
Light Control: Two silver
Rocaflectors
Film: Kodachrome 64
Filtration: Skylight filter
Exposure Metering:
Through-the-lens, center-weighted
Exposure: 1/125 second between
f-5.6 and *f*-8

The professional photographer must conform to constraints imposed by the client. Compositional freedom is not limitless. For example, an advertising photograph usually must fit a predetermined format and layout.

Each of the two images shown here was shot for a two-page spread in a magazine. The proportions of the group, in terms of height and width, had to conform to the printed page. However, there was no limitation on the arrangement of individuals *within* the image format or on the attitude projected by the subjects.

The lighting and technical information for both images reproduced here is the same. The shooting took place at midday. A cloud layer held back much of the light from above. Most of the illumination came horizontally, from beyond the cloudy area. The result was a soft, yet directional low light. Nature's light was enhanced by two large reflectors placed on the sand in front of the group. They bounced additional light up into the faces.

I used a short telephoto lens at a relatively wide aperture. This gave sufficient depth of field to maintain subject sharpness while recording the background slightly out of focus. The viewer sees the subjects clearly without distraction from surrounding elements.

In the photo below, a passive and formal approach to composition and posing was employed. Notice the additional space around the group and the deliberately contrived placement of the individuals. The expressions were also carefully *directed* to complement the feeling and mood of the composition.

The photo at right gives a feeling of freedom and fun. The apparent spontaneity of the subjects' relative positions gives a candid and casual mood to the image. This is in spite of the fact that each individual was carefully directed. Each was given specific instruction as to his or her attitude and relative position in the composition.

As professional photographer, I vary composition and subject attitude to allow my client the greatest freedom in final picture selection. The amateur should take the same approach. Don't just think up one approach and not deviate from it. Shoot as much film as necessary to express the full scope of your creativity and imagination.□

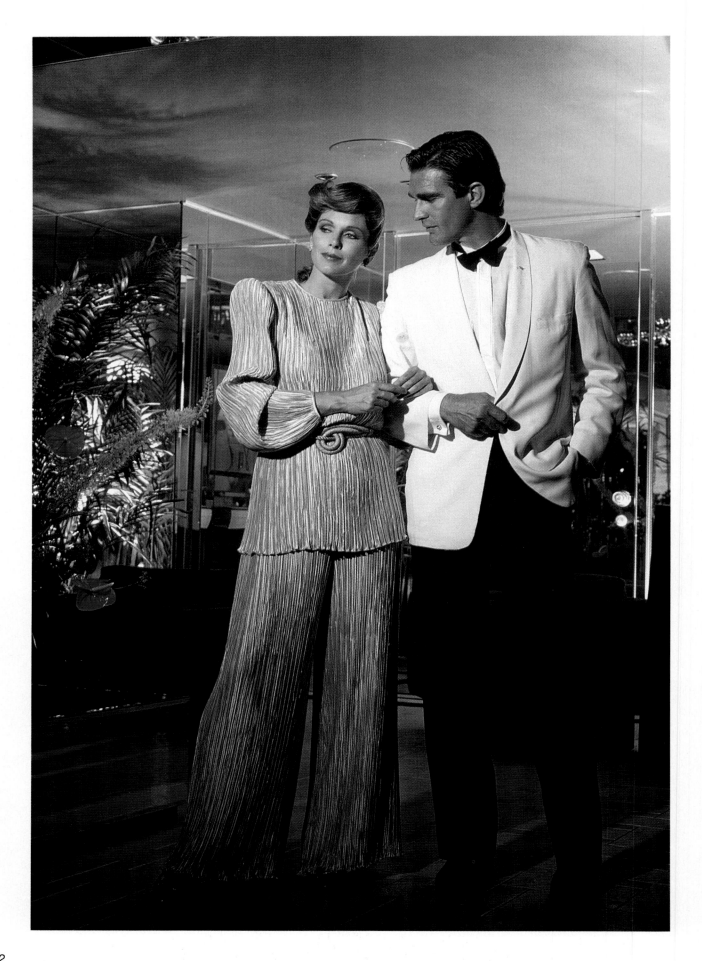

Reflections from mirrored walls are always a challenge to a photographer. In this case, there were mirrors on several background surfaces.

Except for a small chandelier, there was no available room light. I lit the scene with electronic flash. It was imperative to light the environment as well as the subjects.

I began with the background. Lighting placement was limited to areas hidden from the camera's view. One electronic flash unit was placed behind the plant in the far, left corner of the room. This light was pointed straight up.

A carefully placed chair at the right back of the room hides a second flash unit. It was also pointed toward the ceiling. The third flash unit was the main light. It was placed to the left of the camera. I carefully chose its location to avoid mirror reflections in the camera lens.

For added drama, I used a medium *spot-grid* on the mainlight. *Grids* create concentrated lighting with limited area coverage.

Two meter readings were taken from subject position, pointing the incident hemispheres toward the center of the main light, as shown in the small photo. This ensured equal light intensity on both subjects.

To determine overall room exposure, the meter was held at waist height between the models and the back wall. The incident-light hemisphere was pointed at the ceiling. It read *f*-5.6. A second reading was taken from four or five feet above the backlights, pointing the hemisphere down toward the lights. This determined background highlight value. It read *f*-22.

Creating a main-light exposure of *f*-11 on the subjects allowed the overall room light to be *underexposed* by two steps. This added drama. The room highlights were *overexposed* by two steps. This provided the brightness in the plant and generated the dramatic shadow on the ceiling.

Instead of using the normal sync speed of 1/60 second, I used the 1/15-second setting. This enabled me to record some of the *warm* color shift from the tungsten chandelier above the models' heads.□

Subject: Two professional models
Client: La Costa Products International, Inc.
Art Directors: William Randall and Russ Heinze
Location: The La Costa Spa, Carlsbad, California
Camera: Nikon F3
Lens: 55mm *f*-3.5 Auto-Nikkor
Lighting: Three 600-watt-second electronic flash units
Film: Kodachrome 25
Exposure Metering: Minolta Auto-Flash III, incident-light mode
Exposure: 1/15 second at *f*-11

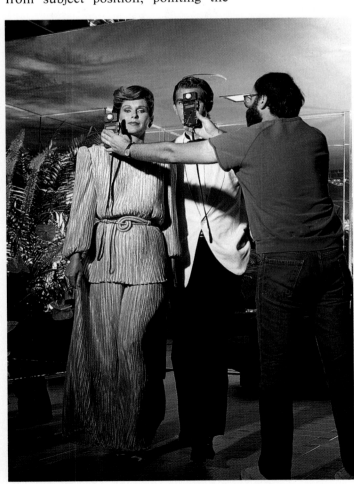

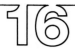

Subject: Reggie Jackson
Client: Pentax Corporation
Art Director: Arthur Nolan
Location: Anaheim Stadium, Anaheim, California
Lighting: Open shade; sunny day; late afternoon
Film: Kodachrome 64
Filtration: Skylight filter
Exposure Metering:
Through-the-lens, center-weighted
Exposure: 1/250 second at f-5.6

Baseball superstar Reggie Jackson is the subject of this photograph. It was taken as part of an advertising series for Pentax Corporation. The client required a natural-light image in which Reggie appeared relaxed and genial. Of equal concern was the appearance of the Pentax camera.

I had to select a main light source flattering to each of the two subjects—Reggie and the camera. I could have used a variety of light sources to light Reggie. He's young and has a face revealing strong character and good skin tone.

However, the metallic surfaces of the camera are highly reflective. Directional light, such as undiffused sunlight or flash, would have caused unwanted specular highlights on the metal. I decided to shoot in open shade. A large expanse of clear sky was my main light.

Because of the inherent bluish color cast in open shade, I used a skylight filter over the lens. It helped to keep Reggie's white uniform white on the film.

Although open shade is a soft light source, it isn't totally shadowless—it has direction. Notice the modeling on Reggie's face. The light on the front of his face is nearly three times as bright as that on the side not receiving direct light from the sky.

Incident-light, spot, and averaging reflected-light meters respond with amazing consistency in uniform lighting such as open shade. With an incident-light meter, I would have placed the plastic hemisphere at the front of Reggie's face, to determine the highlight exposure for the transparency film I was using.

Because Reggie's time was limited, I used the center-weighted meter in the camera. It's much quicker to use. I exposed at the indicated reading and then bracketed to ensure a perfect exposure. I shot as many different poses and expressions as Reggie's time permitted.

There was ample light in the scene, allowing maximum flexibility in selection of shutter speed and lens aperture. I chose 1/250 second at about f-5.6. This exposure setting satisfied two needs. The shutter speed was fast enough to capture rapid changes in Reggie's attitude without image blur. The lens aperture provided just the right amount of depth of field. Reggie and the camera were in sharp focus while the background was sufficiently unsharp to be unobtrusive. □

17

Subject: Frank Gifford and a professional model
Client: Palm Beach, Inc.
Ad Agency: Lord, Geller, Federico, Inc.
Art Director: Gene Federico
Location: Central Park, New York City
Camera: Nikon F with motor drive
Lens: 85mm f-1.8 Auto-Nikkor
Lighting: Daylight; overcast
Film: Kodachrome 64
Filtration: Skylight filter
Exposure Metering: Gossen Luna-Pro, incident-light mode, and Nikon F through-the-lens meter
Exposure: 1/250 second at f-8

A so-called "uniform" light source does not necessarily provide identical meter readings in all directions. Soft and even light, such as from an overcast sky, has some *direction*. Of course, the contrast between shadow areas and highlights is relatively low. Because of low contrast, exposure metering accuracy is not critical.

This photograph features Hall-of-Fame football player, Frank Gifford. It was taken on an overcast afternoon.

To determine the *direction* of the light, I used the incident-light mode on my Gossen Luna-Pro meter. I then had Frank and the model face the brightest part of the illumination. For exposure indication, I took a through-the-lens reading of the subjects at the point where I would take the photograph.

The subjects would be in motion when I took the photo. However, I exposed as they reached and passed through a predetermined mark. With the camera on a tripod, I focused on this mark. I aligned the camera so the vertical elements in the scene were parallel to the vertical edges of the frame.

I instructed the subjects to go about 10 feet behind the point on which I had prefocused. I then asked them to start jogging slowly toward the mark and past it by about five feet.

The picture was composed so there would be more space in front of the "joggers" than behind. This creates the impression in the photo that they still have room to continue running.

Using the motor drive on my Nikon, I fired a burst of shots at two frames per second. I started shooting as the subjects approached the mark and continued until they had passed it by about two feet.

They were asked to return to the starting point and run again. I gave the next set of frames 1/2 f-stop less exposure. I asked them to run a third time. This time I gave 1/2 f-stop more exposure.

When the processed film came back, I had a good selection. I could choose the best of several action shots and three exposures. □

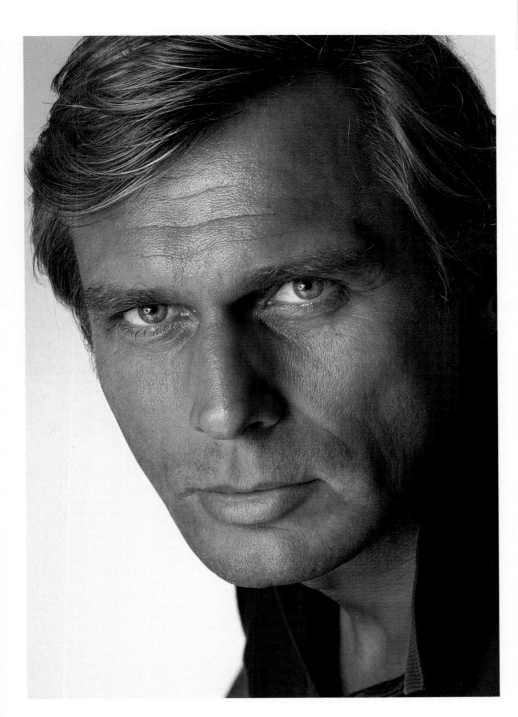

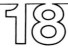

Subject: Professional model
Location: Gary Bernstein Studio, Los Angeles, California
Camera: Nikon FM
Lens: 55mm *f*-3.5 Micro-Nikkor
Lighting: Two 600-watt-second electronic flash units
Light Control: One Larson 27-inch silvered Reflectasol
Film: Kodachrome 25
Exposure Metering: Minolta Auto-Flash III, incident-light mode
Exposure: *f*-4 (shutter at 1/60 second)

The photographic effects possible are limitless. However, they must be applied wisely. For example, few faces are *strong* enough to be recorded with this kind of close-up detail.

I wanted to emphasize the chiseled features and character of the subject, so I selected a macro lens. This lens makes possible extreme close-up photography.

The main 600-watt-second flash was to the subject's right. The light was bounced from a 32-inch silvered umbrella, providing good contrast and specularity. A Larson Super-Silver Reflectasol was used at a distance of three feet below the face. It lessened contrast while maintaining specularity in the image.

A white cardboard was taped to a light stand behind the subject. I directed a second 600-watt-second electronic flash at the cardboard from a high angle. This position ensured that reflection from the cardboard would not come straight back into the lens and cause flare.□

WHITE CARD

REFLECTOR (LOW)

Subject: Professional model
Client: Larson Enterprises, Inc.
Art Directors: George Larson,
Jack Belcher and Gary Bernstein
Location: Beverly Hills, California
Camera: Nikon F3
Lens: 200mm *f*-4 Auto-Nikkor
Lighting: Noon sunlight
Film: Kodak Tri-X
Metering: Through-the-lens,
center-weighted
Exposure: 1/1000 second at *f*-8
Light Control: Silvered
Rocaflector

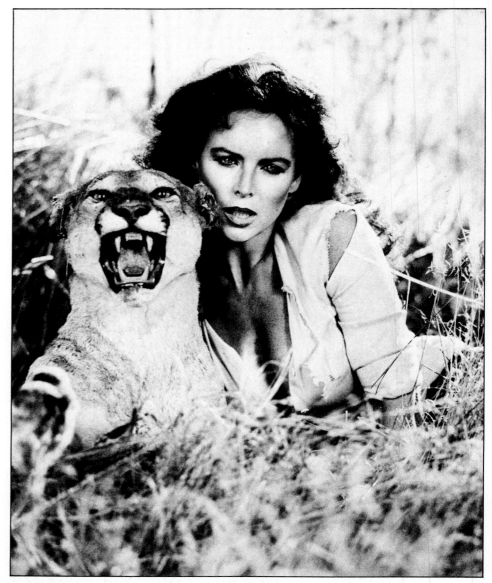

This photograph was taken to advertise Larson's line of Rocaflector reflector panels.

The advantages of reflector lighting over fill flash are many. Reflected light enables you to use fast shutter speeds. A silvered Rocaflector panel reflects about 98% of the incident light. Equipment is lightweight and easy to set up. You can see and evaluate the lighting effect you're going to get. It's easy to make simple through-the-lens meter readings. Film frames can be exposed in rapid succession, because you're not dependent on a flash recycling time.

The above virtues were expounded in the advertising copy accompanying the photograph. To show what the Rocaflector can do, this photo was taken at about noon, with the sun high in the sky. The high sunlight struck the top of the model's head, producing a halo of rim light. Main lighting was provided by a single silvered Rocaflector which redirected the sun's light. The Rocaflector was placed near the camera position. To make the Beverly Hills *jungle* scene more realistic, I asked the model to rip part of her blouse. We couldn't ask the cat to do that job. It was stuffed!□

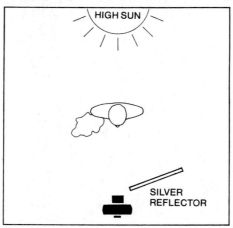

HIGH SUN

SILVER
REFLECTOR

Sun, sand and water are a challenging combination when it comes to accurate metering. In such a highly reflective environment, you can get three different exposure indications with three different meters. For this photo, I used an incident-light meter. I located the meter at the subject position and pointed the plastic hemisphere toward the morning sunlight.

A spot meter would not be very useful in this kind of situation, except perhaps to evaluate the subject brightness range.

The beach presented a problem of a different kind. It was strewn with trash in every direction. For that reason, I used a 300mm telephoto lens for minimal depth of field. With the background out of focus, the beach looked acceptable.

With the 300mm lens, depth of field is so limited that accurate focusing on the subject is critical. This is especially true if you use a wide lens aperture. For this reason, it's wise to use a tripod. Because of the limited depth of field, subject placement is also critical. Notice that I have positioned the models so their bodies are equidistant from the camera. This keeps them near the plane of sharpest focus.

Poses and expressions should appear natural. In this photo, I had to fulfill another requirement: I had to sell swimwear. Both swimsuits had to be visible clearly and at their best.□

Subjects: Two professional models
Client: Woodward and Lothrop
Ad Agency: Barra Graphics, Inc.
Art Director: Bob Barra
Location: Santa Monica beach, California
Camera: Nikon F2
Lens: 300mm f-2.8 Auto-Nikkor
Lighting: Morning sunlight
Film: Kodachrome 25
Exposure Metering: Gossen Luna-Pro, incident-light mode
Exposure: 1/500 second at f-4

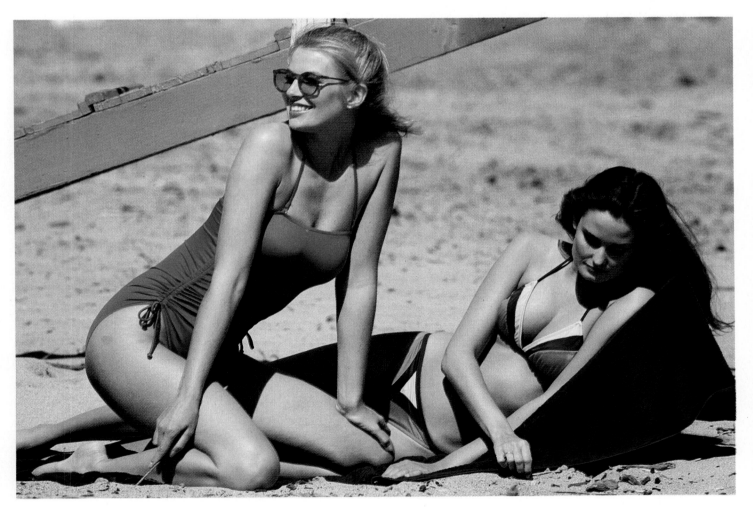

21

Subject: Professional model
Client: Casablanca Record and Filmworks, Inc.
Ad Agency: Art Hotel, Inc.
Art Director: Chris Whorf
Location: Gary Bernstein Studio, Los Angeles, California
Camera: Nikon F3
Lens: 55mm *f*-3.5 Micro-Nikkor
Lighting: Six 600-watt-second electronic flash units
Light Control: Two Larson Gobosols
Film: Kodachrome 25
Exposure Metering: Minolta Auto-Flash III, incident-light mode
Exposure: *f*-11 (shutter at 1/60 second)

This photo was made for the cover of a record album appropriately entitled *Body Shine*. The background was built by stretching pieces of reflective mylar over a sturdy wooden frame. Six electronic flash units were used to illuminate the scene. Five lit the set and one was the main light for the subject.

The extensive lighting created flare and reflections. To protect the lens from unwanted light, I mounted two black Larson Gobosols on my tripod and positioned them around the camera lens.

I made six different incident-light readings. Four were made from the mylar flats and one from the back wall behind the model. The sixth reading was made from the model's face with the plastic hemisphere pointing toward the center of the main light. Exposure was set for the main light. The other lights were adjusted to balance with the main light.

Styling need not be expensive to be visually effective. In this case, the model's outfit was a simple piece of fabric stretched across her body and knotted over the shoulder. A fan added an extra bit of movement to the hair.□

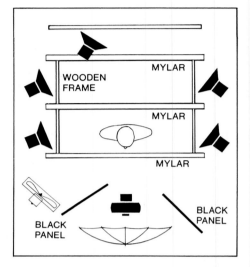

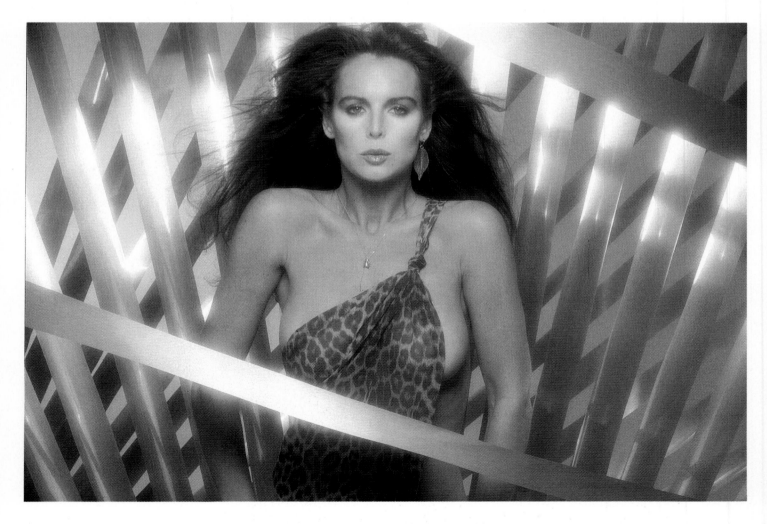

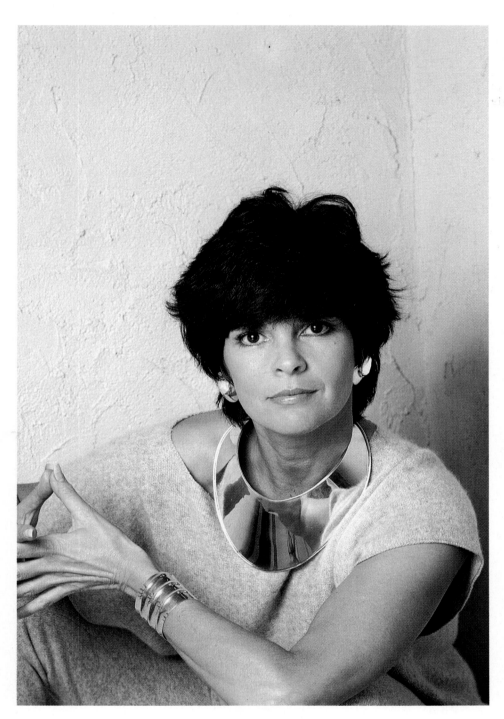

Subject: Ali MacGraw
Client: Family Weekly
Art Director: Robert Altemus
Location: Gary Bernstein Studio, Los Angeles, California
Camera: Nikon F3
Lens: 55mm *f*-3.5 Micro-Nikkor
Lighting: One 600-watt-second electronic flash unit
Light Control: 30-inch Larson Super-Silver Reflectasol
Film: Kodachrome 25
Exposure Metering: Minolta Auto-Flash III, incident-light mode
Exposure: *f*-8 (shutter at 1/60 second)

Beautiful and chic Ali MacGraw is the subject of this magazine-cover photo. Typically, main subject interest would be located in the upper half or third of the frame. In this shot, I deliberately placed the subject toward the lower half of the format. It produced a casual and relaxed feeling in the photograph. It also allowed the art director complete graphic flexibility in placing the magazine logo and cover type.

Eyes as dark as Ali's require extra catchlights, if they are to appear as dynamic on film as they do in life. A square, silvered Larson reflector was used slightly out of camera range and below Ali's eye level. It bounced the main light into her eyes, creating subtle secondary catchlights. The reflector also softened the shadows created by the mainlight. □

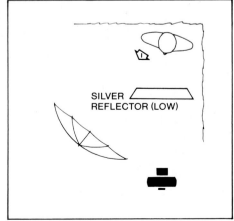

SILVER REFLECTOR (LOW)

23

Subject: Professional model
Client: J.P. Stevens, Inc.
Art Director: Peg Mathews
Location: J.P. Stevens showroom, New York City
Camera: Nikon F2AS
Lens: 55mm *f*-3.5 Micro-Nikkor
Lighting: One Thomastrobe 1200-watt-second electronic flash unit
Film: Kodachrome 25
Exposure Metering: Minolta Auto-Flash II, incident-light mode
Exposure: *f*-5.6 (shutter at 1/60 second)

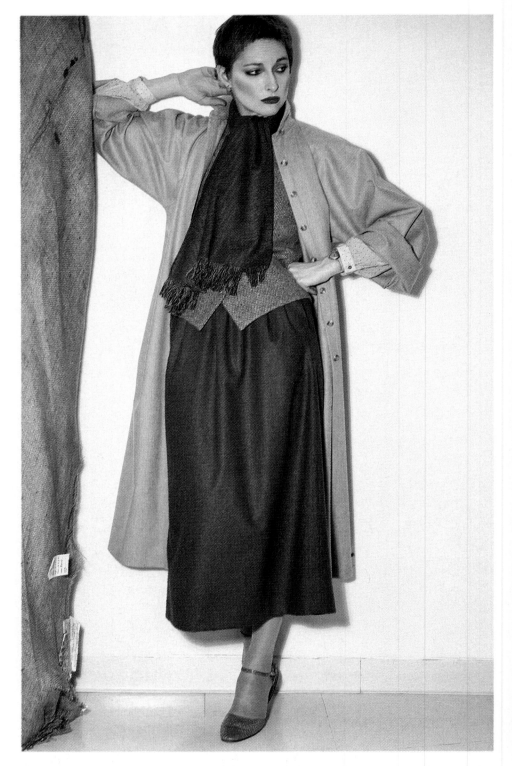

This fashion image was produced as part of a series for a large textile manufacturer. It had to record the quality of a variety of wool blends. I chose spotlighting because of its directional quality, producing specular reflections from shiny surfaces such as metal, skin and certain fabrics.

In this photograph, spotlighting serves two purposes. It emphasizes the luster of the materials and also graphically separates their textures.

An eight-inch narrow-angle reflector was attached to the 1200-watt-second electronic flash, placed to the left of my camera. The light was approximately 12 feet from the model—sufficient distance to ensure even lighting over the subject. Using an incident-light exposure meter, I placed the plastic hemisphere at the model's face and pointed it toward the single light source.

The only prop is a roll of burlap, further emphasizing the textural differences in the composition.□

24

Subject: Two professional models
Client: J.P. Stevens, Inc.
Art Director: Peg Mathews
Location: New York City
Camera: Nikon F2AS
Lens: 85mm f-1.8 Auto-Nikkor
Lighting: Two Thomastrobe
1200-watt-second electronic flash
units
Film: Kodachrome 25
Exposure Metering: Minolta
Auto-Flash II, incident-light mode
Exposure: f-5.6 (shutter at 1/60
second)

Spotlighting created maximum contrast between the light and dark parts in the pattern of the fabric. This accentuated detail emphasizes the surface differences between the fabrics in the models' outfits.

I placed a waist-level spotlight slightly to the right of my camera, so the woman's shadow wouldn't fall on the male model. The overlap of the two fabrics is shown by a subtle but clean line. A second spotlight was placed behind the models and pointed at a white wall a few feet behind them. It eliminated background shadows, creating a clean subject outline.

Using the incident-light mode on my flash meter, I got a reading of f-5.6 from both the models' faces and the back wall. My *direction* of the session is evident from the woman's expression.□

25

Subject: Two professional models
Client: La Costa Products International, Inc.
Art Directors: William Randall and Russ Heinze
Location: Carlsbad, California
Camera: Nikon F3
Lens: 105mm *f*-2.5 Auto Nikkor
Lighting: Two 600-watt-second electronic flash units; one 1200-watt-second electronic flash unit
Film: Kodachrome 25
Exposure Metering: Minolta Auto-Flash III, incident-light mode
Exposure: *f*-8 (shutter at 1/60 second)

This photograph had a dual purpose: To be used as an ad for both the La Costa Spa and Hotel and the portable massage table. The photograph was taken shortly after sunset at a private home in Carlsbad, California.

Three lights were used for the shot. A 1200-watt-second light with a narrow-angle reflector was placed next to camera position, across the pool from the subjects. An incident-light reading from subject position indicated an exposure between *f*-4 and *f*-5.6 on Kodachrome 25 film. This was the fill light. Highlight value was introduced with two other 600-watt-second lighting units. The lights were placed to either side and slightly behind the models, out of camera range.

Notice that the light to the right of the camera was placed to give classic profile lighting to the woman's face. The light was adjusted to record an *f*-8 on the model's face. This provided 1-1/2 steps more highlight exposure than the fill light next to my camera. The third light highlighted the right side of the male model. This light was adjusted to the same *f*-8 exposure.

Because I was shooting transparency film, I exposed for the highlights, at *f*-8. With a negative film, I would have exposed between *f*-4 and *f*-5.6, to allow for adequate shadow detail. The highlight areas could then be *burned in* at the printing stage.

Most of my work for quality magazine reproduction is shot on slow transparency films. You are capable of producing the same kind of lighting effects I do, with less powerful lights, if you use faster film. □

Reflective backgrounds can produce dramatic photographs. Lighting placement becomes critical, however, so that destructive reflections and flare are avoided. For this photograph, taken for the model's portfolio, I used a piece of silver mylar as background. The mylar is available in four-foot-wide rolls at most photo-supply shops. The reverse side is usually a gold or bronze mylar.

I stapled the mylar to a studio wall and draped it over a plywood cube to create a platform for the model. A single 600-watt-second flash was bounced from a flat reflector. The light was above and slightly to the right of my camera.

For correct light placement, it's always useful to remember this basic law of physics: The angle of reflection equals the angle of incidence. By placing the light above the subject, I created a rim-light effect with the reflected light coming from the background. Notice the edge highlights on the subject's midriff and leg and partially on her hair.

The only way to evaluate flare and potentially damaging reflections is visually from the camera position. When I'm working with reflective backgrounds, I like to use a relatively long lens to increase my distance from the reflective surface. This photo was taken with a 180mm lens. Taking an incident-light reading from the subject to the single light source, I bracketed up to two steps in each direction to ensure correct exposure. □

Subject: Professional model (Test for model's portfolio)
Location: Gary Bernstein Studio, Los Angeles, California
Camera: Nikon F3
Lens: 180mm f-2.8 Auto-Nikkor
Lighting: One 600-watt-second electronic flash unit
Film: Kodachrome 25
Exposure Metering: Minolta Auto-Flash III, incident-light mode
Exposure: f-11 (shutter at 1/60 second)

Subject: Lee Majors
Client: Diet-Rite Cola
Ad Agency: Dancer, Fitzgerald, Sample, Inc.
Art Director: Donna Weinheim
Location: Malibu Colony, California
Camera: Nikon F3
Lens: 85mm ƒ-1.8 Auto-Nikkor
Lighting: Direct late-afternoon sunlight
Film: Kodachrome 25
Exposure Metering: Minolta Auto-Flash III, incident-light mode
Exposure: 1/1000 second at ƒ-5.6

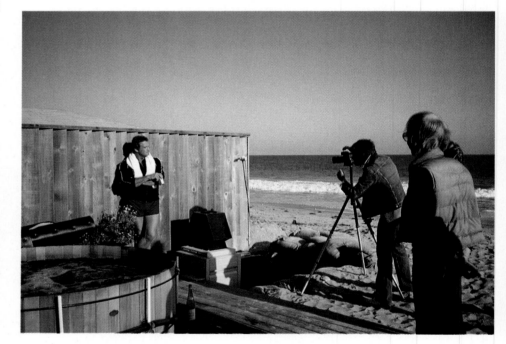

As photographers, we have a distinct advantage: We can include in the composition only what we want the viewer to see. In this case, among such unwanted elements as a rooftop, sandbags, a filtration system and ductwork, I produced a clean, uncluttered image of actor Lee Majors.

Direct late-afternoon sunlight was the main light source. I placed the plastic hemisphere of my exposure meter to the front of Lee's face. Pointing the meter directly into the sun recorded an abundance of light. To deliberately limit depth of field, I used a fast shutter speed, allowing the lens to be set at ƒ-5.6. This gave sufficient depth to maintain subject sharpness while allowing the vertical slats to be slightly blurred.

Few backgrounds are more distracting than vertical elements that are not recorded vertically. To keep the slats parallel to the vertical edges of the film, I used the camera on a tripod. This freed me to work with Lee, concentrating on facial angle and expression, rather than on keeping background elements perfectly vertical.□

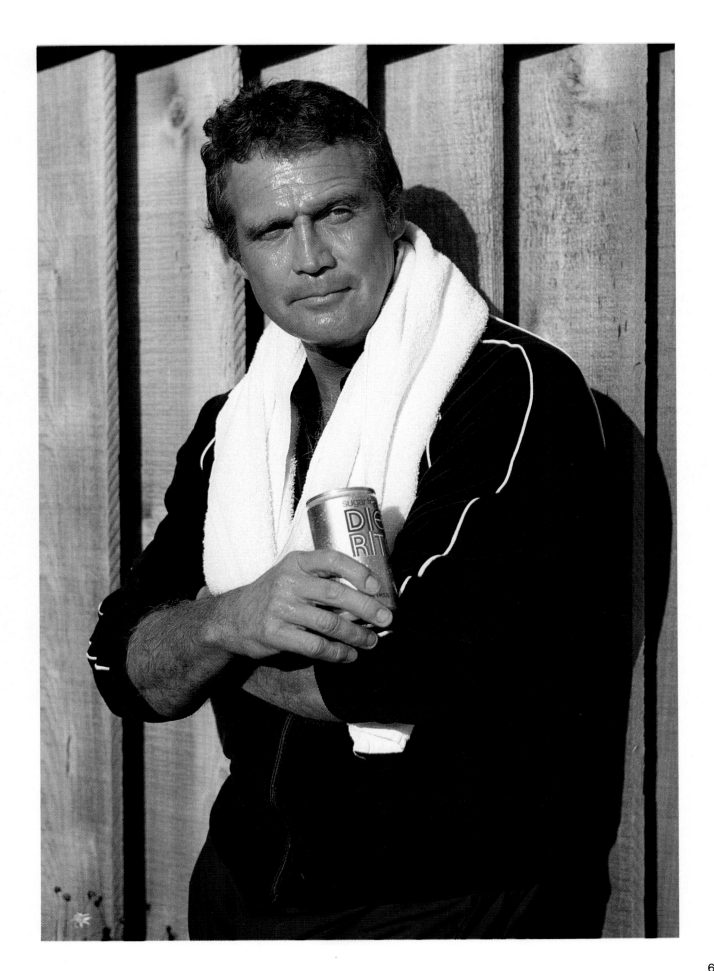

28

Subject: Professional model
Location: Aruba, Netherland Antilles
Camera: Nikon F2AS
Lens: 55mm ƒ-3.5 Micro-Nikkor
Lighting: Direct midday sunlight
Film: Kodachrome 25
Filtration: Acetate diffusion filter
Exposure Metering: Through-the-lens, center-weighted
Exposure: 1/60 second at about ƒ-8

This shot is a rare example of effective facial illumination by unmodified midday sunlight. I wanted to create an image of woman cavorting with nature, enjoying the elements of sun and water.

The sun's light strikes the model's face at an ideal angle to display her fine features because her head is tilted back. Adding to the mood of the photograph is slight subject blur, achieved by using a relatively slow shutter speed. The blur suggests movement without destroying image detail.

The photograph was made on Kodachrome 25 film, which yields high contrast and brilliant colors. I softened the image to a pastel shade by using a simple diffusion attachment on the lens. It was a sheet of acetate sprayed with clear fixative. □

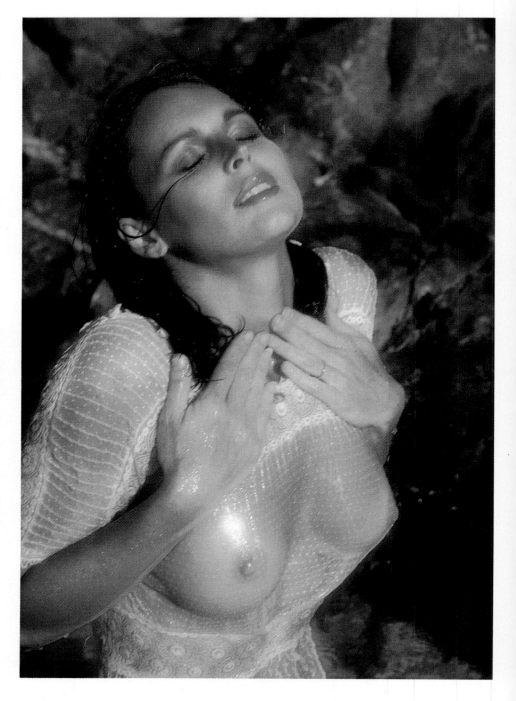

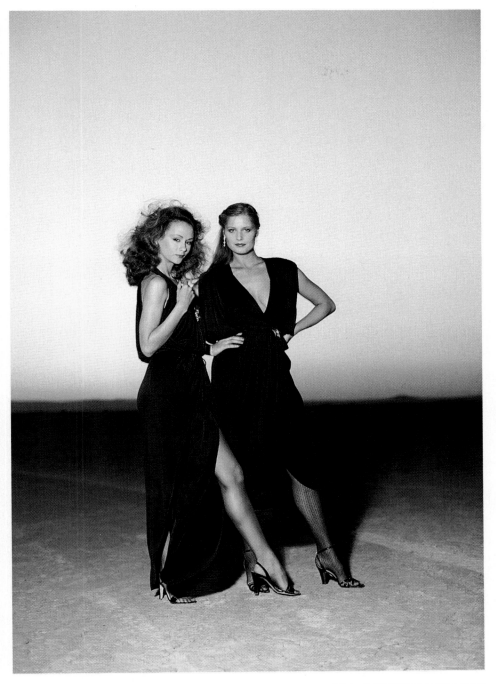

Subject: Two professional models
Client: Bullock's, Inc.
Ad Agency: Harrison Services, Inc.
Location: Mohave Desert, California
Camera: Nikon F2AS
Lens: 50mm f-1.4 Auto-Nikkor
Lighting: Available light and one electronic flash unit
Film: Kodachrome 25
Exposure Metering: Gossen Luna-Pro, reflected-light mode, for available light; Minolta Auto-Flash III, incident-light mode, for flash
Exposure: 1/15 second at f-11

You can achieve dramatic photographs with the most basic equipment. This fashion photo, for example, was taken with a single 600-watt-second electronic flash unit and a standard 50mm lens on my 35mm camera.

When mixing available light with electronic flash, meter the available light first because you cannot change it's intensity. I used a handheld Gossen Luna-Pro meter. However, the averaging reflected-light meter in your camera will do the same job. The natural-light exposure for the sky recorded 1/15 second at between f-8 and f-11 for Kodachrome 25 film.

I used the 600-watt-second flash at full power. With the light placed next to my camera and about 12 feet from the models, I got an aperture reading of f-11 for subject exposure. Using the f-11 setting allowed the background to record slightly darker—with more intense coloration—because it was underexposed by one step.

Cameras with focal plane shutters usually synchronize at a maximum speed of 1/60 or 1/125 second. Leaf shutters, typically found on medium-format camera lenses, sync over their entire range—up to 1/500 or 1/1000 second. This makes the leaf shutter considerably more versatile for balancing flash with daylight.

The camera was almost at ground level. This low viewpoint, together with the long, expansive shadow behind the models, created by the flash, gives the photograph a majestic quality. □

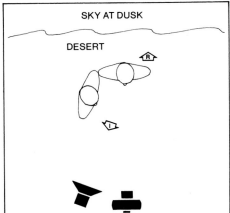

SKY AT DUSK

DESERT

R REFLECTED-LIGHT METER READING

Subjects: Tom Kite and Bill Rogers
Client: Munsingwear, Inc.
Ad Agency: Haller Schwarz, Inc.
Art Director: Tony Haller
Location: Dallas, Texas
Camera: Nikon F3
Lens: 180mm *f*-2.8 Auto-Nikkor
Lighting: Daylight
Light Control: Silvered Rocalfector
Film: Kodachrome 25
Exposure Metering: Minolta Auto-Flash III, incident-light mode
Exposure: 1/125 second at *f*-4

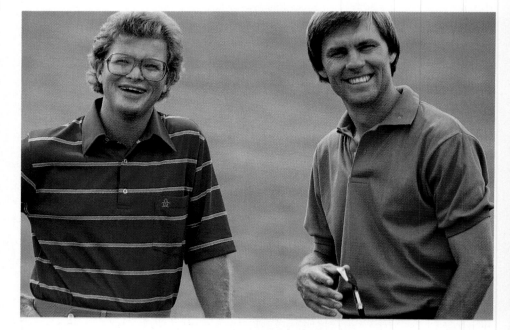

Hazy late-afternoon sunlight provided some backlighting for this photograph of championship golfers Tom Kite and Bill Rogers. To isolate the subjects against an expanse of green, two techniques were used. First, I used a medium telephoto lens at a wide aperture for shallow depth of field. The subjects were carefully positioned to be equidistant from the camera, to ensure sharp focus on both. Second, I placed the subjects on a hill, providing a uniform, green "backdrop."

To enhance facial modeling, an assistant held a silvered Rocaflector to the left of camera position. The light from it was metered from subject position on incident-light mode.

Bill (right) is considerably taller than Tom. I had wanted to maintain realistic scale, but it just didn't work photographically. So I placed Tom on slightly higher ground to make the two look more even. Notice, however, that I have maintained a slight difference in their heights. This is important in all group photographs. The eyes of the subjects should be at different levels in the frame. It makes for better composition.

It's usually apparent when there is harmony between subjects and photographer. The three of us were talking and having fun as we were shooting the ad series. It shows in the pleasant expressions, the relaxed attitudes and the candid spontaneity.☐

Subject: Formal portrait
Location: Washington, D.C.
Camera: Nikon F
Lens: 105mm *f*-2.5 Auto-Nikkor
Lighting: One 1200-watt-second Thomastrobe electronic flash unit
Film: Kodak Panatomic-X
Exposure Metering: Wein flash meter
Exposure: *f*-11 (shutter at 1/60 second)

I took this photograph of my father many years ago. It shows the quality you can get with fine-grain 35mm b&w films. A single light source was placed directly in front of the subject at a distance of about eight feet. The light was bounced from a silvered umbrella, producing beautiful specular highlights and good contrast.

The photograph is a good example of the classic *3/4 pose*. Notice that the far eye comes to the edge of the face. The subject's eyes are centered in their sockets, as viewed from camera position. The head is tipped slightly toward the far shoulder.

I metered the incident light from the shadow side of the face, pointing the meter's hemisphere toward the light source.□

Subject: Six professional models
Client: Gant Shirtmakers, Inc. and Classic Magazine
Ad Agency: Waring and LaRosa, Inc.
Art Directors: Howard Title and Helen Klein
Location: San Franciso, California
Camera: Nikon F2
Lens: 35mm *f*-2 Auto-Nikkor
Lighting: One 1200-watt-second power pack; two flash heads at 100-watt-seconds each
Light Control: Black gobo above lens
Film: Kodachrome 25
Exposure Metering: Minolta Auto-Flash II
Exposure: *f*-16 (shutter at 1/60 second)

This photograph was produced as part of an ad series for Gant Shirtmakers, to be used as an insert in *Classic Magazine*.

To simulate typical card-game illumination, I placed a flash head just a few feet above the center of the table. A second light was bounced off the ceiling, adding detail to the background. The main light was close enough to the models to allow a rating of 100 watt-seconds. Rapid flash recycling occurs at such low ratings. This allowed the models to involve themselves in an actual game. The results are real expressions and attitudes, making the scene believable.

In a group photograph like this, each individual should receive the same graphic emphasis. This requires both balanced composition and lighting. To be certain, I took a separate incident-light reading for each subject prior to shooting. In each case, the hemisphere was placed next to the subject's face and pointed toward the main light over the center of the table. □

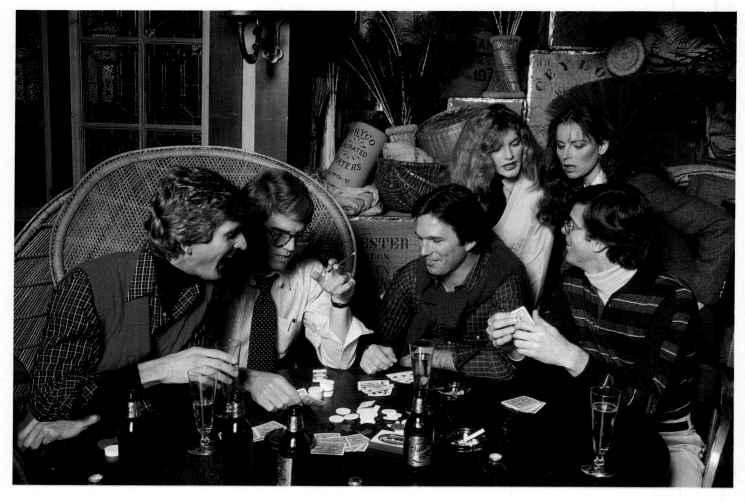

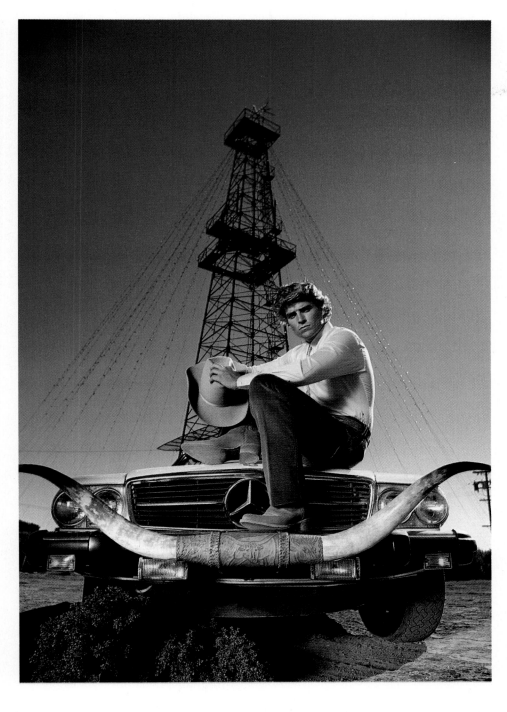

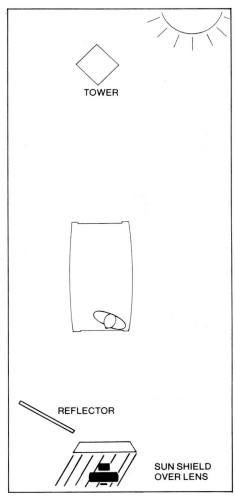

This wide-angle photograph was produced to advertise corduroy jeans. It was midday when we spotted the oil field. That gave us enough time to rent the Mercedes and stop at a Hollywood prop house to rent the horns. We got back to the location an hour before sunset.

I looked at the scene through various lenses. The 24mm was the shortest lens that recorded substantial subject size, yet included the entire oil rig in the background. Placing a silvered reflector to the left of camera position, I bounced direct sunlight back toward the subject. I took an incident-light reading, with the meter at subject position and pointed toward the reflector.

The late afternoon sun was behind the subject and to the right of the camera axis. When using a wide-angle lens, it's particularly important to be on the watch for possible lens flare. The lens was carefully shielded from the sun with a black Larson Gobosol.□

Subject: Professional model
Client: Paul Davril, Inc.
Art Director: Michel Harouche
Location: Gary Bernstein Studio,
Los Angeles, California
Camera: Nikon F2AS
Lens: 105mm *f*-4 Micro-Nikkor
Lighting: Two 600-watt-second
electronic flash units
Film: Kodachrome 25
Exposure Metering: Minolta
Auto-Flash III, incident-light mode
Exposure: *f*-11 (shutter at 1/60
second)

The specular quality of spotlighting is immediately apparent in the glistening skin tones in this head shot. Spotlighting can be ideal for bringing out skin texture and character lines in masculine portraits.

Two spotlights were used as main lighting. One was located slightly to the right of camera position and about eight feet from the subject. The second was placed about 20 feet from the subject and two feet lower than the first. The second light had no significant effect on exposure but produced the lower catchlights in the subject's eyes.

The contrast produced by the spotlighting is so great that the film failed to record detail on the shadow side of the model's nose. Is this factor critical to the result achieved? Definitely — but in a positive way. It is the *contrast* that attracts attention and brings the image to life. □

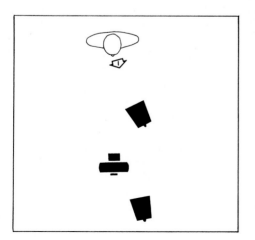

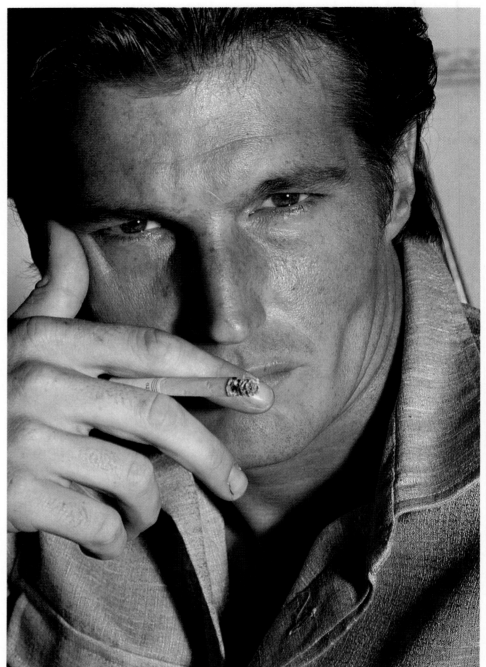

Subject: Professional model
Client: Aldo Cipullo, Ltd.
Location: Gary Bernstein Studio,
Los Angeles, California
Camera: Nikon F3
Lens: 105mm *f*-4 Micro-Nikkor
Lighting: Two 600-watt-second
electronic flash units
Light Control: Larson Softbox
Film: Kodachrome 25
Exposure Metering: Minolta
Auto-Flash III
Exposure: *f*-8 (shutter at 1/60
second)

I'm not a big fan of softboxes, designed to give very soft, shadow-free lighting. I prefer smaller light sources that give greater lighting contrast. However, when it comes to lighting highly reflective products, nothing does it better than a softbox.

The belts were photographed for noted jewelry designer Aldo Cipullo. The model was seated on a small cube. A 600-watt-second flash was two feet to her right. A 42-inch Larson Softbox was mounted to the light. The model was positioned about three feet from a white background. Behind her, I placed a 600-watt-second flash with a wide-angle reflector. It was pointed toward the background and set to overexpose it by one exposure step to ensure a pure white background on the film.

An electric fan added some movement to the hair, completing an effective image.□

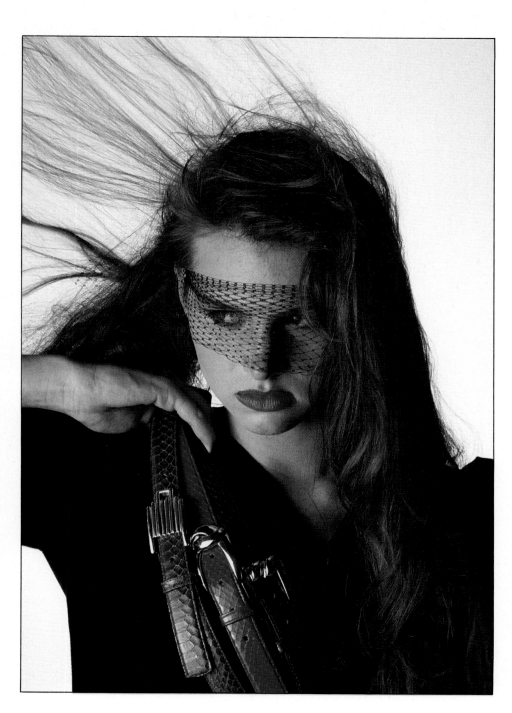

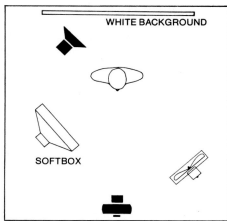

WHITE BACKGROUND

SOFTBOX

36

Subject: Professional model
Client: Esquire
Art Director: Max Evans
Location: Gary Bernstein Studio, New York City
Camera: Nikon F
Lens: 105mm *f*-2.5 Auto-Nikkor
Lighting: Two 1200-watt-second Thomastrobe electronic flash units
Film: Kodachrome 25
Exposure Metering: Wein Electronic-Flash Meter, incident-light mode
Exposure: *f*-8 (shutter at 1/60 second)

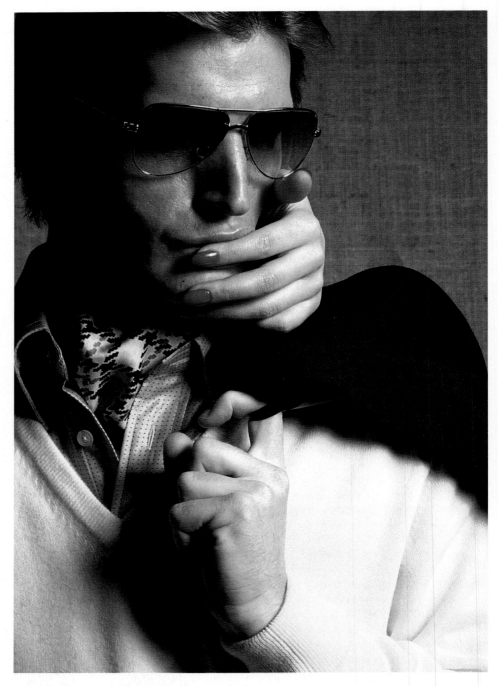

Hands look most attractive when delineation of the fingers is clearly visible. In this photograph—part of a fashion series for *Esquire* magazine—I added a woman's hand as a surprise element. This hand was selected as carefully as the male model. I chose a hand with nicely shaped, long fingers and good skin texture.

The surrealistic effect of the apparently detached hand was emphasized by placing it closest to the main light source. It received the greatest light intensity. The main light was an umbrella-bounced 1200-watt-second electronic flash. It was positioned approximately three feet to the model's left. A second umbrella-bounced light was placed behind the model. It highlighted the background behind the shadow side of his face. This served to emphasize the absence of an arm with the woman's hand.

An incident-light exposure reading was taken from the woman's hand and exposure was based on this. The background illumination was carefully balanced to record as a medium gray.□

High-key photographs can have a special beauty. Special care must be taken with light placement and exposure, to ensure there are no significant dark areas in the picture.

This photo was made for a display card for Conair haircurlers. Bare flash is ideal for providing a uniform white background. I placed two bare-bulb flash units a few feet behind the model. One was on the left and the other on the right side. The camera lens was shielded from each with a Rocaflector.

I placed the model's head at one of the effective visual points, as indicated by the *Golden Rectangle,* page 25. I cropped the head a little to bring the eyes to what I considered the most effective height. In the finished photo, the model has strong impact without detracting from the centrally placed product being advertised.

The main light, reflected from a silvered umbrella, was about four feet from the subject. It gave just the right facial modeling without producing excessive contrast. To ensure a pure white background, it received one exposure step more light than the subject. An incident-light reading was taken from the model's face. Another was made from the background, with the meter pointed toward the camera.□

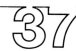

Subject: Professional model
Client: Conair, Inc.
Ad Agency: Ted Bates, Inc.
Art Director: Jack Jones
Location: Gary Bernstein Studio, New York City
Camera: Nikon F2AS
Lens: 55mm *f*-3.5 Micro Nikkor
Lighting: Three 1200-watt-second electronic flash units
Light Control: Two white Rocaflectors
Film: Kodachrome 25
Exposure Metering: Minolta Auto-Flash II, incident-light mode
Exposure: *f*-8 (shutter at 1/60 second)

Subject: Professional model
Client: Palm Beach, Inc.
Ad Agency: Blaise Associates, Inc.
Art Director: Ceci Murphy
Location: Peapack, New York
Camera: Nikon F2
Lens: 105mm *f*-2.5 Auto-Nikkor
Lighting: Daylight; overcast
Film: Kodachrome 64
Exposure Metering:
Through-the-lens, center-weighted
Exposure: 1/60 second at *f*-4

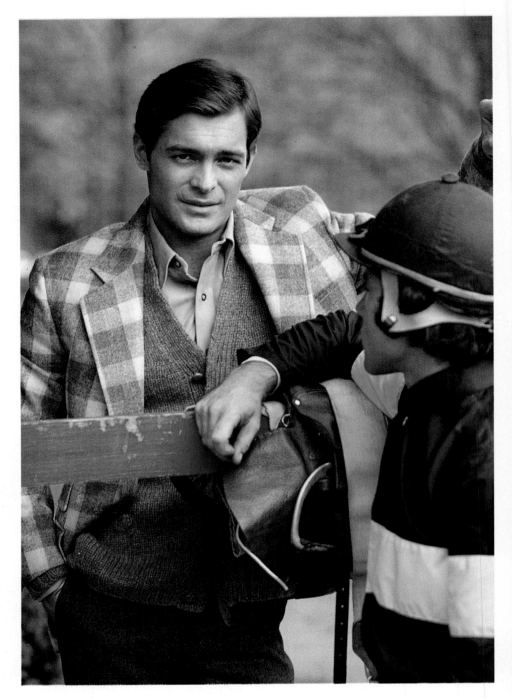

Few backgrounds are more beautiful than the rich colors of autumn. However, foliage in sharp focus can make for a very distracting background. For this reason, shallow depth of field was essential in this photograph.

Limited depth of field was needed in the foreground, too. I wanted the jockey to appear soft and indistinct. He was included only as a prop, to establish the photograph's mood. It was most important for the viewer's attention to go immediately to the main subject.

Your eyes are attracted naturally to the sharpest part of a composition. Selective depth of field is a useful tool to direct viewer attention where you want it. The effect in this photo was achieved with a 105mm lens at *f*-4.

It was just about to rain when I took the photograph. I needed to shoot quickly. Because of the relatively low contrast of the scene, perfect exposure metering was not critical. I was quite confident in using the through-the-lens meter in my Nikon.

Behind me and to the subject's left remained a small area of open sky. I positioned the model so he was lit at a 45° angle by that area of sky. Exposure was based on a reading from the face. I bracketed about one *f*-stop in each direction. The result is a pleasing image with good facial detail and modeling.□

I had the pleasure of photographing Dudley Moore for the *Arthur* motion-picture poster. The photograph was produced with six lights and a gobo.

A six-foot umbrella flash was placed near the floor to the left of camera position. It gave overall lighting coverage to the scene. One light on each side of the race car was directed on the background, to give a pure white, shadowless background. The 600-watt-second main light, in silvered umbrella, gave modeling and highlights to Dudley's face.

A wide-angle light was placed on the floor to the left, to eliminate the shadow below the car. A final light, shielded with a gobo, was placed to Dudley's left to add a highlight value to his legs. This visually separated his legs from his coat and the left rear tire.

I didn't want the length of the car to dominate the scene. I wanted Dudley to have prominence. Consequently, I used a medium-length telephoto lens. It visually compressed the distance between the front of the car and the subject. The entire image needed to be sharp. Significant depth of field was required because of the length of the car and the eventual enlargement of the image. With the telephoto lens, I needed to stop down to *f*-16 to render all in sharp focus. To use *f*-16 with Kodachrome 25 film, a great deal of light was needed. Hence the 3600 watt-seconds of light.□

39

Subject: Dudley Moore
Client: Warner Brothers, Inc.
Ad Agency: Seiniger Advertising, Inc.
Art Director: Tony Seiniger
Location: Los Angeles, California
Camera: Nikon F3
Lens: 85mm *f*-1.8 Auto-Nikkor
Lighting: Six 600-watt-second electronic flash units
Light Control: Silvered Rocaflector
Film: Kodachrome 25
Exposure Metering: Minolta Auto-Flash II, incident-light mode
Exposure: *f*-16 (shutter at 1/60 second)

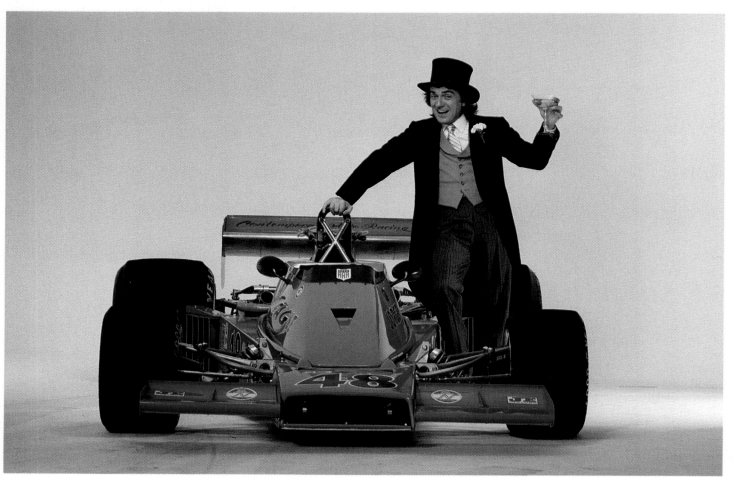

Subject: Tommy Jacobs
Client: La Costa Spa
Art Directors: William Randall and Russ Heinze
Location: Rancho La Costa, California
Camera: Nikon F2AS
Lens: 180mm *f*-2.8 Auto-Nikkor
Lighting: Late-afternoon sunlight, redirected
Light Control: Larson Super-Silver Reflectasol
Film: Kodachrome 25
Exposure Metering: Through-the-lens, center-weighted
Exposure: 1/125 second at *f*-5.6

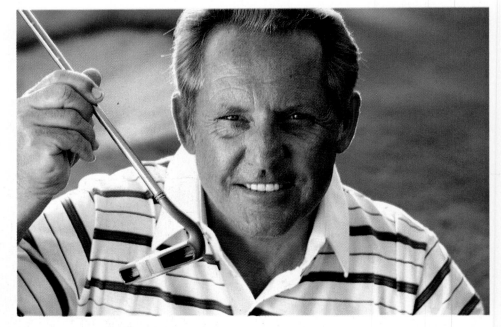

Golfing pro Tommy Jacobs needed a photo for an ad promoting his new line of putters. At the time of photography, the art directors were indecisive regarding final layout and type position. By placing Tommy in the center of the frame, I provided maximum layout freedom. I used a medium-length telephoto lens at a small aperture. This enabled me to record the background as a recognizable golfing environment without having it disturbingly sharp.

The photo was taken during the last few minutes of waning afternoon light. I had wanted Tommy to face into the sun. However, his pale-blue eyes narrowed to a squint from the light's intensity. So I turned Tommy's back to the sun and placed a Larson Super-Silver Reflectasol on the ground to Tommy's right. The Reflectasol redirected the sun into his face. A Larson Gobosol on my camera served to eliminate the possibility of lens flare.

The scene was metered through the lens of my Nikon. I positioned the center-weighted spot in the camera's finder on the highlight portion of Tommy's face. I did this because I was exposing transparency film, which needs accurate *highlight* exposure.

The silver Reflectasol reflects most of the light reaching it. If subjects feel discomfort looking at it, I tell them to look away from the reflector until the moment I take the picture. Pauses of this kind have the added advantage of encouraging constantly new expressions in the subject.□

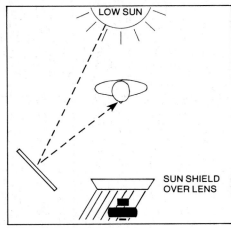

LOW SUN

SUN SHIELD OVER LENS

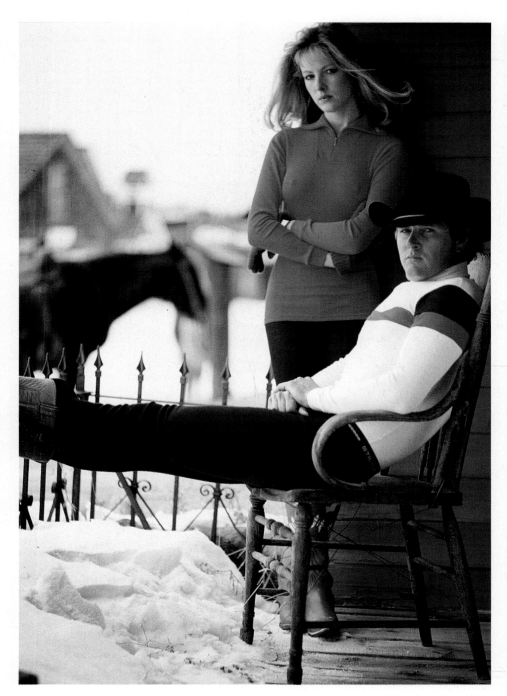

41

Subject: Two professional models
Client: Skyr/Scandia Inc.
Ad Agency: Marvin & Leonard, Inc.
Art Director: Harry Kerker
Location: Fairplay, Colorado
Camera: Nikon F3
Lens: 55mm f-3.5 Micro-Nikkor
Lighting: Daylight, overcast
Light Control: Silvered Rocaflector
Film: Kodachrome 25
Filtration: Ultraviolet filter
Exposure Metering: Minolta Auto-Flash III
Exposure: 1/500 second at f-5.6

A ghost town in Fairplay, Colorado, was the scene for this available-light photo for an underwear ad. The wind-chill factor was 30 below zero. I placed my subjects under the short awning of an old house, so most of the skylight reaching the faces came from a low angle. The shadow side of the subjects was sparingly filled with a silvered reflector.

Lens selection and aperture were critical to the mood of the photograph. My 55mm micro lens provided a wide enough field of view to include the horse in the background. An f-5.6 aperture provided sufficient depth of field for subject sharpness, while softening the background. The subjects were placed high in the composition to allow for type and body copy at the bottom of the finished advertisement.

Excessive ultraviolet reflection can be a problem in the snow, so I used a UV filter on both the camera lens and the meter's sensor. □

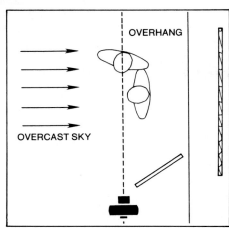

42

Subject: Larry Hagman
Client: BVD Underwear, Inc.
Ad Agency: Compton Advertising, Inc.
Art Director: Sue Forman
Location: Dallas, Texas
Camera: Nikon F3
Lens: 85mm *f*-1.8 Auto-Nikkor
Lighting: Three 600-watt-second electronic flash units
Light Control: Larson Super-Silver Reflectasol
Film: Kodachrome 25
Exposure Metering: Minolta Auto-Flash III, incident-light mode
Exposure: *f*-5.6 (shutter at 1/60 second)

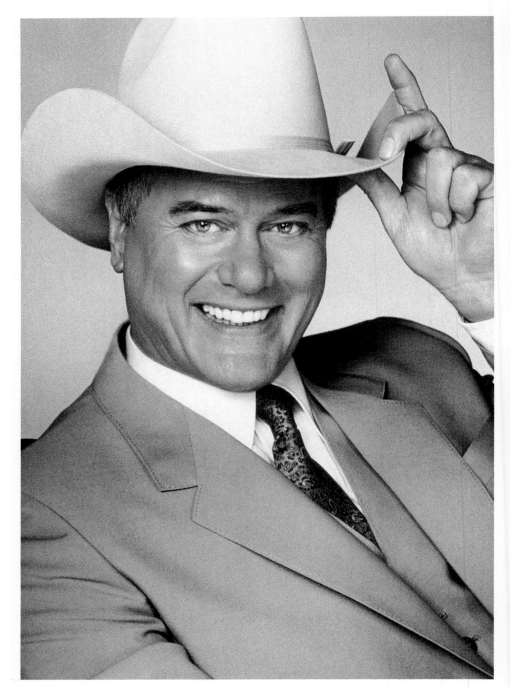

Two main lights were used to make this photograph. One was placed to Larry's right and bounced from a 40-inch umbrella. The second light was a *bare flash* without a reflector. It was located behind camera position and to Larry's left. Primary facial modeling came from the umbrella light. The bare flash added specular highlights to the cheeks, forehead and tip of the nose. It also added an extra catchlight to each eye. This creates additional sparkle in Hagman's striking blue eyes.

The facial illumination was completed by the addition of a square silvered reflector. I placed it below Hagman's face, to the right of the camera. It softened contrast around the subject's nose and added some light under the brim of the hat.

A 600-watt-second flash, with 4-inch reflector and grid spot, provided the background light. The light was placed on the floor behind Hagman's chair and pointed at the background wall. It was focused to give a bright spot behind the head and then fall off around the hat. This emphasized the subject's face and, at the same time, kept the white hat from merging with a white background.□

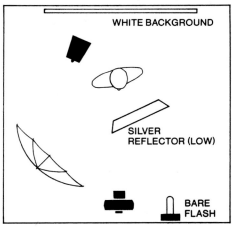

WHITE BACKGROUND

SILVER REFLECTOR (LOW)

BARE FLASH

Subject: Linda Gray
Location: Gary Bernstein Studio,
Los Angeles, California
Camera: Nikon F3
Lens: 85mm *f*-1.8 Auto-Nikkor
Lighting: Three 150-watt tungsten
modeling lights
Film: 3M 640T
Exposure Metering: Minolta
Auto-Flash III, incident-light mode
Exposure: 1/60 second at *f*-8

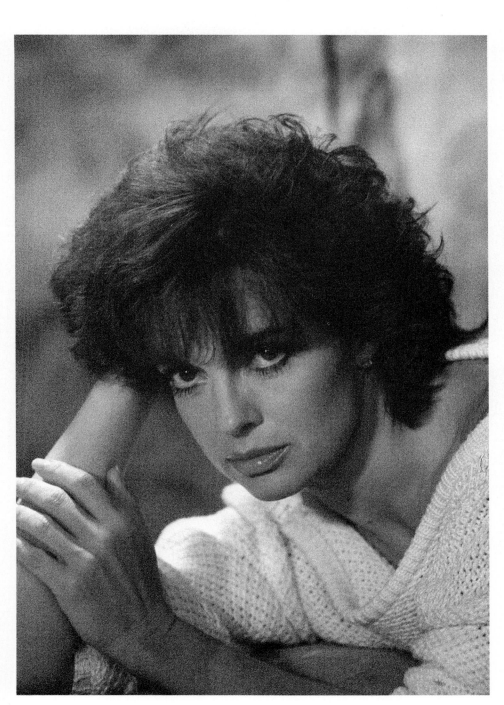

Striking Linda Gray is the subject of this pensive portrait study. The photograph was taken against a randomly painted canvas background. Linda was placed about six feet from the background. The lighting came from the modeling lights of three flash units, each with a focusing spot. Main lighting was frontal and slightly to the camera's left. The hair light was high and slightly behind the subject. The third light was on the background.

Mottled backgrounds allow for considerable exposure variations in that area. They also facilitate the use of uneven background lighting.

In this photo, I gave the background twice as much light as the subject. This helped produce a mysterious, smoky appearance.

The coarse grain of the ISO 640/29° film was further emphasized by under-exposure and push-processing. The added grain, the smoky background and the warm colors all helped produce the special atmosphere of this photo.□

PAINTED BACKGROUND

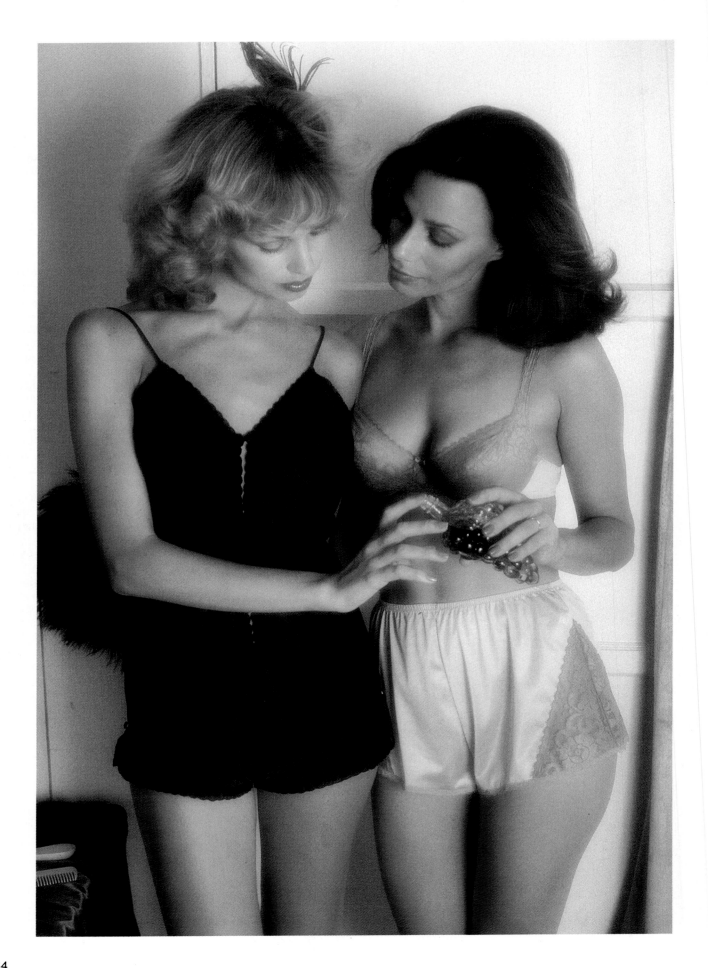

Subject: Professional models
Client: Bullock's, Inc.
Ad Agency: Harrison Services, Inc.
Location: Los Angeles, California
Camera: Nikon FM
Lens: 85mm *f*-1.8 Auto-Nikkor
Lighting: Three 1200-watt-second electronic flash units
Light Control: Three white Rocaflectors
Film: Kodachrome 64
Filtration: Diffusion filter
Exposure Metering: Minolta Auto-Flash III, incident-light mode
Exposure: *f*-5.6 (shutter at 1/60 second)

Optimum image resolution is not always desirable. In some photographic situations, suppressing detail enhances the beauty of the image. This lingerie photograph is a typical example.

To soften the image, made for consumer advertising, I combined soft lighting with the use of a lens diffuser. I made the diffuser by spraying acrylic fixative on a 52mm haze filter.

By bouncing electronic-flash light into the center of three large, white reflectors, I simulated soft, diffused daylight. Two reflectors were placed to the models' right and the third to their left.

I made incident-light exposure readings from *both* sides of the subjects' faces. Light bounced from white matte reflectors produces uniform subject illumination, with little falloff. By pointing the meter's incident-light hemisphere toward each of the three reflectors, I was able to determine *maximum* highlight value for optimum exposure of the transparency film.

A similar lighting effect can be produced with tungsten lights. However, you must remember that these have a different color temperature. You must compensate for this, either by using color-conversion filters or by using a film balanced for tungsten illumination.□

Subject: Professional model
Client: Hart, Schaffner and Marx, Inc.
Art Director: Scott Davis
Location: Gary Bernstein Studio, Los Angeles, California
Camera: Nikon F3
Lens: 85mm *f*-1.8 Auto-Nikkor
Lighting: Two 600-watt-second electronic flash units
Light Control: 20-inch Larson Super-Silver Reflectasol
Film: Kodachrome 25
Exposure Metering: Minolta Auto-Flash III, incident-light mode
Exposure: *f*-8 (shutter at 1/60 second)

The subject was positioned about 10 feet from a large painted canvas background. The background was far enough from the subject to be recorded slightly out of focus at the aperture used.

The main light was a flash in a silvered umbrella. It was placed to the subject's right. The background was lit from the same side by a second umbrella flash. The distance between subject and background and the addition of a background light eliminated background shadows. I placed a silvered reflector to the subject's left to bounce the main light into the shadow side of the face and reduce contrast.

Background and the subject lighting were balanced for an *f*-8 exposure. □

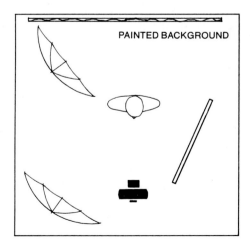

PAINTED BACKGROUND

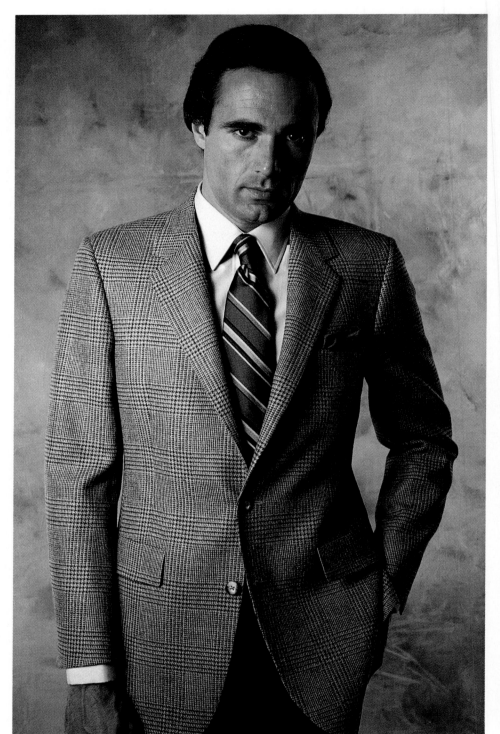

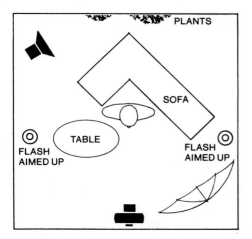

PLANTS

SOFA

TABLE

FLASH AIMED UP

FLASH AIMED UP

Subject: Professional model
Client: Leslie Fay, Inc.
Art Director: Barbara Sadtler
Location: United Nations Plaza, New York City
Camera: Nikon F2
Lens: 55mm ƒ-3.5 Micro-Nikkor
Lighting: One 1200-watt-second Thomastrobe power pack with three lights: two in wide-angle reflectors and one bounced from a 34-inch white umbrella. Also, one 100-watt-second portable flash.
Film: Kodachrome 25
Exposure Metering: Wein electronic-flash meter
Exposure: ƒ-16 (shutter at 1/60 second)

This full-length fashion photo was taken for use in a national ad. The natural-looking room lighting was produced with a three-light setup from a portable 1200-watt-second power pack and a small 100-watt-second portable flash.

Two flash heads, equipped with wide-angle reflectors, were set on either side of the model. The units were raised to within two feet from the ceiling and pointed straight up. This provided soft, even room illumination. A third flash head from the same flash generator was bounced from a 34-inch white umbrella to serve as a main light. Each flash head was providing an output of 400 watt-seconds. I placed a small 100-watt-second flash behind the model to accent the plants in the background. That flash was triggered with a slave unit.

I metered the incident light in stages. The overall room light was adjusted to give one step less exposure than the subject main light. This emphasized the subject. I metered the accent light on the plants by pointing the incident-light hemisphere down toward the flash from the center of the plant. This flash was adjusted to give the same exposure as the main light.

Notice the use of a low camera angle. It elongates the model, emphasizing her and the gown.□

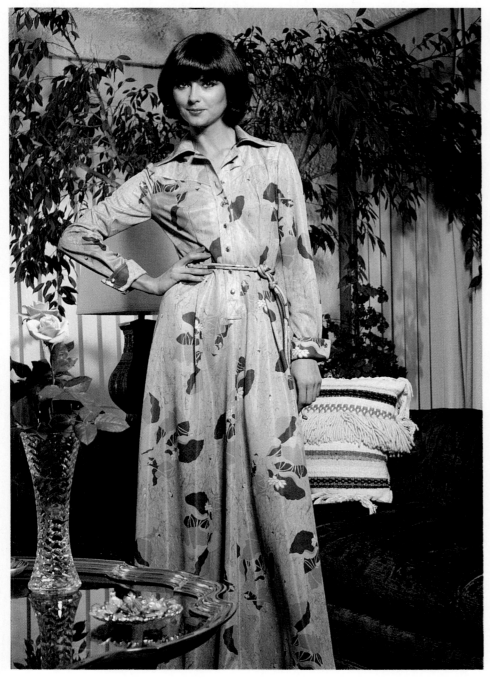

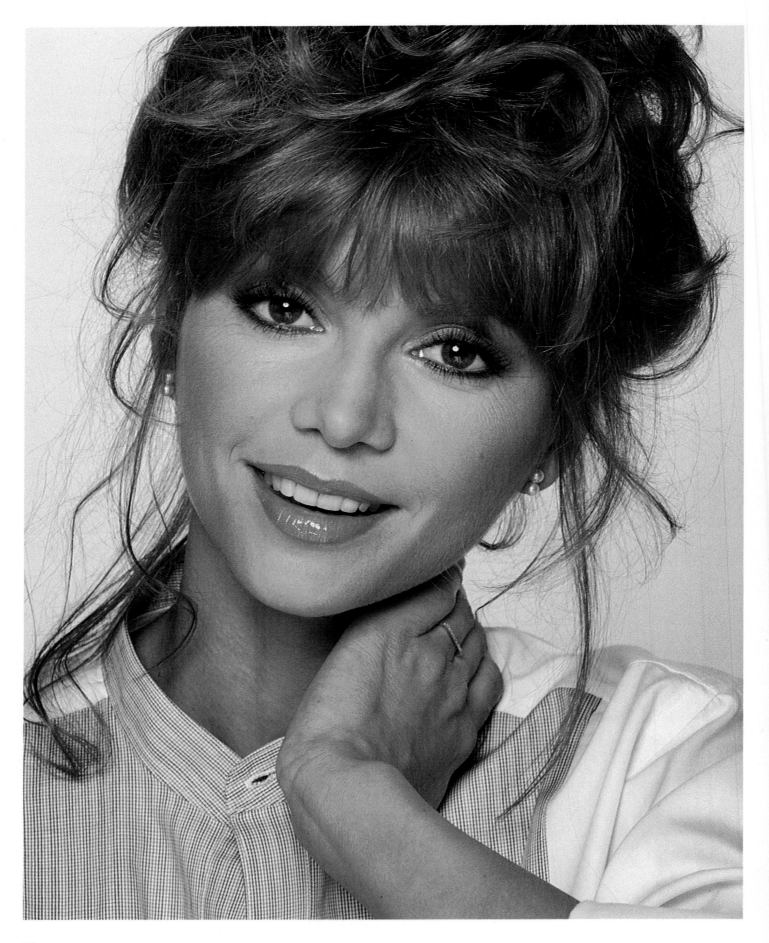

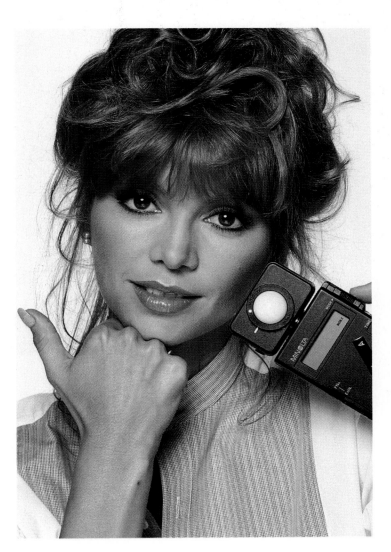

Subject: Victoria Principal
Client: Jean-Paul Germain, Ltd.
Location: Gary Bernstein Studio, Los Angeles, California
Camera: Nikon F3
Lens: 105mm *f*-2.5 Auto-Nikkor
Lighting: Three 600-watt-second electronic flash units
Light Control: Silvered 27-inch Reflectasol and two white Rocaflectors
Film: Kodachrome 25
Exposure Metering: Minolta Auto-Flash III, incident-light mode
Exposure: *f*-11 (shutter at 1/60 second)

For this session with beautiful Victoria Principal, my main light was a 600-watt-second flash, bounced from a 40-inch silvered umbrella. I placed a 27-inch silvered reflector below Victoria's face to bounce additional light into her eyes and soften contrast.

Two 600-watt-second flash units were used to provide a clean, white background. I used two Rocaflectors as gobos between the background lights and the camera. They eliminated excessive reflection from the back wall, which could have caused lens flare and degraded the image.

The small photo shows the correct placement of the incident-light hemisphere to meter the main light for transparency exposure.□

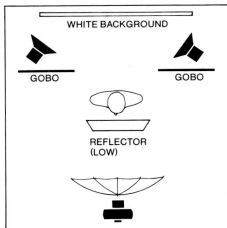

48

Subject: Johnny Carson
Client: M. Wile & Company, Inc.
Art Director: Joe Starzec
Location: Malibu, California
Camera: Nikon F3
Lens: 180mm *f*-2.8 Auto-Nikkor
Lighting: Two 600-watt-second electronic flash units
Film: Kodachrome 25
Exposure Metering: Minolta Auto-Flash III, incident-light mode
Exposure: *f*-5.6 (shutter at 1/60 second)

After producing a series of fashion ads for *Johnny Carson Clothing,* we ended the session with some headshots. Johnny was standing in front of a bookcase in his living room. My camera was on a tripod. I used a telephoto lens to get a detailed shot of the strong character in the popular Carson face without "crowding" him by coming too close. Using the depth-of-field preview button on my camera, I selected an aperture that softened the background but kept it recognizable.

Two lights were used. A single main light, bounced from an umbrella, was located to Johnny's right. Another umbrella flash lit the background. It was set to give 1/2 step less exposure than the main light. □

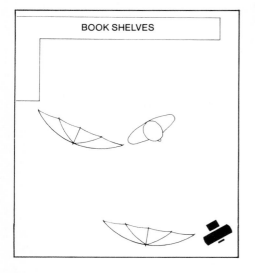

BOOK SHELVES

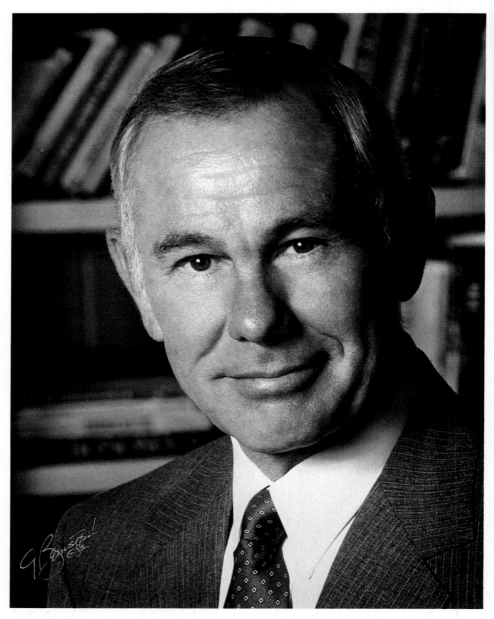

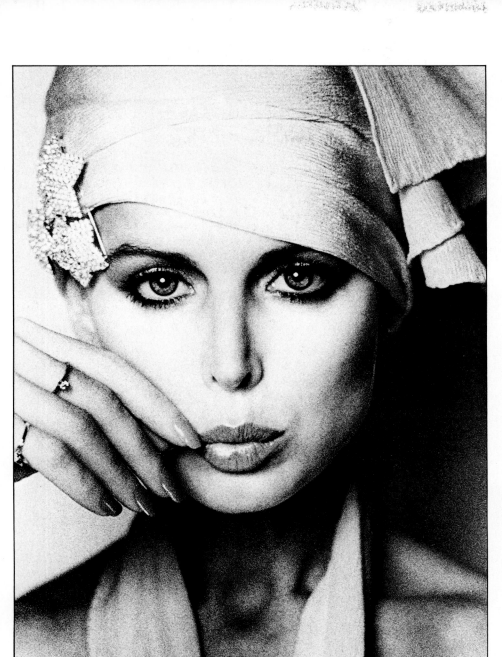

Subject: Professional model
Client: Pauline Trigere, Inc.
Location: Gary Bernstein Studio, New York City
Camera: Nikon F2AS
Lens: 105mm *f*-4 Micro-Nikkor
Lighting: One 1250-watt-second Rollei flash, set for 100 watt-seconds
Film: Kodak 2475 Recording Film
Exposure Metering: Minolta Auto-Flash III, incident-light mode
Exposure: *f*-8 (shutter at 1/60 second)

This headshot shows the soft, granular beauty of Kodak 2475 Recording Film. The film has tremendous exposure latitude.

The photograph was taken with a single flash unit set for an output of approximately 100 watt-seconds. The light was six feet in front of the model, who was leaning against a white wall.

Notice the position of the eyes in the composition: They are about a third of the way down into the frame, giving maximum viewer impact. □

Subject: Professional model
Client: Max Factor, Inc.
Art Director: Mirella Forlani Buchanon
Location: Gary Bernstein Studio, Los Angeles, California
Camera: Nikon F2AS
Lens: 85mm *f*-1.8 Auto-Nikkor
Lighting: Two 1200-watt-second electronic flash units
Light Control: Two 40-inch silvered umbrellas
Film: Kodakchrome 64
Exposure Metering: Minolta Auto-Flash II, incident-light mode
Exposure: *f*-5.6 (shutter at 1/60 second)

For the introduction of a new cosmetic line, Max Factor wanted a soft, ethereal photograph. I chose Kodachrome 64 film. It is less contrasty than Kodachrome 25. Although faster than Kodachrome 25, it provides a remarkably smooth, homogeneous image. The soft, pastel hues in this photo are not broken up by graininess. The soft effect was enhanced further by using a simple diffuser on the camera lens. The diffuser was a sheet of clear acetate, sprayed with clear Krylon fixative.

Photo-specialty houses offer a great selection of painted backgrounds. This cloud background, however, was homemade. I sparingly used white spray paint on a uniform, blue background.

The scene was lit with two flash units, each bounced from a 40-inch silvered umbrella. The main light was positioned to the right of my camera to give even illumination to the model and the background. This light created a shadow behind the model. I placed a second light between the model and the background to eliminate the shadow. The light was *fanned* toward the model to produce the rim light on her hair.

An incident-light reading, taken from the back of the model's head, indicated a rim-light exposure of between *f*-8 and *f*-11. The exposure indication for the background and the front of the model was *f*-5.6. By setting my lens at *f*-5.6, I got a correctly exposed subject and background together with rim lighting that was overexposed by 1-1/2 exposure steps. □

PAINTED BACKGROUND

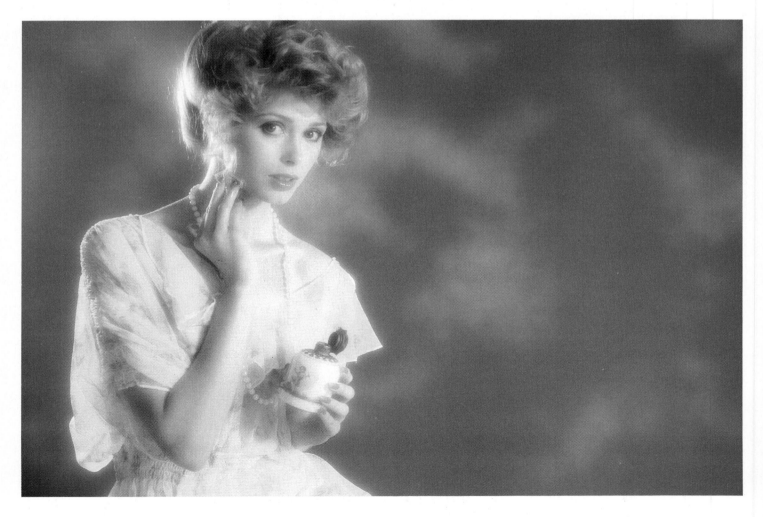

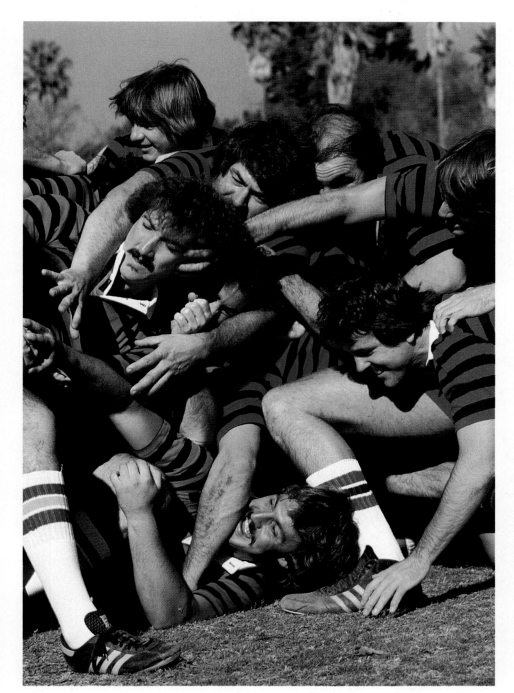

51

Subject: Professional rugby football team
Client: Gant Shirtmakers and Anheuser Busch for Michelob
Art Director: Gary Aronson
Location: Orange, California
Camera: Nikon F3
Lens: 55mm *f*-3.5 Micro-Nikkor
Lighting: Sunlight
Film: Kodachrome 64
Exposure Metering: Through-the-lens, center-weighted
Exposure: 1/250 second on shutter-priority automatic. Aperture varied for a series of shots between about *f*-4 and *f*-8

This action photo was part of a series of illustrations produced for Gant and Michelob. The art director wanted the players to actually play the game, yet show as many rugby shirts as possible in the composition. Consequently, we carefully choreographed each move. I instructed the players where to start, in which direction to move and when to have a group confrontation.

In spite of the planning, the action covered a wide area. I selected a standard 55mm lens to keep as much activity as possible in focus. I set my Nikon for automatic exposure control. Consequently, I wasn't aware of precise aperture settings. The camera's motor drive was used at its fastest speed.

Notice that the faces featured display good lighting angles and facial modeling. Action photography does not give an excuse for improper lighting or poor picture quality. □

52

Subject: Elliott Gould
Location: Gary Bernstein Studio, Los Angeles, California
Camera: Nikon F3
Lens: 105mm *f*-4 Micro-Nikkor
Lighting: One 600-watt-second electronic flash
Light Control: 40-inch silvered umbrella
Film: Kodachrome 25
Exposure Metering: Minolta Auto-Flash III, incident-light mode
Exposure: *f*-11 (shutter at 1/60 second)

To the subject, the one factor that determines whether a photo is good or bad is expression. For the photographer, there are other important considerations. They include lighting, lens selection, camera angle, background, pose and many more.

The key to successful portraiture lies in mastering photographic technique so it becomes second nature. This frees you to concentrate on the subject's expression and attitude.

I believe in *simplicity*. I won't use two lights when one is enough. This three-shot study of actor Elliott Gould was taken with a single light source against a background of white seamless paper. The background appears gray because of its distance from the lights. This effectively underexposed it by about two exposure steps.

I used a short telephoto lens. It provided a good compromise: I was far enough away from the subject to avoid perspective distortion and crowding him. I was also close enough to permit comfortable conversation.

For light metering, I placed my Minolta meter on Elliott's right cheek and pointed the incident-light hemisphere toward the light source. Electronic flash gives very consistent light output, so exposures are accurately repeatable. I bracketed just 1/2 *f*-stop in either direction, to allow for possible variations due to Elliott's movement in relationship to the light.

The success of the session is largely due to good conversation and a good *rapport* with the subject. □

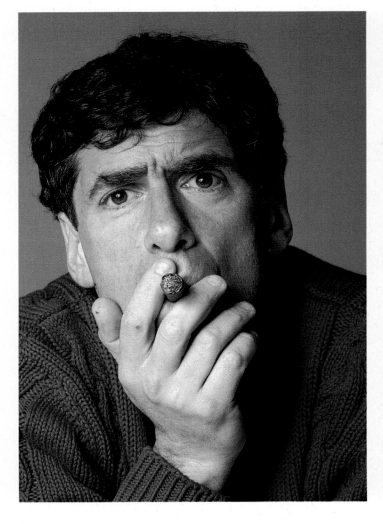
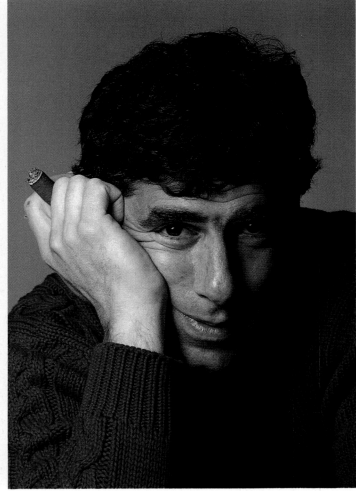

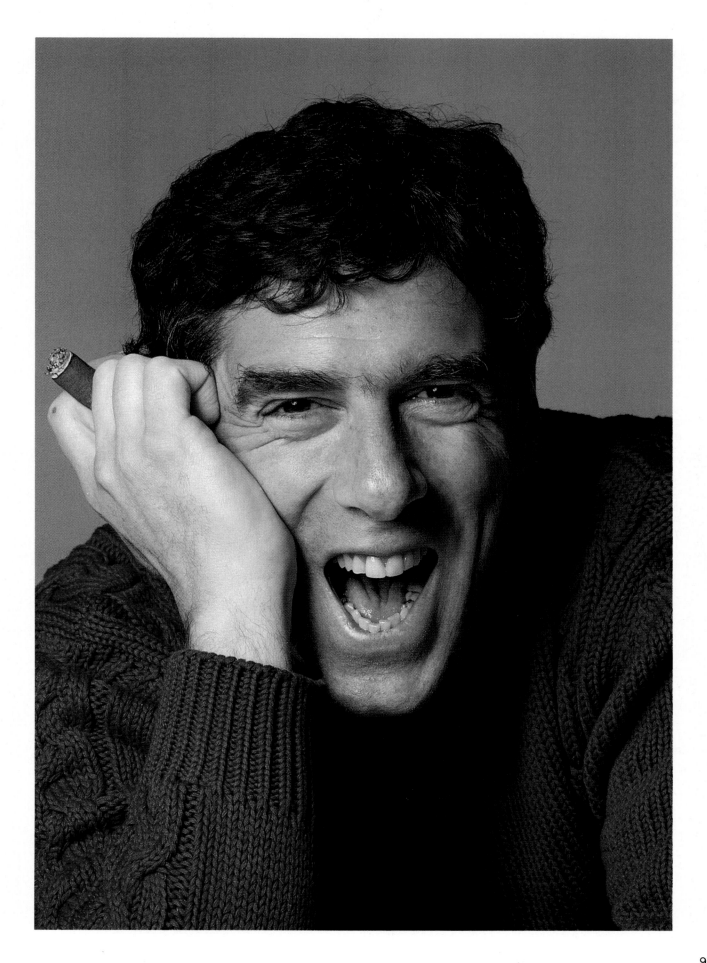

Subject: Professional model
Location: Gary Bernstein Studio, New York City
Camera: Nikon F2AS
Lens: 55mm ƒ-3.5 Auto-Nikkor
Lighting: 1200-watt-second bare flash
Light Control: White Rocaflector
Film: Kodak Plus-X
Exposure Metering: Minolta Auto-Flash II, incident-light mode
Exposure: ƒ-11 (shutter at 1/60 second)

Bare-bulb flash can yield high-quality results. It acts like a point source, producing well-defined shadows and subject highlights. Flash light reflected from nearby walls and ceiling softens shadows. To reduce lighting contrast even more and give a softer edge to the shadows, I placed a large white reflector just out of camera range to the right of the camera.

Props need not be elaborate to be effective. Here I used a 4x8-foot sheet of fake tile—available from building-supply stores—to provide the "floor." White, seamless paper formed the "wall." An electric fan added the necessary movement to complete this humorous shot. □

WHITE BACKGROUND

BARE FLASH

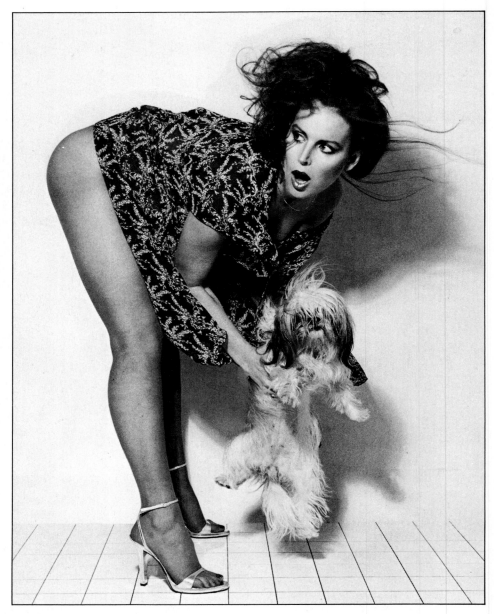

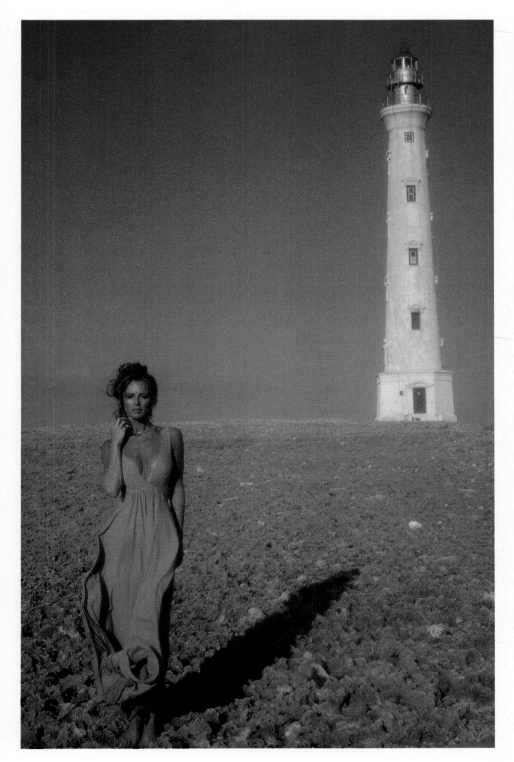

54

Subject: Professional model
Location: Aruba, Netherlands Antilles
Camera: Nikon F2
Lens: 55mm ƒ-3.5 Micro-Nikkor
Lighting: Late-afternoon sunlight
Film: Kodachrome 25
Exposure Metering: Through-the-lens, center-weighted
Exposure: 1/500 second at ƒ-8

This photograph is an outtake from my first book, *Burning Cold.* In this case, I chose to break a basic rule of composition by emphasizing *two* centers of interest—the model and the lighthouse. I had a choice as to where to place the subject in the frame. I selected this position because her shadow leads your eye to the lighthouse—emphasizing the statuesque similarity of their forms.

The photograph was taken in direct late-afternoon sunlight. The facial modeling is similar to that produced by a single spotlight, from the same angle, in the studio. Notice the hard, well-defined shadows, typical of a small light source.

When two centers of interest appear in one photograph, it's important to eliminate other elements of possible confusion. For example, in this case a gown was selected which harmonized with the tonality of the sky.

I used the Nikon's depth-of-field preview button to determine the best aperture. Appropriate depth of field was provided with the lens at ƒ-8. □

Subject: Four professional models
Client: The Palm Beach Company
Art Director: Ceci Murphy
Location: Zuma, California
Camera: Nikon F3
Lens: 105mm f-2.5 Auto-Nikkor
Lighting: Hazy sunlight
Light Control: Two silvered Rocaflectors
Film: Kodachrome 64
Exposure Metering: Gossen Luna-Pro, incident-light mode
Exposure: 1/125 second at f-8

The 35mm frame is ideal for horizontal pictures of groups, as in photograph 56. Composition gets a bit cumbersome, however, when shooting vertical groups on the 35mm format.

Photograph 55 was composed to display the four outfits with equal emphasis. Extra space is provided at the top of the frame for possible cropping or for the addition of a headline and body copy in the finished ad.

Because the hazy midday sun lacked proper direction, I used two silvered reflectors to bounce the light into the models' faces.

In photograph 56, early morning sunlight was used as a direct source. It provided beautiful facial lighting for all four models. For each photo, a Gossen handheld meter, set for incident-light reading, was used to determine exposure.

A great advantage of working with groups is the interaction among the individuals. To some extent, they are part of a team and accept some of the photographer's burden of creating an appealing image. However, groups tend to have a limited attention span. It's best to know what you want to express photographically beforehand and to achieve it in the shortest possible time. □

Subject: Four professional models
Client: Hunter Hair Clothing
Art Directors: Hal Dubonah and Ceci Murphy
Location: Peapack, New York
Camera: Nikon F2
Lens: 105mm *f*-2.5 Auto-Nikkor
Lighting: Hazy sunlight
Film: Kodachrome 25
Exposure Metering: Gossen Luna-Pro, incident-light mode
Exposure: 1/250 second at *f*-8

Subject: Infant (First portrait)
Location: Gary Bernstein Studio, New York City
Camera: Nikon F2AS
Lens: 50mm ƒ-1.4 Auto-Nikkor
Lighting: Daylight through north window
Light Control: White cardboard reflector
Film: Kodachrome 64
Filtration: Skylight filter
Exposure Metering: Gossen Luna-Pro, incident-light mode
Exposure: 1/15 second at ƒ-2.8

The four-days-old infant was sleeping by the north window of my New York City office. I draped a white blanket around her head to graphically separate her new, brunette hair from the dark leather couch on which she was lying.

Placing my handheld meter near the highlighted part of the baby's face, I pointed the incident-light hemisphere toward the center of the window. I got an exposure reading of 1/15 second at f-2.8. My Nikon, with 50mm ƒ-1.4 standard lens, was tripod-mounted for steadiness.

In the Northern Hemisphere, north windows rarely receive direct sunlight. This makes them an ideal light source for diffused available-light photography. North light tends to have a blue color cast similar to that in open shade. To reduce this, I used a skylight filter on the lens. It helped to keep skin tones pure and the white parts of the scene white. A white cardboard was used as a reflector on the shadow side of the infant's face, just out of camera range.□

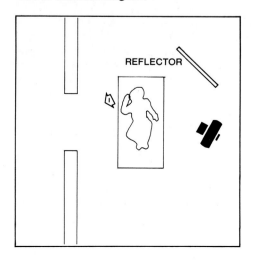

REFLECTOR

Subject: Professional model
Client: Max Factor, Inc.
Ad Agency: Wells, Rich and Greene (West), Inc.
Art Director: Bob Cole
Location: Gary Bernstein Studio, Los Angeles, California
Camera: Nikon FM
Lens: 105mm *f*-2.5 Auto-Nikkor
Lighting: One 1250-watt-second electronic flash with pan reflector; two 1200-watt-second electronic flash units
Light Control: Three white Rocaflectors
Film: Kodachrome 25
Exposure Metering: Minolta Auto-Flash III, incident-light mode
Exposure: *f*-16 (shutter at 1/60 second)

Advertising models are selected with the same care as actors for a feature film. Because the product advertised was designed for young buyers, a junior model was chosen. To emphasize the subject's youth, I used soft lighting.

The main flash, in a pan reflector, was placed about three feet from the subject, slightly to her right. But her hat brim made proper facial lighting difficult. The white floor functioned as a large reflector, bouncing the main light up, under the hat and into the model's face. The main lighting was further softened by light from a large reflector to the model's left.

Two flash units were used as background lights, one to either side of the subject. I gave the background a full exposure step more light than the model's face. This was done to ensure a pure white background.

Powerful background lights, especially in a small room, can create unwanted reflections. To prevent these, I positioned a gobo between each background light and the subject.□

Subject: Jacki Sorensen and aerobic dancing instructors
Client: Kraft, Inc.
Ad Agency: J. Walter Thompson, Chicago
Art Director: Roberta McClennon
Location: Gary Bernstein Studio, Los Angeles, California
Camera: Nikon FM
Lens: 55mm ƒ-3.5 Micro-Nikkor
Lighting: One 1250-watt-second Rollei electronic flash unit; two 1200-watt-second electronic flash units
Film: Kodachrome 25
Exposure Metering: Minolta Auto-Flash III, incident-light mode
Exposure: ƒ-8 (shutter at 1/60 second)

Jacki Sorensen, inventor of aerobic dancing, is the subject of the photograph on this page. In the photographs on the opposite page, she is joined by two of her instructors. A three-light arrangement was used for all three photos. One flash, in pan reflector, lit the subjects. Two umbrella flashes were directed at the background, one from each side.

Prior to the photo session, I was instructed as to the subject positions the client wanted. The background was to vary from medium gray to white. I set up the basic lighting prior to the arrival of the subjects.

In all three photographs, the lighting was set for average subject exposure at ƒ-8. This gave sufficient depth of field to record all subjects in sharp detail.

In the photo on this page, the background lights were adjusted to underexpose the background about 1-1/2 exposure steps relative to the subject. This caused the white background to record as medium gray. In the left photo on the opposite page, background exposure was increased by about 1/2 exposure step. The background reproduced lighter.

In the photo at far right, background exposure was matched with subject exposure, allowing the white background to record its normal shade. The three lights remained in the same positions throughout the session, only the power settings were changed.

The consistency of movement and attitude among these three images is a result of communication between the subjects and myself. Before beginning photography, Jacki choreographed the possible combinations she could do alone, and with her associates. After deciding on one particular series of steps, we rehearsed the timing relative to the point at which the shutter would be released. The results look natural and believable. □

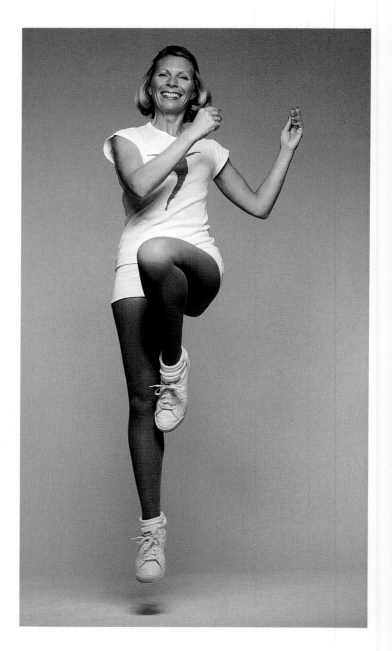

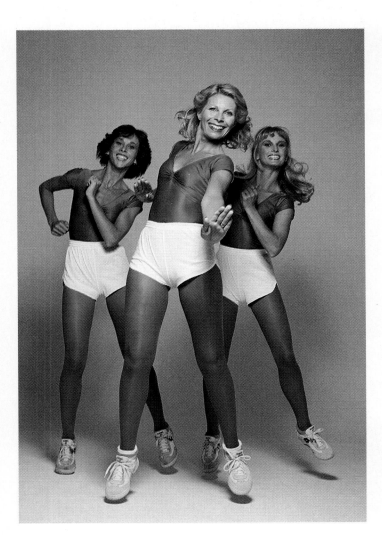

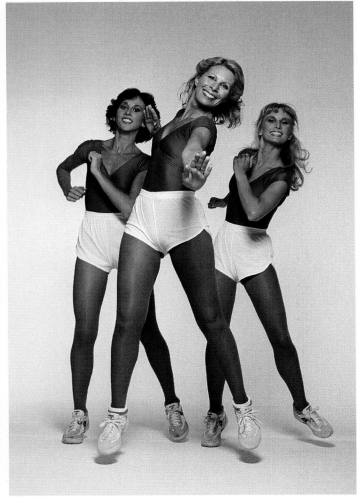

60

Subjects: Margaux Hemingway, Pat Amari, Prince Egon Von Furstenberg and Errol Wetson (Test session)
Location: Gary Bernstein Studio, New York City
Camera: Hasselblad EL/M
Lens: 80mm *f*-2.8 Zeiss Planar
Lighting: Two 1200-watt-second Thomastrobe electronic flash units
Film: Kodak Plus-X Pan
Exposure Metering: Wein Electronic-Flash Meter, incident-light mode
Exposure: *f*-16 (shutter at 1/250 second)

An international gathering like this can make for exciting group photography. I asked all four to dress in black. The purpose was to keep viewer attention on the faces. I positioned the subjects one at a time, beginning at the bottom of the image area.

The main light was a flash bounced from a 40-inch umbrella in front of the group. A second umbrella-reflected flash lit the hand-painted background.

Eye placement of the three in profile was critical. These subjects appear to be looking straight ahead. However, each profiled subject is actually looking about 45° toward the camera. This is important because it makes most of the iris visible. If they looked straight ahead, there would be too much white of the eye visible.

I love the character in these four faces. My aim was to create the chiseled appearance of a statue. To help produce this effect, I removed the eye catchlights from the photo with a retouching brush. □

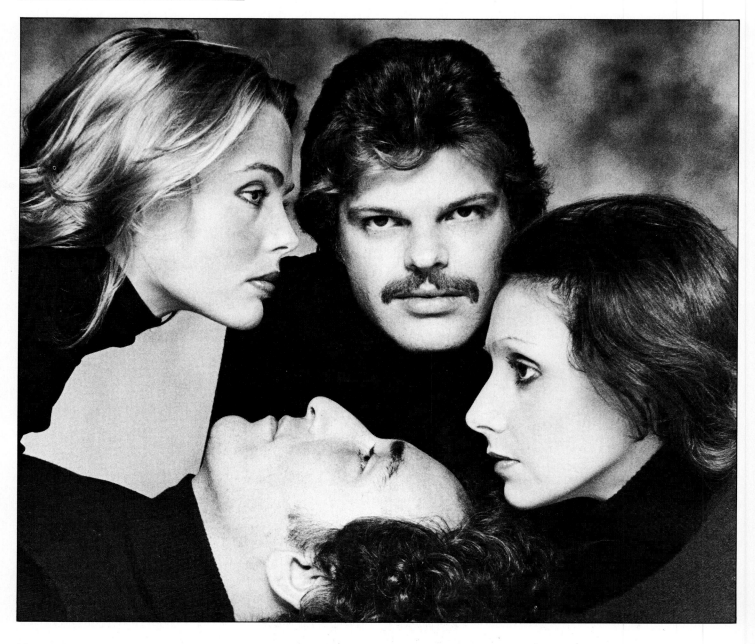

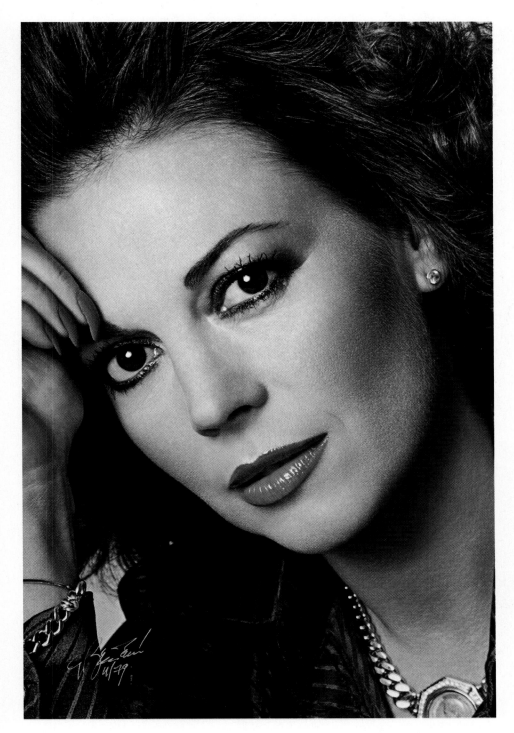

Subject: Natalie Wood
Location: Gary Bernstein Studio, Los Angeles, California
Camera: Nikon F3
Lens: 105mm *f*-4 Micro-Nikkor
Lighting: One 1250-watt-second Rollei flash in pan reflector
Film: Kodachrome 25
Exposure Metering: Minolta Auto-Flash III, incident-light mode
Exposure: *f*-8 (shutter at 1/60 second)

Natalie Wood was as wonderful a person as she was beautiful. I'll always remember this as one of my favorite sessions. To work with Natalie was to work with a consummate actress. I was fortunate to be her *director* for a few brief hours.

The image is an example of simple, but effective, one-light photography. I like to think that I captured Natalie's beauty and sensitivity. To achieve this, good subject-photographer rapport is essential.

Natalie was sitting on the white floor of my studio for most of the session. The floor reflected the main light, filling shadows and lowering lighting contrast slightly. The reflective floor also brought out some detail in those famous dark-brown eyes.

Notice how the hand frames the picture on one side. Natalie is resting her forehead on the hand, leaving her face unobstructed. Natalie posed herself quite naturally—I was fortunate to be there, to capture the image. □

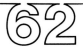

Subject: Professional models
Clients: Harper's Bazaar; Ford Motor Company; Dupont and Columbia Pictures
Art Director: Nancy Dinsmore
Location: Beverly Hills, California
Camera: Nikon F2
Lens: 35mm f-2 Auto-Nikkor
Lighting: Two 1200-watt-second Thomastrobe flash units
Film: Kodachrome 25
Exposure Metering: Nikon through-the-lens, averaging, for daylight; Minolta Auto-Flash II, incident-light mode, for flash
Exposure: 1/60 second at f-16

There were four clients for this advertising photograph. This arrangement is called a *co-op*. Each client contributes to the cost of photography and media space. Each client has his own need, which must be fulfilled photographically.

Columbia Pictures was advertising

Neil Simon's *California Suite*. So, the first consideration was to use a Beverly Hills background. The Ford Motor Company was concerned with classic shots of the new Mustangs, so the cars were positioned to show them to their best advantage. The models were positioned to display their outfits from Dupont in the best way.

The photograph was taken in midday sunlight. The sun was too high for direct illumination. I used two 1200-watt-second flash units with wide-angle reflectors. Each of the women was lit separately. The male model received *spill* light from both lights.

The overall light in the scene was metered first. This was done from camera position with my Nikon's TTL meter. It recorded 1/60 second at f-11. To eliminate the possible effect of extraneous highlights from the sun, I gave one step more exposure than the meter indicated. The flash units were set for f-16 exposure on each of the women. The male model received about 1/2 step more light.

A word of caution: When metering electronic flash in direct sunlight, remember to shield the meter's light sensor from extraneous natural light.□

Subject: Gene Kelly
Client: Jean-Paul Germain, Ltd.
Location: Beverly Hills, California
Camera: Nikon F3
Lens: 85mm *f*-1.8 Auto Nikkor
Lighting: Late-afternoon sunlight
Film: Kodachrome 25
Exposure Metering: Minolta
Auto-Flash III, incident-light mode
Exposure: 1/15 second at *f*-4

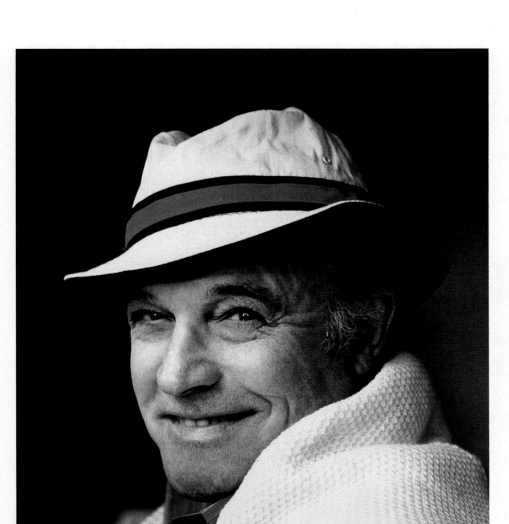

Legendary Gene Kelly is the subject of this portrait, taken for an ad for Jean-Paul Germain *Winners*. We arrived late in the afternoon. Gene was still on the tennis court, involved in a good workout.

The original plan had been to photograph indoors. So I was equipped with studio flash and had only Kodachrome 25 film. Gene's preference for outdoor photography came as a total surprise. My exposure reading indicated 1/15 second at *f*-4. Though I would have loved to make a run to my studio for some faster film, or at least a portable flash, there wasn't time. Gene had an appointment to go to—and I had to make do.

I'm not the steadiest photographer in town, and I didn't have a tripod with me. So I dug my elbows into my ribs in an attempt to steady my movement. We had time for a single roll of film before Gene had to leave.□

64

Subject: Professional model
Client: Conair, Inc.
Ad Agency: Ted Bates, Inc.
Art Director: Jack Jones
Location: Gary Bernstein Studio, New York City
Camera: Nikon F2
Lens: 55mm *f*-3.5 Micro-Nikkor
Lighting: One 1250-watt-second Rollei flash in pan reflector
Light Control: White Rocaflector
Film: Kodachrome 25
Exposure Metering: Minolta Auto-Flash II, incident-light mode, for flash; Gossen Luna-Pro, reflected-light mode, for ambient light
Exposure: 1/2 second between *f*-16 and *f*-22.

This photo is part of an ad series produced for Conair products. The art director wanted the dim lights in the make-up mirror to glow in the photograph. I took a reflected-light reading of the ambient light coming from the make-up mirror. It recorded *f*-16 at 1/4 second. A second reading was made to determine flash exposure.

I wanted to underexpose the flash by 1/2 step and overexpose the ambient light by the same amount. This would give the lighting from the make-up mirror proper emphasis in the photo. The electronic flash was set to record 1/2 second at *f*-16 on the meter. The actual camera exposure was 1/2 second between *f*-16 and *f*-22. Notice that the model and her reflection are both in sharp focus.

The flash was positioned to approximate the direction of the light coming from the make-up mirror.

When working with subjects in front of mirrors, remember you see them from both sides. Be sure that each image—the real and the reflected—is flattering. □

WHITE BACKGROUND

MIRROR WITH BUILT-IN LIGHTS

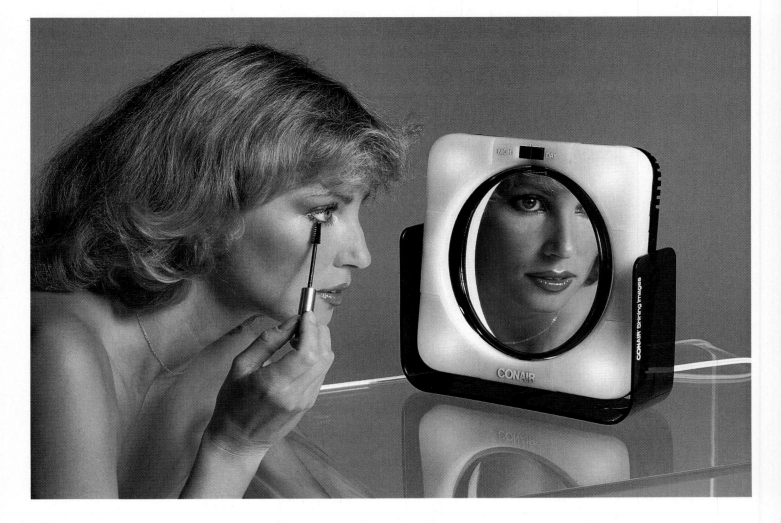

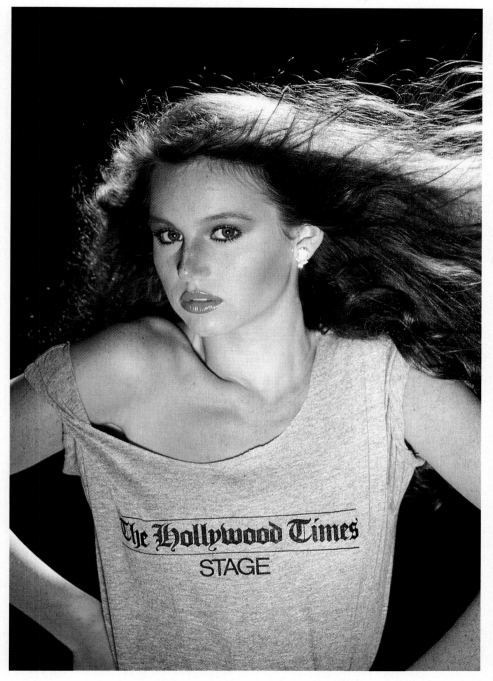

Subject: Professional model
Client: The Hollywood Times Stage
Ad Agency: Haller Schwarz, Inc.
Art Director: Tony Haller
Location: Los Angeles, California
Camera: Nikon F2AS
Lens: 85mm *f*-1.8 Auto-Nikkor
Lighting: Two 600-watt-second
electronic flash units
Light Control: Medium grid spots
Film: Kodachrome 25
Exposure Metering: Minolta
Auto-Flash III, incident-light mode
Exposure: *f*-16 (shutter at 1/60
second)

Each of the two lights used had a grid spot to confine the light to the areas where I wanted it. I wanted the illumination to fall off in areas of lesser importance.

The first light was located below the lens of my camera, on direct axis with the subject's face. The lamp was aimed between the model's face and the logo on her shirt. The grid spot caused an effective exposure falloff of three steps at waist-level.

The second source was used as a hair light to graphically separate the subject's dark hair from the background. This light was mounted on a boom stand above the subject's head. The grid spot on this lamp limited the light angle on the subject and avoided spill light on the background.

The balance between main light and hair light is largely a matter of personal interpretation. It is also affected by the subject's hair and skin coloration and the background tonality. On a light background, I would have had to overexpose the hair light by as much as three or four steps. In this case, the background was black velvet paper. The hair light had no background brightness to compete with. One step more brightness on the hair light than on the face provided the effect I wanted.

Regardless of the intensity of the hairlight, exposure is determined by metering the subject's face and exposing for it.

The subject's hair was blown by a small fan, adding movement and excitement to the photograph. □

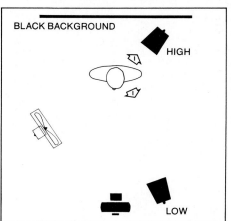

BLACK BACKGROUND
HIGH
LOW

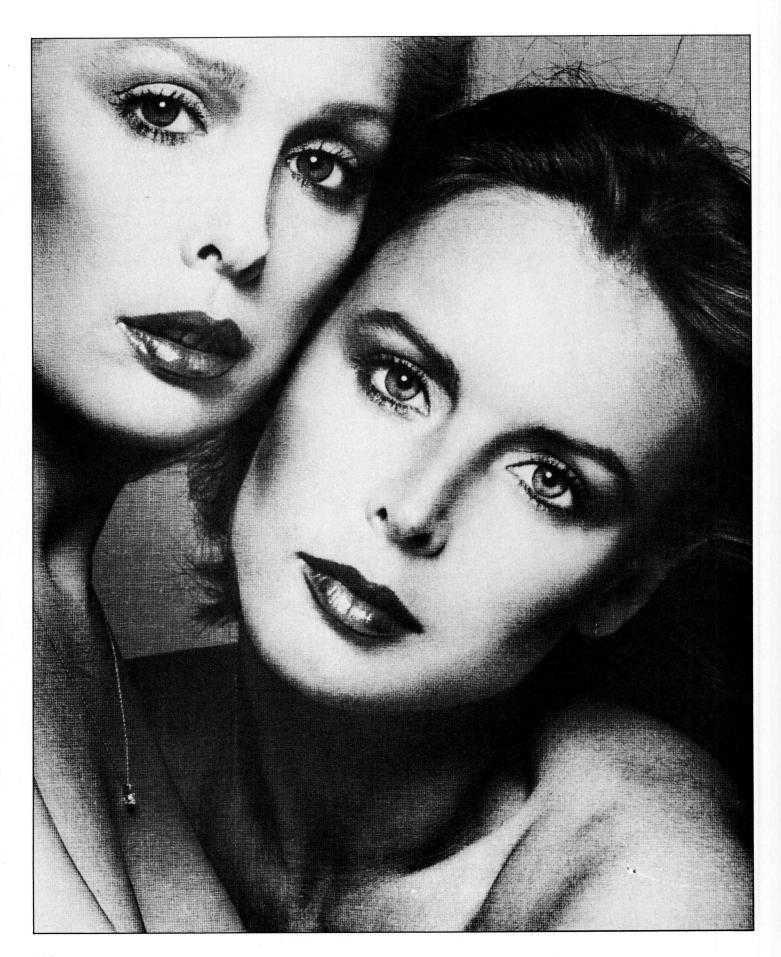

Subject: Two sisters
Location: Gary Bernstein Studio, New York City
Camera: Nikon F2AS
Lens: 85mm ƒ-1.8 Auto-Nikkor
Lighting: One 600-watt-second electronic flash in pan reflector
Light Control: Two black Larson Rocaflectors
Film: Kodak Plus-X Pan
Exposure Metering: Minolta Auto-Flash II, incident-light mode
Exposure: ƒ-16 (shutter at 1/60 second)

Kay Sutton York and her sister Jan Sutton were positioned on the floor of my New York studio for this photograph. For such situations, I keep plenty of pillows handy to raise and lower subjects with comfort and ease.

Notice the placement of the subjects' heads. Kay's eyes fall midway between Jan's eyes and lips. This arrangement, and the close pose, direct viewer attention to both subjects simultaneously. If the heads were farther apart, your eye would tend to jump back and forth between the two subjects.

There is a secondary advantage to the close pose: It's easier to use lighting that is flattering to both subjects. In this case, I noticed that Jan looked better with a lower main light than Kay. So I positioned Jan higher in the composition.

I used two black Larson Rocaflectors, one on each side of the subjects. This added some side shadows and contrast to the image. The final photograph was printed through an etching screen.□

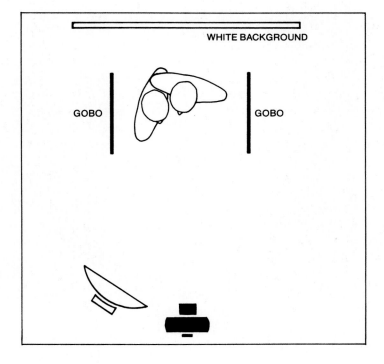

WHITE BACKGROUND

GOBO GOBO

Subject: Professional model
Location: Aruba, Netherlands Antilles
Camera: Nikon F2
Lens: 105mm *f*-2.5 Auto-Nikkor
Lighting: Diffused sunlight
Film: Ektachrome 400
Filtration: Diffusing attachment
Exposure Metering: Gossen Luna-Pro, incident-light mode
Exposure: 1/1000 second at *f*-4

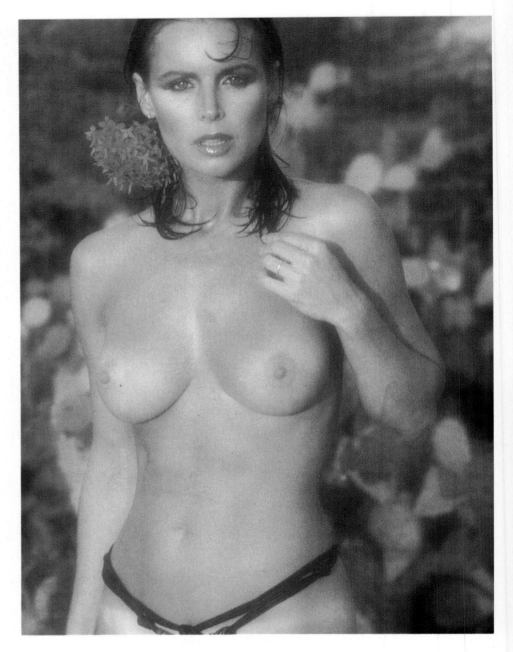

I took this photo in Aruba for my first book, *Burning Cold.* It was not used in the book, however, but was subsequently purchased by Fabergé. The flower was removed from the model's hair before the picture was used in a Fabergé ad.

The softness of the image was created by three factors: I used high-speed Ektachrome film to deliberately give the image its grainy look. A home-made lens diffuser, consisting of a UV filter sprayed with plastic fixative, added a little diffusion. A thin cloud layer in front of the sun softened the illumination.

My 105mm lens was opened to *f*-4. This provided limited depth of field, softening the background cacti to a fluffy, abstract pattern.

The beauty and grace of the model completed the sensual image. □

Subject: Jacki Sorensen
Client: Aerobic Dancing, Inc.
Art Director: Neil Sorensen
Location: Gary Bernstein Studio, Los Angeles, California
Camera: Nikon F3
Lens: 55mm ƒ-3.5 Micro-Nikkor
Lighting: One 600-watt-second electronic flash unit
Film: Kodachrome 25
Exposure Metering: Minolta Auto-Flash III, incident-light mode
Exposure: ƒ-16 (shutter at B)

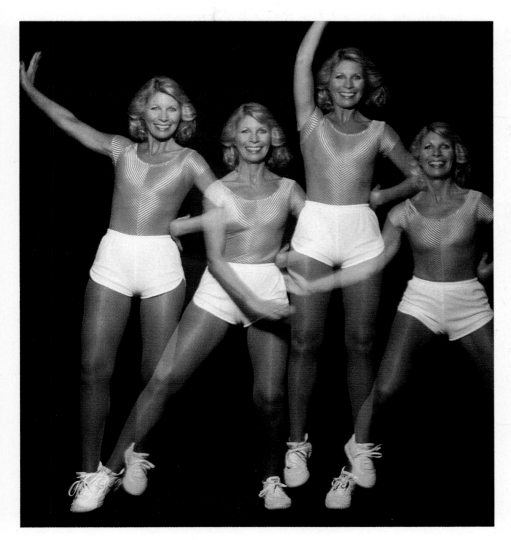

Taken as an album cover for Aerobic Dancing, Inc., this photograph of its inventor, Jacki Sorensen, is a departure into special effects.

To illustrate the form and motion of aerobics, I made four exposures on one film frame. Jacki choreographed a series of steps which would allow for final cropping into a square format for the album cover.

The studio was darkened sufficiently to ensure that only the flash would be recorded. It was essential that ambient light would not affect the film. The background was black. I used a standard lens at a small aperture to ensure total sharpness over my moving subject. I set the electronic flash for stroboscopic operation, to give rapidly repeating flashes. The image was recorded with the shutter at the B setting. Jacki's graceful movements completed the picture. □

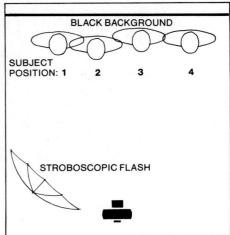

113

Subject: Professional model
Client: Conair, Inc.
Ad Agency: Ted Bates, Inc.
Art Director: Jack Jones
Location: Gary Bernstein Studio, New York City
Camera: Nikon F2AS
Lens: 55mm *f*-3.5 Micro-Nikkor
Lighting: One 1250-watt-second Rollei flash in pan reflector
Film: Kodachrome 25
Exposure Metering: Minolta Auto-Flash III, incident-light mode
Exposure: *f*-5.6 (shutter at 1/60 second)

This photograph was taken for a cover for a Conair Hair Products brochure. The single light was placed about five feet from the model. Although the shot is nearly full-length, the main consideration in light placement was the face. A light falloff of about two exposure steps accounts for the medium-gray background.

Notice that the model's arms and legs are placed parallel to the film plane. This avoids image distortion when working at close range with a standard lens.

I took two meter readings—one from the subject and a second from the background. In each case, the incident-light hemisphere was pointed toward the light source. □

The single light was at the same distance from the subject as in photograph 69. However, the light was farther from the camera, creating crosslighting on the body. This brings out the contours of the upper part of the body. It also provides classic profile lighting for the face. Because both subject and light were closer to the background than in photograph 69, the background is lighter.

The subject looks at ease. That's because the photo wasn't truly *posed* by me. I simply told the subject what I was looking for compositionally. He responded with a pose that was comfortable for him. Of course, I modified the pose slightly to suit my specific requirements. □

Subject: Professional model
Location: Gary Bernstein Studio, New York City
Camera: Nikon F2AS
Lens: 55mm *f*-3.5 Micro-Nikkor
Lighting: One 1250-watt-second Rollei flash in pan reflector
Film: Kodachrome 25
Exposure Metering: Minolta Auto-Flash II, incident-light mode
Exposure: *f*-5.6 (shutter at 1/60 second)

71

Subject: Infant
Location: Gary Bernstein Studio, New York City
Camera: Nikon F2AS
Lens: 55mm *f*-3.5 Micro-Nikkor
Lighting: One 1250-watt-second Rollei flash in pan reflector
Film: Kodachrome 25
Exposure Metering: Minolta Auto-Flash II, incident-light mode
Exposure: *f*-16 (shutter at 1/60 second)

This photograph of my youngest daughter was taken when she was three months old. My wife's beaver coat provided an attractive, as well as comfortable, base.

The only light source was one Rollei flash in pan reflector, located near the camera position. I metered it from the subject and background positions. The low light is ideal for a young face, which has not yet developed prominent features and lines.

Rules of basic composition change in the photography of children: Notice that there is considerable space above and around the baby. This emphasizes the small size of the child.

Children tend to be in constant motion and are difficult to photograph. It helps to use a motor-driven camera or a camera equipped with an auto winder. That way, you're more likely to capture that special expression. It also helps to use a small lens aperture, to be sure a moving child remains within the area of acceptable sharpness. □

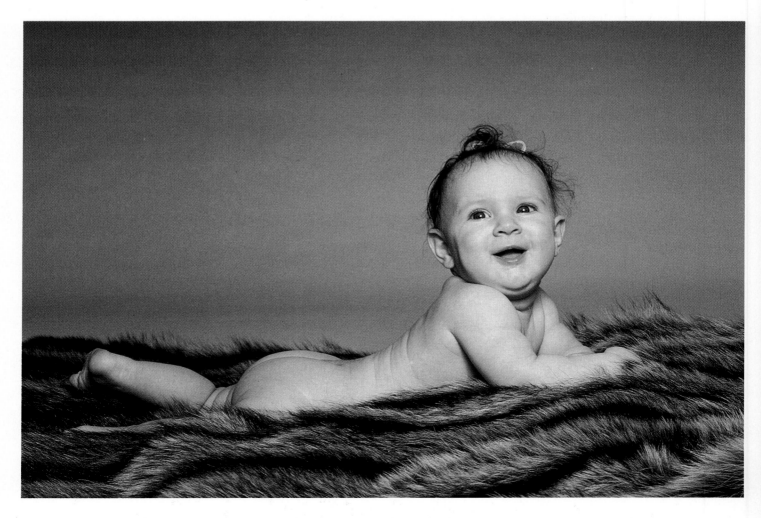

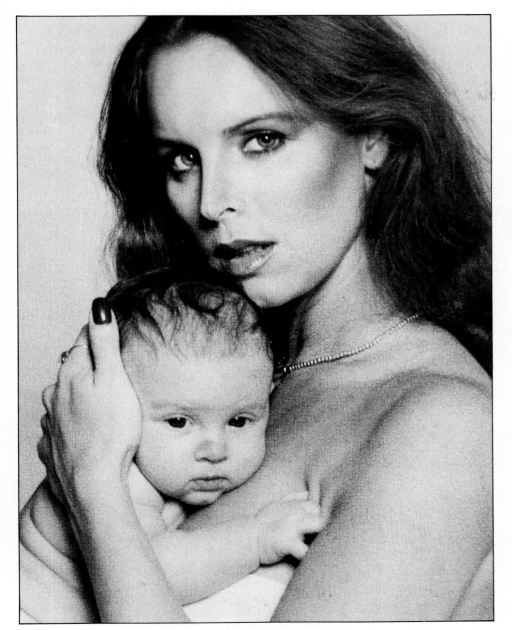

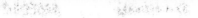

72

Subject: Mother and child
Location: Gary Bernstein Studio, New York City
Camera: Nikon F2
Lens: 85mm f-1.8 Auto-Nikkor
Lighting: One 1200-watt-second electronic flash unit, set for 200 watt-seconds and fast recycle
Light Control: Larson Rocaflector
Film: Kodak Plus-X Pan
Exposure Metering: Minolta Auto-Flash III, incident-light mode
Exposure: f-8 (shutter at 1/60 second)

Our daughter was a few weeks old when I took this photo. I wanted to simulate the softness and directional qualities of window light. I aimed a single flash head with wide-angle reflector into the middle of a white standing Rocaflector. The light came from slightly to the right of my camera.

Dialing the setting of the flash down to 200 watt-seconds, I received rapid recycling. This allowed me to use my Nikon motor drive at a fast setting to capture the infant's rapidly changing expression.

The viewer's eye cannot focus on two centers of interest at the same time, so I kept the two heads close together. This technique is appropriate for adult couples, too. However, if heads lean against each other, be sure this causes no facial distortion.

The finished photograph was printed through an etching screen to give it its aged appearance.□

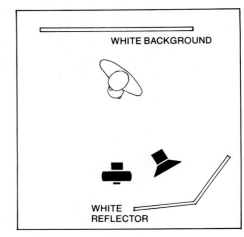

WHITE BACKGROUND

WHITE REFLECTOR

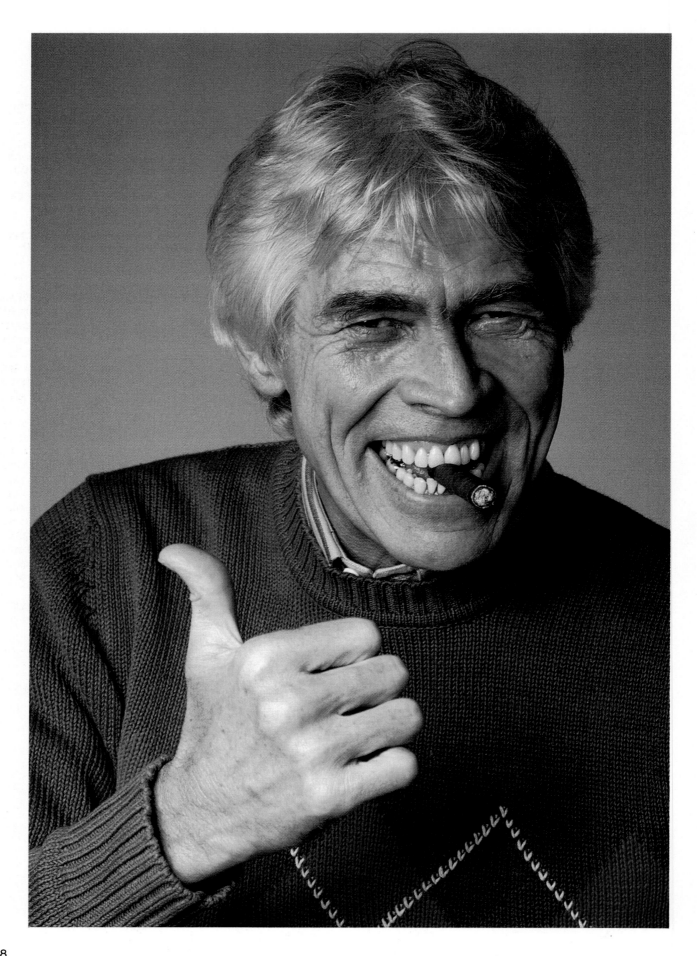

Subject: James Coburn
Client: Jean-Paul Germain, Ltd.
Location: Gary Bernstein Studio,
Los Angeles, California
Camera: Nikon F3
Lens: 105mm *f*-2.5 Auto-Nikkor
Lighting: One 600-watt-second
electronic flash in 32-inch
umbrella
Film: Kodachrome 25
Exposure Metering: Minolta
Auto-Flash III, incident-light mode
Exposure: *f*-4 (shutter at 1/60
second)

The Jean-Paul Germain *Winners* campaign has been running for years. In each situation, advertising continuity is ensured with a symbolic "thumb-up" sign.

A medium-gray background serves a useful purpose in advertising photography. It provides flexibility in type selection and a neutral background frame for *warm* skin tones. In this photo, a single light on the subject produced a two-step exposure falloff on a white background. The subject's shadow fell on the background out of camera range.

To determine exposure relationships, I placed the incident-light hemisphere of the meter at subject position and pointed it toward the single light source. I took a second reading with the meter on the background and pointed toward the light. The subject/light-source/background distances were arranged to produce the needed exposure differential.

For a close-up head shot like this, only a small background area is required. To take this kind of photo in your home, for example, a 30x40-inch piece of white cardboard would suffice as background. □

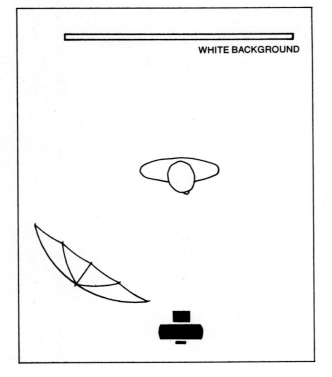

WHITE BACKGROUND

74

Subject: Professional model
Client: Esquire
Art Director: Max Evans
Location: Zuma, California
Camera: Nikon F
Lens: 105mm ƒ-2.5 Auto-Nikkor
Lighting: Direct late-afternoon sunlight
Film: Kodachrome 25
Exposure Metering: Gossen Luna-Pro, incident-light mode
Exposure: 1/250 second at ƒ-4

Masculinity is emphasized by texture. Recording texture calls for hard light sources and extreme lighting angles. Even the handsome features of this model can be enhanced by directional side lighting. Specular highlights enhance the portrait. No reflector was used to add light to the shadow side of the face. Nor do catchlights appear in the eyes. This departure from the rule was justified to create a mysterious mood and further emphasize the chiselled features of the subject.

When there's exteme contrast between the highlight and shadow areas in the subject, background tonality plays an important role in picture impact and balance. Notice that the *lighter* part of the background is behind the *shadow* side of the body. This clearly outlines the shaded side of the body. □

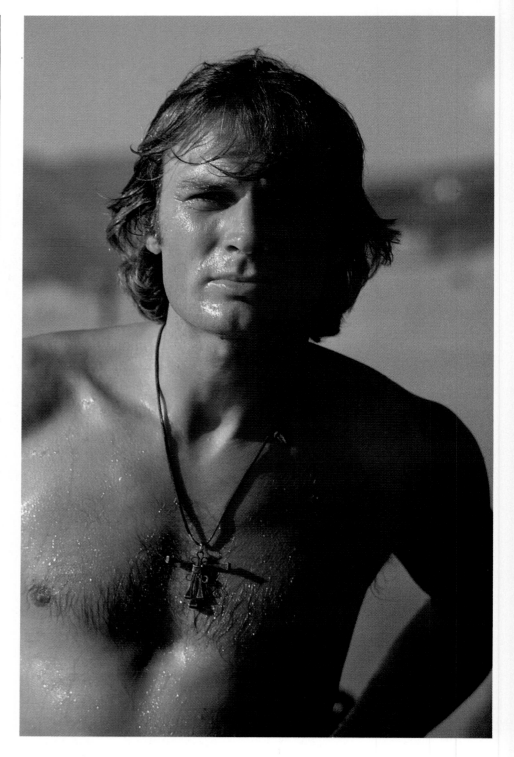

Subject: Professional model (Test session for portfolio)
Location: Gary Bernstein Studio, Los Angeles, California
Camera: Nikon F3
Lens: 105mm f-2.5 Auto-Nikkor
Lighting: One 600-watt-second electronic flash unit with four-inch reflector
Film: Kodachrome 25
Exposure Metering: Minolta Auto-Flash III, incident-light mode
Exposure: f-5.6 (shutter at 1/60 second)

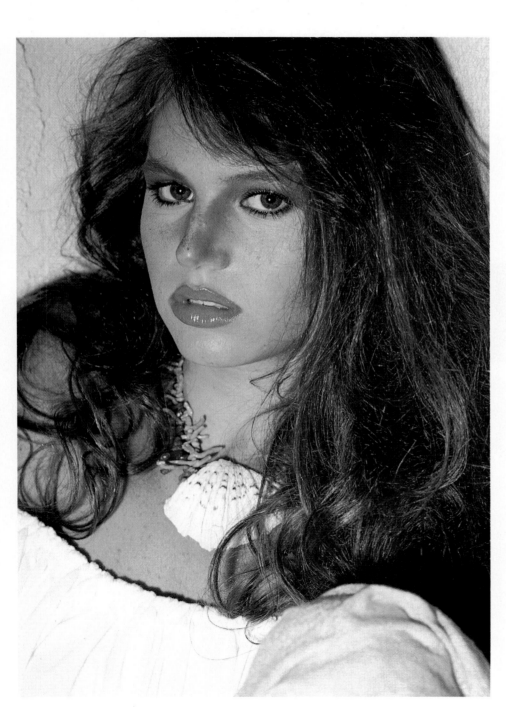

If used with care, unmodified spotlighting can be appropriate for the youthful feminine face. I placed this junior model against a stuccoed wall in my studio and lit her with a single electronic flash. The small, directional light source created glistening highlights on nose and lips. It also emphasized every eyelash and every strand of hair near the plane of the face.

The f-5.6 aperture I used provided just enough depth of field for the eyes and the facial plane to be sharp. The foreground and background are distinctly soft. Because the viewer is attracted to the sharpest part of a photograph, this technique directs your attention to the model's strong features.□

STUCCO WALL

76

Subject: Professional models
Client: Munsingwear, Inc.
Ad Agency: Haller Schwarz, Inc.
Art Director: Tony Haller
Location: Burbank, California
Camera: Nikon F3
Lens: 180mm *f*-2.8 Auto-Nikkor
Lighting: Sunlight
Film: Kodachrome 25
Exposure Metering: Minolta
Auto-Flash III, incident-light mode
Exposure: 1/125 second at *f*-11

Much time was spent positioning and directing each individual prior to photography. After placing an individual in position, I returned to my tripod-mounted camera to confer with the art director for Munsingwear. Slowly, the composition came together.

Fortunately, there are an unlimited number of groupings for any given situation. Once the overall arrangement has been determined, you can make subtle changes, as shown by these pictures. The key lies in picture balance—making sure that each individual occupies an area of equal importance in the frame.

Prior to photography we determined the atmosphere for the shot. The photo was to express lightheartedness and good-natured fun. Group sessions are extremely draining, both mentally and physically. It's imperative to control each individual's response—making sure it harmonizes with the group's overall attitude. If one person fails to respond, the photograph becomes unsuccessful. For me, a strong graphic image is always worth a little extra effort.□

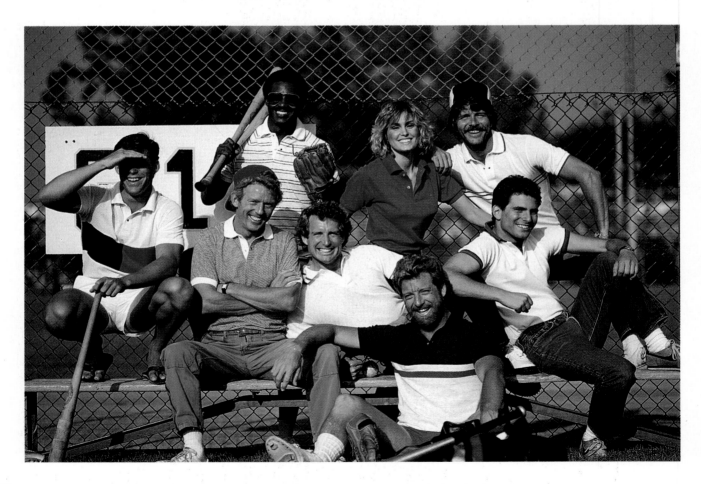

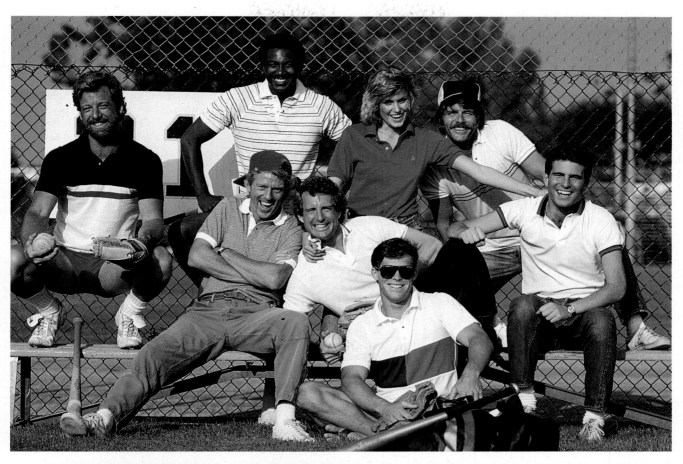

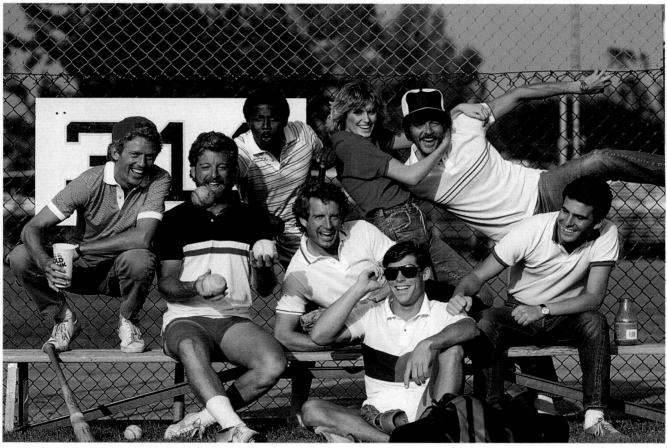

77

Subject: Catherine Bach
Client: Tugboat Productions, Inc.
Art Director: Denny Bond
Location: Gary Bernstein Studio, Los Angeles, California
Camera: Nikon F3
Lens: 300mm *f*-2.8 Auto-Nikkor
Lighting: 100-watt-second Sunpak 611 portable electronic flash
Film: Kodachrome 64
Exposure Metering: Minolta Auto-Flash III, incident-light mode, for flash; Gossen Luna-Pro, reflected-light mode, for daylight background
Exposure: 1/60 second between *f*-2.8 and *f*-4.

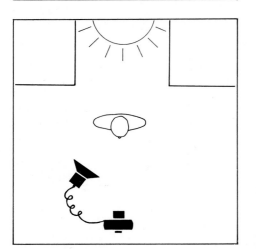

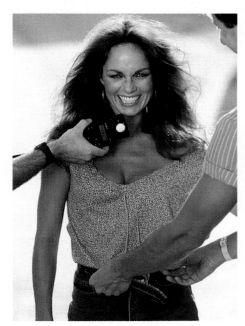

Pretty Catherine Bach is the subject of this synchro-sunlight photograph. The photo was taken at about 5:00 in the afternoon in an alley next to my studio. Catherine was positioned so the sun was behind her, at a slight angle to camera axis. With a 300mm lens, limited depth of field gave me an uncluttered background.

I used a portable flash unit as main light. Because of the limited power of the flash, it had to be considerably closer to the subject than the camera. The flash was set up on a separate stand and connected to the camera with an extra-long PC extension cord. Most camera stores carry such accessories.

Prior to determining flash exposure at subject position, I took a background reading with a reflected-light meter. In balancing flash with daylight, I deliberately overexposed the background by one full step. This helped further eliminate unwanted background detail.

The small photo shows Catherine being readied for photography as an incident-light flash-meter reading is taken. □

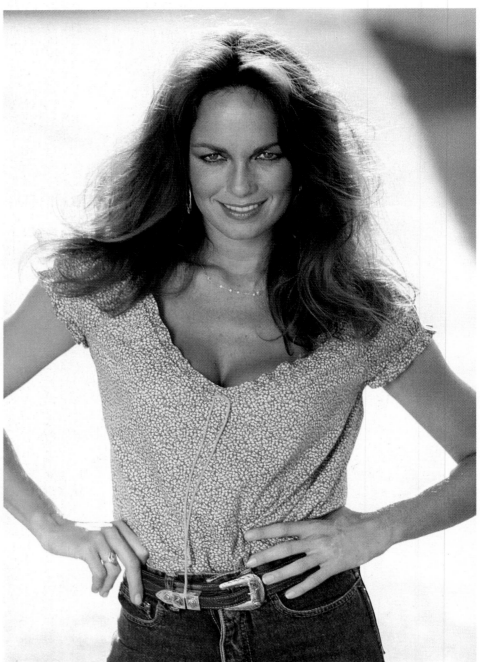

Subject: Chuck Reiser
Location: Gary Bernstein Studio,
Los Angeles, California
Camera: Nikon F3
Lens: 105mm *f*-4 Micro-Nikkor
Lighting: Three 600-watt-second
electronic flash units
Film: Kodachrome 25
Exposure Metering: Minolta
Auto-Flash III, incident-light mode
Exposure: *f*-11 (shutter at 1/60
second)

Backgrounds can be subtle, yet effective. In this close-up study of Chuck Reiser, Eastman Kodak executive, a small grid-spot, focused on the background behind the subject, directs viewer attention to the face. This highlighted background area was needed to balance with the strong rim light on the hair.

Photographic lighting is a matter of careful *addition* and, sometimes, *subtraction*. The image is *built* in stages. This photograph is a good example. With Chuck positioned comfortably, the main light was set to give the desired facial modeling. Next, the hair light was added to balance with the intensity of the main light. Finally, the background spot was added to give emphasis to the face.

The interrelationship of photographic elements, such as lighting, can't be dictated or standardized. Each subject and image is unique and should be treated as such.□

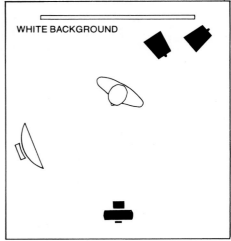

WHITE BACKGROUND

Subject: Jack Hemingway
Client: Esquire
Art Director: Max Evans
Location: Sun Valley, Idaho
Camera: Nikon F
Lens: 105mm *f*-2.5 Auto-Nikkor
Lighting: Daylight
Film: Kodachrome 64
Exposure Metering: Gossen Luna-Pro, incident-light mode
Exposure: 1/250 second between *f*-2.8 and *f*-4

Ernest Hemingway's son Jack is the subject of these two photographs taken as part of an eight-page fashion layout for *Esquire* magazine. Love of the outdoors is in the Hemingway blood. The entire layout was photographed in the woods near Jack's Sun Valley home.

The foliage around Jack tended to create pictorial confusion, hindering viewer scrutiny of the main subjects—Jack and the clothes. I selected a short telephoto lens and exposed both photos at a large aperture. Limited depth of field gave me a sharp subject, surrounded by soft trees and foliage. The classic Hemingway look completed the images. □

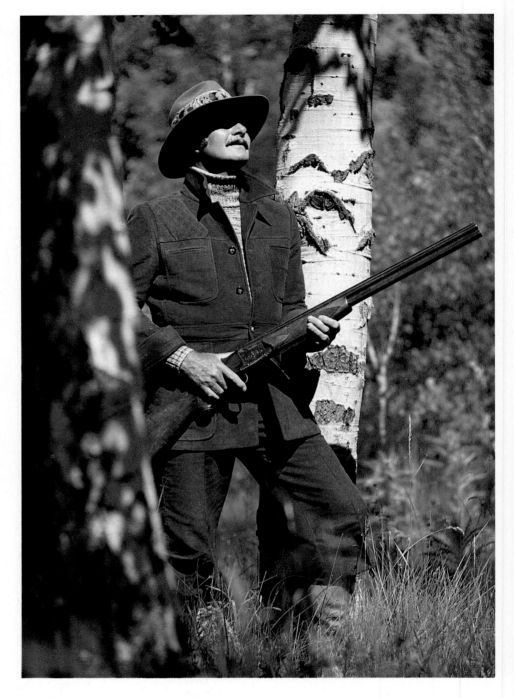

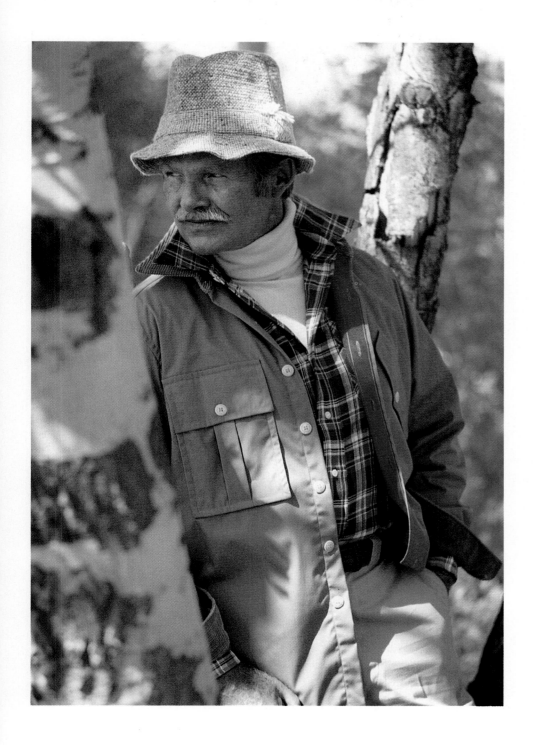

Subject: Professional model
Client: Max Factor
Art Director: Mirella Forlani
Buchanon
Location: Gary Bernstein Studio,
Los Angeles, California
Camera: Nikon F2AS
Lens: 200mm *f*-4 Auto-Nikkor
Lighting: Late-afternoon sunlight
Light Control: Silvered
Rocaflector
Film: Kodachrome 25
Filtration: Skylight filter
Exposure Metering: Gossen
Luna-Pro, incident-light mode
Exposure: 1/125 second at *f*-5.6

The model was seated in a car with her back to the late-afternoon sunlight. The car body blocks the sun and the car roof acts as a gobo, blocking much of the overhead skylight. Most of the effective illumination comes from skylight, but at a low and flattering angle.

The lighting was a little too soft, so I used a silvered reflector to the left of my camera to create more modeling and specularity in the face.

To put the background out of focus, I used a 200mm telephoto lens at a wide aperture. The camera was on a tripod. I metered the light by placing the incident-light hemisphere of my Gossen meter next to the model's face and pointing it toward the reflector. □

Subject: Jerry Mathers
Client: Family Weekly
Art Director: Robert Altemus
Location: Gary Bernstein Studio, Los Angeles, California
Camera: Nikon F3
Lens: 85mm f-1.8 Auto-Nikkor
Lighting: Three 600-watt-second electronic flash units; one 1250-watt-second electronic flash unit
Film: Kodachrome 25
Exposure Metering: Minolta Auto-Flash III, incident-light mode
Exposure: f-5.6 (shutter at 1/60 second)

I made this photo for the cover of *Family Weekly* magazine. Jerry Mathers, known for his legendary portrayal of Beaver in the T.V. series *Leave It To Beaver,* was the subject. The magazine cover related to a lead article about young children using foul language. The shot depicts Jerry's mouth being washed out with soap.

Clear, specific graphics are important in a cover layout. There must be space for the magazine logo and body type. Because of the necessary activity surrounding Jerry's face, we decided to use a white, high-key background. The backup model is dressed in white as well, so viewer attention is directed to Jerry alone. The surrounding light area is suitable for surprinting in a variety of dark tones.

Two flash units with wide-angle reflectors illuminated the white background. The main flash, in a pan reflector, was just to the left of the camera. To fill shadows and reduce overall contrast, I added a Larson Softbox to the right of camera position. The softbox added light to the backup model's white outfit, ensuring that it would record as a clean white.

Verbal communication between subject and photographer is essential in a photo session of this kind. I like to encourage my subjects constantly during the shooting. There must be a feeling of mutual confidence. There was here, as is apparent in the result. Incidentally, the Beaver's happy expression is a giveaway—indicating that whipped cream was used instead of soap.□

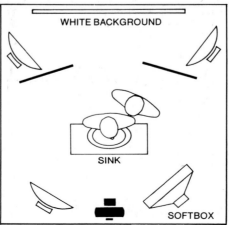

WHITE BACKGROUND

SINK

SOFTBOX

Subject: Professional model
Location: Aruba, Netherlands Antilles
Camera: Nikon F2
Lens: 105mm *f*-4
Lighting: Direct sunlight
Film: Kodachrome 25
Filtration: Diffusion attachment
Exposure Metering: Gossen Luna-Pro, incident-light mode
Exposure: 1/1000 second at *f*-4

This photograph, taken for my book *Burning Cold*, illustrates the use of direct frontal sunlight. The image is slightly soft because I used a minimal diffuser over the lens. Diffusers are most effective at large lens apertures. They are also sensitive to reflective elements around the subject. This photograph was taken at the beach, with highly reflective sand and water surrounding the subject.

Because of the brightness of the sun, I asked the subject to look away to avoid squinting. When a subject doesn't look directly at the camera, a viewer feels freer to look intently at the subject.

The temperature was nearly 100F when the photo was made. Keeping the model's hair wet would have required the use of a spray-bottle every few minutes. Consequently, we produced the wet appearance by combing baby oil through the hair prior to photography.

Notice the soft background. It consisted of a row of steps, put out of focus by the large lens aperture. This relatively uniform background lends additional emphasis to the striking subject.□

STEPS

BRIGHT SANDY BEACH

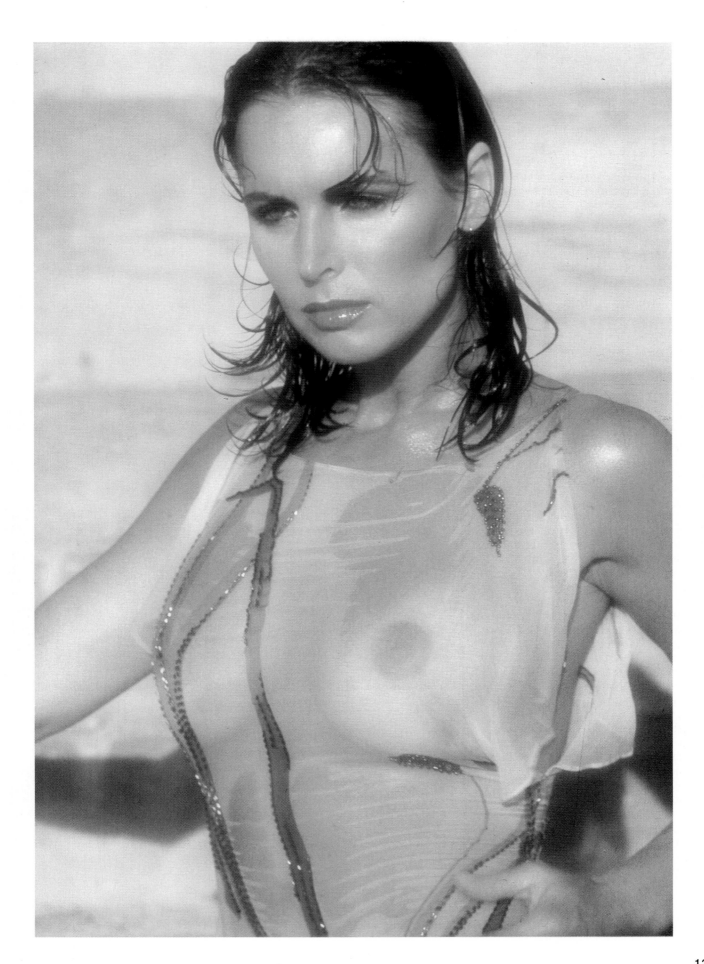

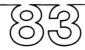

Subject: Two professional models
Client: John Weitz, Inc.
Ad Agency: Blaise Associates, Inc.
Art Director: Ceci Murphy
Location: Nyack, New York
Camera: Nikon F2
Lens: 55mm f-3.5 Micro-Nikkor
Lighting: Three 1200-watt-second Thomastrobe electronic flash units and available room light
Film: Kodachrome 64
Exposure Metering: Minolta Auto-Flash II, incident-light mode
Exposure: 1/8 second at f-5.6

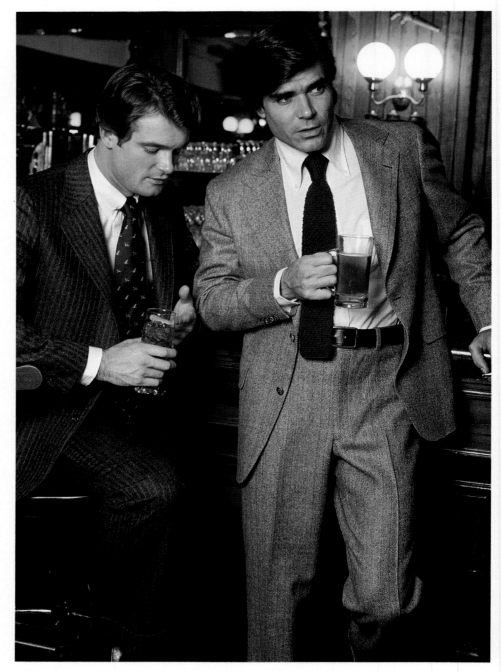

Two different color temperatures are recorded on the same film. I used Kodachrome 64 film, balanced for average daylight of about 5500K. The reddish glow in the background is caused by the tungsten room lights. Their light has a color temperature of about 3200K. On the daylight-balanced film, this light appears distinctly reddish.

The light used on the subjects was electronic flash. It's balanced for daylight and, therefore, produced accurate skin-tone rendition.

The wood paneling just below the wall lamps was very dark. To lighten that area, I placed a second flash on the floor behind the bar. To limit the light to the area where I wanted it, I used a grid spot on the flash.

In the viewfinder, I noticed the dark room reflected in the mirror behind the bar. To brighten that part of the scene, I placed a third flash unit behind the camera and aimed it at the reflected wall surface. Its effect is evident in the mirror reflection.

From the camera position, I took a reflected-light meter reading of the background wall. It indicated a tungsten-light exposure of 1/8 second at f-5.6. Each electronic flash unit was balanced for this tungsten exposure. To achieve this balance, I took incident-light meter readings from the subject position, the wall behind the subjects and the wall reflected in the mirror.□

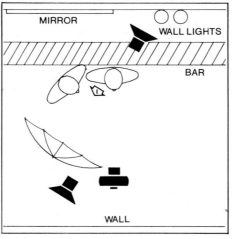

MIRROR
WALL LIGHTS
BAR
WALL

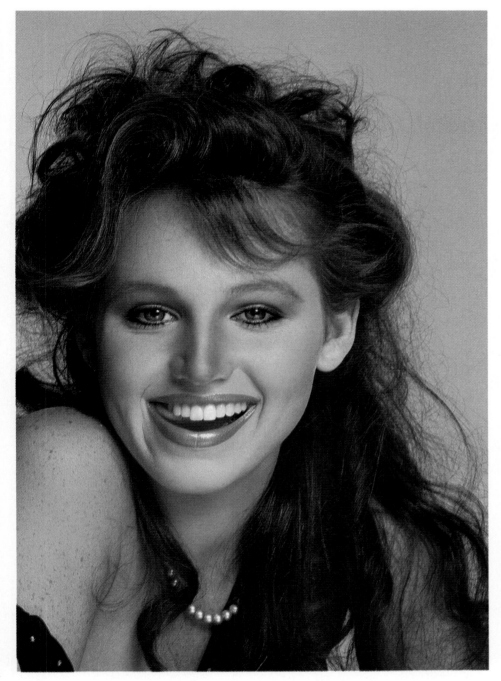

Subject: Professional model
Client: The Hollywood Times Stage
Ad Agency: Haller Schwarz, Inc.
Art Director: Tony Haller
Location: Gary Bernstein Studio, Los Angeles, California
Camera: Nikon F3
Lens: 105mm *f*-2.5 Auto-Nikkor
Lighting: Two 600-watt-second electronic flash units
Light Control: Silvered Rocaflector
Film: Kodachrome 25
Exposure Metering: Minolta Auto-Flash III, incident-light mode
Exposure: *f*-11 (shutter at 1/60 second)

This photograph—an outtake from another session—appeared on the cover of *Petersen's Photographic* magazine. It represents my oldest daughter's entry into professional modeling.

I placed a single background light with wide-angle reflector behind the subject and directed it toward a white background. The background was lit for 1-1/2 steps less exposure than the subject, to provide the medium-gray tone.

The main flash was just to the right of the camera. Some extra sparkle was added to the eyes by a silvered Rocaflector below the face.

My daughter was a little nervous at her first session. Her sparkling expression is a result of our lighthearted communication during the shooting. As we talked, I was alert to her expressions, ready to shoot at the precise right moment.□

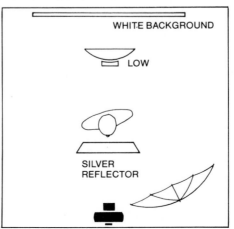

WHITE BACKGROUND

LOW

SILVER REFLECTOR

85

Subject: Four professional models
Client: The Palm Beach Company, Inc.
Ad Agency: Blaise Associates
Art Directors: Hal Dubonah and Ceci Murphy
Location: Southampton, New York
Camera: Hasselblad EL/M
Lens: 80mm *f*-2.8 Zeiss Planar
Lighting: Midday sunlight
Film: Ektachrome 64 Professional
Filtration: Hasselblad Softar I diffuser
Exposure Metering: Gossen Luna-Pro, incident-light mode
Exposure: 1/125 second at *f*-8

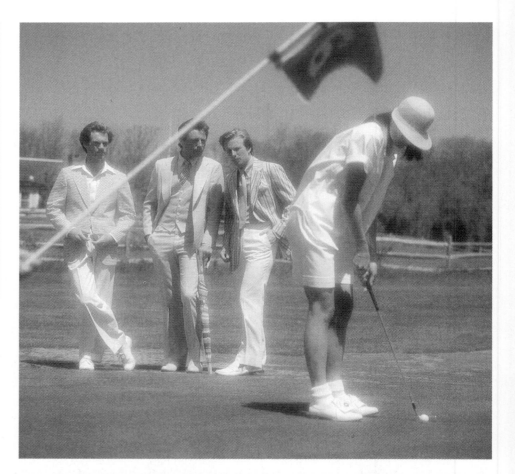

Communication between an advertising client and the photographer is critical. Prior to actual photography, however, creative discussions and decisions are only verbal. For that reason I try to shoot visual variations on a theme. I do this in case my interpretation of my client's desires differs from his actual needs. These three photographs illustrate the point.

The purpose of the photographs was to show the outfits of the three men. The woman is there only to add mood to the images. As these three photos show, compositional variations are limitless in photography.

Because the catalogue was to be printed in square format, I decided to use the 2-1/4-inch square film format. This allowed the client to view the composition in the viewfinder prior to exposure.

There are exceptions to any rule. In this case, I departed from the norm by using overhead sunlight as direct main source. The light was metered with a handheld incident-light meter. The hemisphere was pointed toward the sun. I exposed accordingly.

The client wanted an ethereal image, so I used a lens diffuser to soften the hard midday sunlight. Because of the larger film format, the diffussion did not endanger the appearance of texture and detail in the garments.□

86

Subject: Professional model
Client: Larry LeGaspi for Moonstone, Inc.
Location: Gary Bernstein Studio, New York City
Camera: Nikon F
Lens: 105mm *f*-2.5 Auto-Nikkor
Lighting: Four Thomastrobe 1200-watt-second electronic flash units
Film: Kodachrome 25
Exposure Metering: Wein Flash Meter, incident-light mode, for subject; Thomas Flash Meter, spot mode, for background
Exposure: *f*-8 (shutter at 1/60 second)

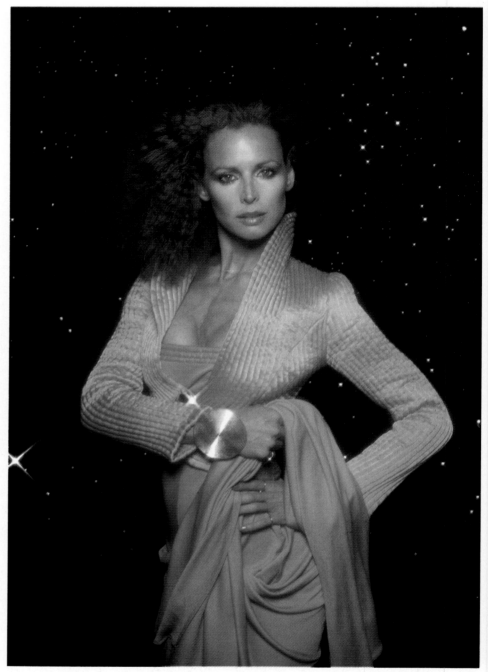

A background of stars is perfect for Larry LeGaspi's space-age fashions. The set was produced by placing white seamless paper a few feet behind black seamless paper. The latter had been punched with holes of different sizes at random locations. I placed three bare electronic flash heads between these two paper backgrounds so the entire surface of the white paper was lit. The artificial "stars" shone through the holes in the black paper.

The main illumination for the subject came from a single flash, bounced from a white 40-inch umbrella. The light was located over my camera on a boom stand. It was about 10 feet from the subject.

I took a spot-meter reading of the background to determine how much light was coming through the black paper. I also took an incident-light reading for subject exposure. The meter was at the subject's face, with the incident-light hemisphere pointed at the main light. I balanced the lights for an *f*-8 exposure.

A diffusing star-filter on the camera lens added an extra cosmic touch to this striking image. □

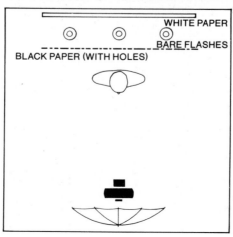

WHITE PAPER
BARE FLASHES
BLACK PAPER (WITH HOLES)

Subject: Robert Stack
Location: Gary Bernstein Studio, Los Angeles, California
Camera: Nikon F3
Lens: 105mm *f*-2.5 Auto-Nikkor
Lighting: Two 600-watt-second electronic flash units with umbrella reflectors
Light Control: Silvered Rocaflector
Film: Kodachrome 25
Exposure Metering: Minolta Auto-Flash III, incident-light mode
Exposure: *f*-8 (shutter at 1/60 second)

Legendary actor Robert Stack is the subject of this head-and-shoulders portrait. The main light source was placed about three feet to Bob's right. To his left, I placed a silvered reflector to fill in shadows and reduce contrast. A second flash lit the background.

When photographing couples, select clothing that harmonizes. In photographing individual subjects, you have greater flexibility. The main criteria are that the individual feel comfortable in the outfit and that it not detract from the the subject's face. For example, I ask subjects to avoid plaids and loud patterns and to bring a selection of solid-color outfits.

Remember that a person feels better—and generally looks better—in an outfit he likes. In the case of consummate outdoorsman Robert Stack, casual denim was ideal. □

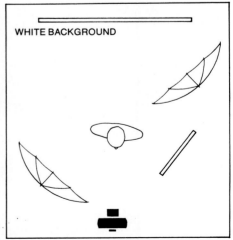

WHITE BACKGROUND

Subject: A mother and her two daughters
Location: Washington, D.C.
Camera: Nikon F3
Lens: 55mm *f*-3.5 Micro-Nikkor
Lighting: Three 600-watt-second electronic flash units
Film: Kodachrome 25
Filtration: Diffusing attachment
Exposure Metering: Minolta Auto-Flash III, incident-light mode
Exposure: *f*-8 (shutter at 1/60 second)

These three pretty ladies were photographed at a private portrait session in Washington, D.C. In preparation for the session, I painted a special "cloud" background by selectively applying white spray paint to medium-blue background paper. Blue backgrounds are wonderful for portraits. They emphasize the warmth of skin tones, giving subjects a healthy look.

My subjects were posed one at a time on the floor of the studio. When more than one person appears in a photograph, different centers of interest are created. Compositional placement becomes critical, to effectively "hold the image together" in the frame.

The mother was positioned first. She forms the base of an inverted triangle. Each daughter tilted her head toward the mother. This directs the attention toward the center of the composition. Notice that each subject is at a different height. This helps to give equal but individual emphasis to each person. To keep the composition simple, I deliberately kept hands out.

The subjects were lit with a single flash, bounced from a 32-inch silvered umbrella. Two umbrella lights illuminated the background uniformly. When more than one subject appears in a photograph, it's difficult to give ideal lighting to each. In this case, however, lighting placement was near perfect for all three.

Incidentally, the pose was not a comfortable one for the subjects. This is proof, once again, that the *best* pose is not necessarily a *comfortable* pose. □

PAINTED CLOUD BACKGROUND

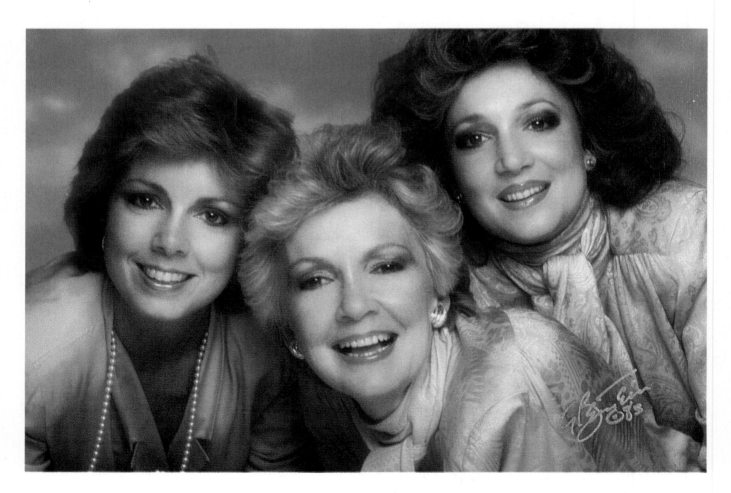

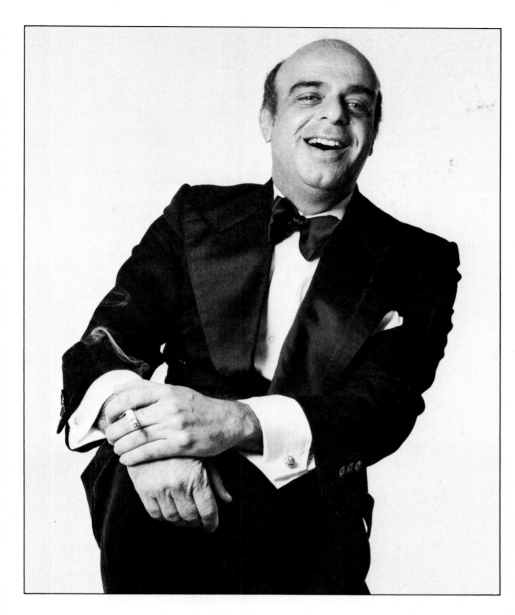

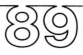

Subject: Donald Brooks
Location: Gary Bernstein Studio,
New York City
Camera: Rollei SL-66
Lens: 80mm *f*-2.8 Zeiss Planar
Lighting: Three 1200-watt-second
electronic flash units
Film: Kodak Plus-X Pan
Exposure Metering: Minolta
Auto-Flash II, incident-light mode
Exposure: *f*-16 (shutter at 1/125
second)

I describe this study of multi-talented designer Donald Brooks as "casual formal portraiture."

A single light, bounced from an umbrella, was placed high to Donald's right. It emphasizes the subject's strong character and confidence. Two lights in wide-angle reflectors illuminated the white background.

My standard lens, set at *f*-16, recorded sharp detail from the front of Donald's hands to his face. The camera viewpoint caused some distortion, the close-up hands recording rather larger than they actually are. I liked the effect—it gave emphasis to a pair of truly talented hands.

Donald was standing for the photograph, with one foot resting on a small cube. This allowed him some freedom of movement. We talked throughout the session, during the course of which I believe I captured Donald's vibrant personality well. □

WHITE BACKGROUND

HIGH

Subject: Professional model
Location: Gary Bernstein Studio, New York City
Camera: Nikon F2
Lens: 55mm *f*-3.5 Micro-Nikkor
Lighting: One 1250-watt-second Rollei flash in pan reflector
Film: Kodachrome 25
Exposure Metering: Minolta Auto-Flash II, incident-light mode
Exposure: *f*-8 (shutter at 1/60 second)

This horizontal full-length was taken for a sportswear manufacturer. It's a good example of effective single-light photography.

I positioned the subject about four feet from a white, seamless background. The light was placed about 10 feet from the subject. I needed that distance to illuminate her evenly. Generally, as a source of light is moved farther from the subject, contrast increases. This is because the light source effectively becomes smaller.

Notice that I posed the subject in such a way that all parts of her body were about equidistant from the camera. Such a pose achieves three ends: It avoids image distortion, ensures uniform image sharpness, and yields even subject illumination.□

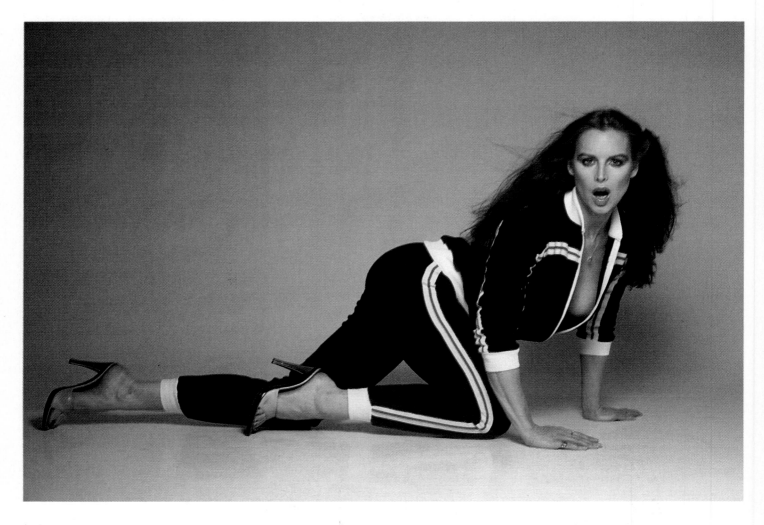

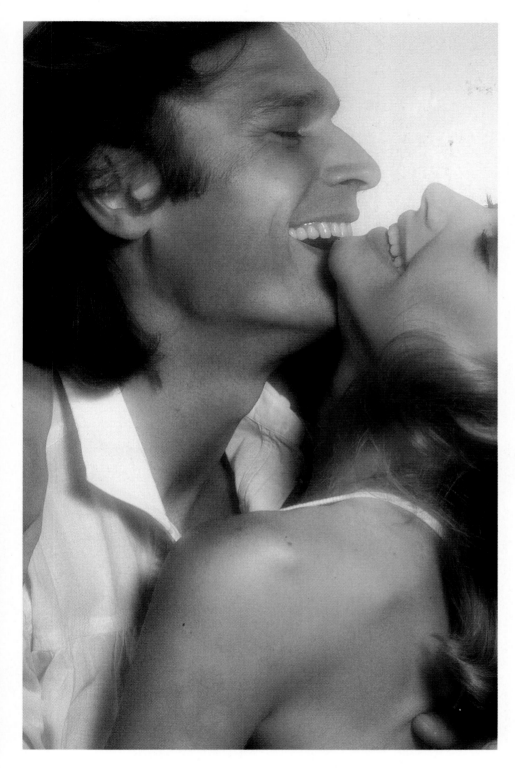

Subject: Professional models
Client: Avon, Inc.
Location: Gary Bernstein Studio, New York City
Camera: Nikon F2
Lens: 105mm ƒ-2.5 Auto-Nikkor
Lighting: Two 1200-watt-second Thomastrobe electronic flash units
Film: Kodachrome 25
Filtration: Diffusing attachment
Exposure Metering: Minolta Auto-Flash II, incident-light mode
Exposure: ƒ-8 (shutter at 1/60 second)

Mood and attitude are important in a photograph. It's the subjects who make this photograph work, because their emotion is so genuine. Many times it's best for a photographer to just let things happen naturally. However, first you must establish a solid rapport with your subjects. The rapport must be based on mutual understanding and confidence.

An experienced photographer, who's not preoccupied with technicalities, responds quickly. That is essential, if you're going to capture those rare moments. □

92

Subject: Two professional models
Client: Climax, Inc.
Ad Agency: L.A. Ad, Inc.
Art Director: Leslie Abramson
Location: Gary Bernstein Studio, Los Angeles, California
Camera: Nikon F3
Lens: 85mm ƒ-1.8 Auto-Nikkor
Lighting: One 1200-watt-second electronic flash in 40-inch umbrella
Film: Kodachrome 25
Exposure Metering: Minolta Auto-Flash III, incident-light mode
Exposure: ƒ-5.6 (shutter at 1/60 second)

These three photographs illustrate the lighting versatility possible with a single light source.

For the photo on this page, the light was aimed at the models from a frontal position. This provided soft subject lighting and slight shadows on the background. For the other two photos, the light source was raised. In the left photo on the opposite page, the light was pointing down at a 60° angle from the horizontal.

As a light is raised, it must be aimed downward more. This causes the background to record darker. In the photo at far right, the light is almost directly above the models' heads. The eyes are in deep shadow. The background is a dark gray. Although this is an extreme departure from normal lighting rules, I thought it was justified. The outfits are recorded with tremendous impact and depth. The image also has an attractive air of mystery.

Experimentation is the ultimate key to good lighting. When you see something you like—use it. □

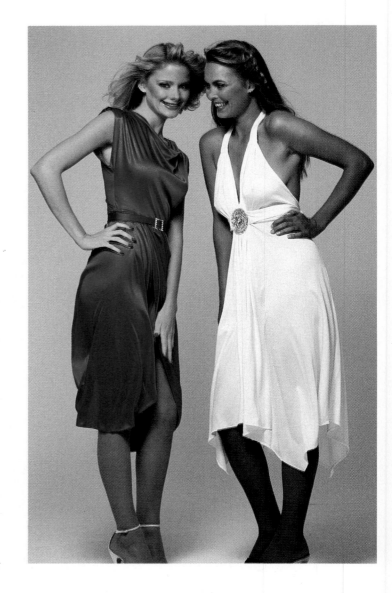

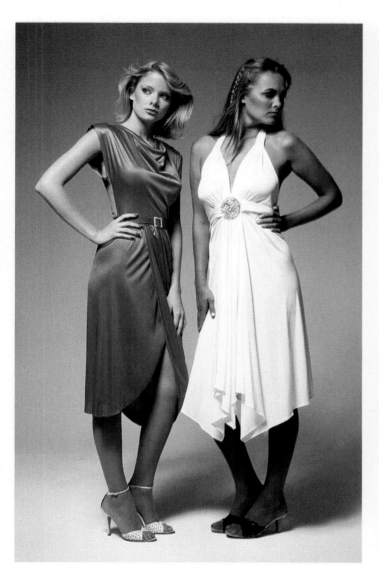

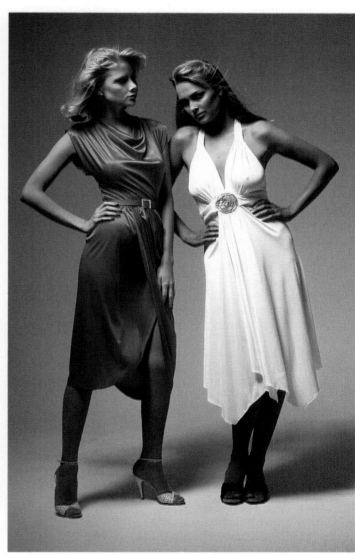

Subject: Lee Majors
Client: Tugboat Productions, Inc.
Location: Los Angeles, California
Camera: Nikon F3
Lens: 105mm f-2.5 Auto-Nikkor
Lighting: Three 600-watt-second electronic flash units
Light Control: Silver Rocaflector
Film: Kodachrome 25
Exposure Metering: Minolta Auto-Flash III, incident-light mode
Exposure: f-16 (shutter at 1/60 second)

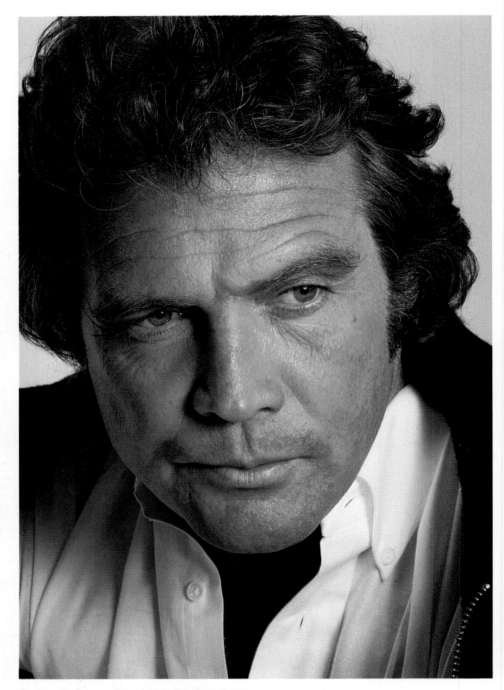

This photograph of super talent Lee Majors is not a *posed "candid."* It is a *real candid* shot. I was making promotional pictures for the television show *The Fall Guy.* While we were in conversation, Lee momentarily looked away. I *stole* the shot without his awareness. His attitude is totally genuine.

You can see Lee Majors as you have never seen him before. There is no eye contact. The subject is apparently unaware of your scrutiny. This enables you to study him without any feeling of self-consciousness.

I used a single main light, bounced from a 40-inch silver umbrella. It was slightly to the right of the camera and a little higher than the camera. To provide a uniformly bright background, I used two background lights of equal intensity.

By placing a silver Rocaflector on the shadow side of Lee's face and partially behind him, I achieved subtle edge lighting on the right side of his face. This helped to emphasize his strong, angular features.

As you move closer to a subject, depth of field decreases. I want to shoot without concern for accurate focus so that I can concentrate on the subject. Therefore, I choose an aperture setting that gives adequate depth of field. In this case, I shot at f-16. This gave enough depth of field to allow for some subject movement without losing sharpness. □

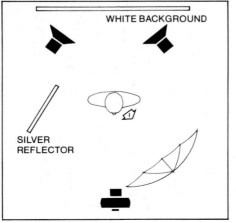

WHITE BACKGROUND

SILVER REFLECTOR

Subjects: Bjorn Borg, Vitas Gerulaitis, John McEnroe
Client: Jean-Paul Germain, Ltd.
Location: New York City
Camera: Nikon F3
Lens: 55mm ƒ-3.5 Micro-Nikkor
Lighting: One 1200-watt-second electronic flash unit
Film: Kodachrome 25
Exposure Metering: Minolta Auto-Flash II, incident-light mode
Exposure: ƒ-8 (shutter at 1/60 second)

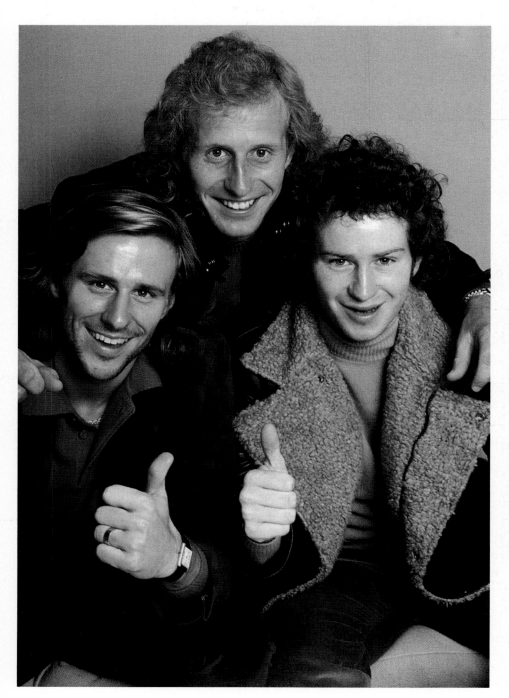

Three of the greatest names in tennis were united in this ad. Because their time was limited, the entire session took no more than 15 minutes. The photograph was taken in the executive offices of Jean-Paul Germain. The subjects were seated on a sofa in front of a wheat-colored wall covering. I used a single flash, bounced from a 32-inch silvered umbrella.

To maintain a balanced exposure on all three, the main light was pulled back to camera position, about eight feet from the men. I used a standard lens to maintain sufficient depth of field. This ensured a sharp image, even with some subject movement.

When several subjects appear in the frame, it's important to place them to receive equal graphic emphasis. The three heads were about the same distance from the camera and the distance between the heads was about equal. The eyes of the three are at different levels, to create a pleasing composition.

The importance of subject-photographer rapport can't be overemphasized. And, in situations where time is limited, it's critical to establish the rapport quickly. As I recall, we four started singing a current advertising jingle together. The result couldn't have turned out better. □

95

Subject: Professional model
Location: Gary Bernstein Studio,
New York City
Camera: Nikon F
Lens: 55mm *f*-3.5 Micro Nikkor
Lighting: Four 1200-watt-second
Thomastrobe electronic flash units
Film: Kodachrome II
Exposure Metering: Wein flash
meter
Exposure: *f*-8 (shutter at 1/60
second)

This photograph was taken for my
first studio promotional poster in New
York.

The background consisted of
translucent fabric, supported on an
8x10-foot wooden frame. About two
feet behind this frame, I placed white
seamless background paper. I placed
three electronic flash units with wide-
angle reflectors between the frame
and the seamless paper. They illu-
minated the seamless paper
uniformly. A soft main light was near
the camera position.

Notice the placement of the door in
the composition. It was positioned to
graphically frame the subject and
separate the light dress from the
bright background. □

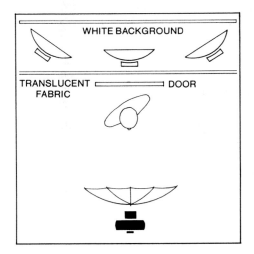

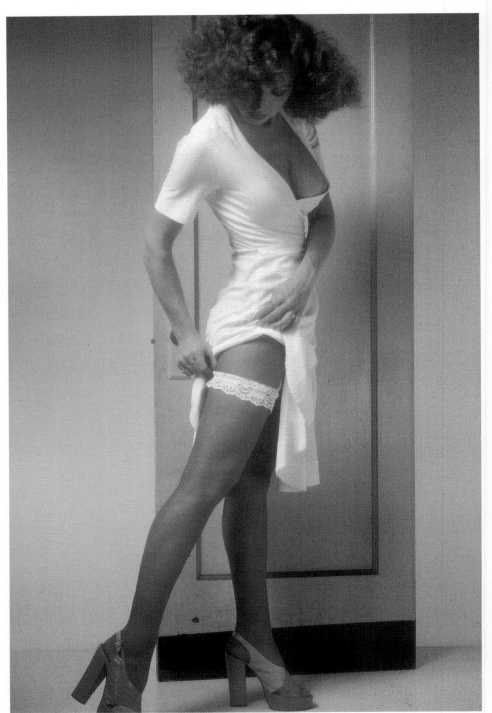

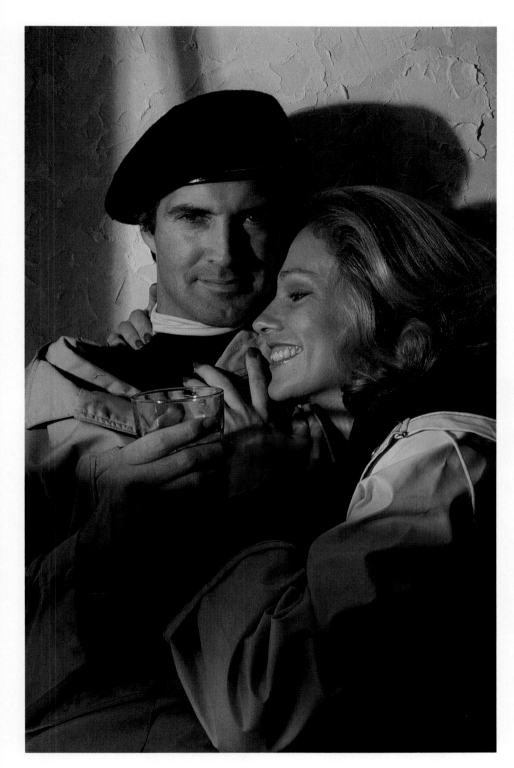

Subject: Two professional models
Client: A liquor manufacturer
Location: Gary Bernstein Studio,
New York City
Camera: Nikon F2
Lens: 105mm *f*-2.5 Auto-Nikkor
Lighting: One 1250-watt-second
Rollei Pan-Light
Film: Kodachrome 64
Filtration: Yellow filter
Exposure Metering: Minolta
Auto-Flash II
Exposure: *f*-11 (shutter at 1/60
second)

The studio environment allows for total photographic control. In this photograph, the client wanted to simulate an outdoor scene taken during late afternoon sunlight. I placed my single light source at a low angle to the subjects and at a distance of about 10 feet. It created long shadows on the stucco background.

I placed a ladder between the light and the subjects, to provide secondary shadows that did not affect the faces and the glass. A yellow filter was used, to approximate the color of late-afternoon light.

Because I was shooting transparency film, I metered the highlights with a flash meter on incident-light mode. I took one reading from the right side of the man's face and a second from the glass, to balance exposure. A third reading was taken in the shadow created by the ladder to determine that there was sufficient light to render details in the shadow areas. □

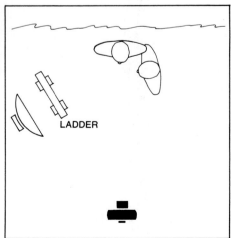

LADDER

Subject: John Schneider
Client: CBS Television
Location: Los Angeles, California
Camera: Nikon F2AS
Lens: 85mm *f*-1.8 Auto-Nikkor
Lighting: One 600-watt-second electronic flash unit
Light Control: One silver Rocaflector
Film: Kodachrome 25
Exposure Metering: Minolta Auto-Flash III, incident-light mode
Exposure: *f*-16 (shutter at 1/60 second)

The main light source was placed far enough to the right of TV star John Schneider to create *angular* lighting. This emphasizes John's strong features. The main light was also placed relatively high. Notice the length of the nose shadow. It touches the top of the upper lip.

I positioned the silver side of a Rocaflector under the main light to create a second set of catchlights in the eyes. The carefully lit light-colored hat helped to separate John from the dark background.

Dark-haired subjects can also be photographed against black. However, it involves using a secondary light source above or behind the subject to create rim lighting on the hair. This bright outline separates the subject's head from the background. □

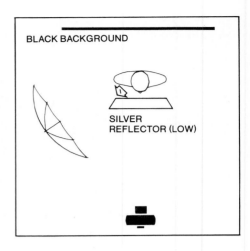

BLACK BACKGROUND

SILVER REFLECTOR (LOW)

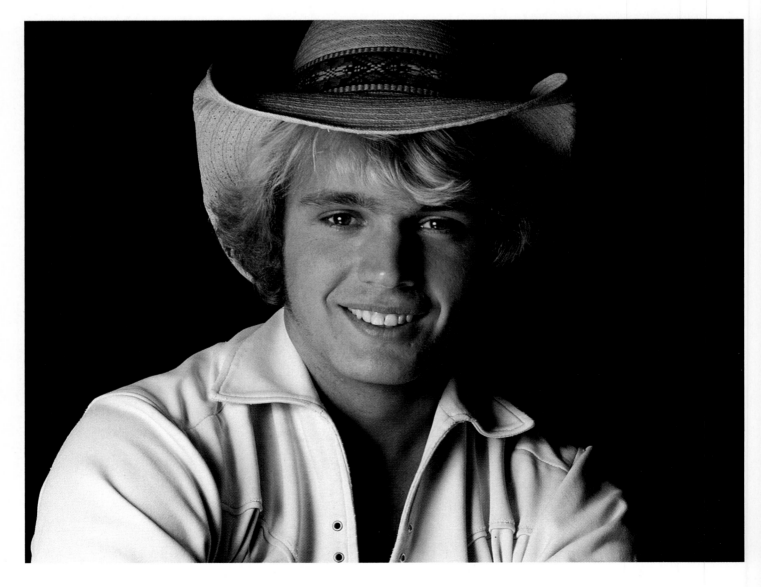

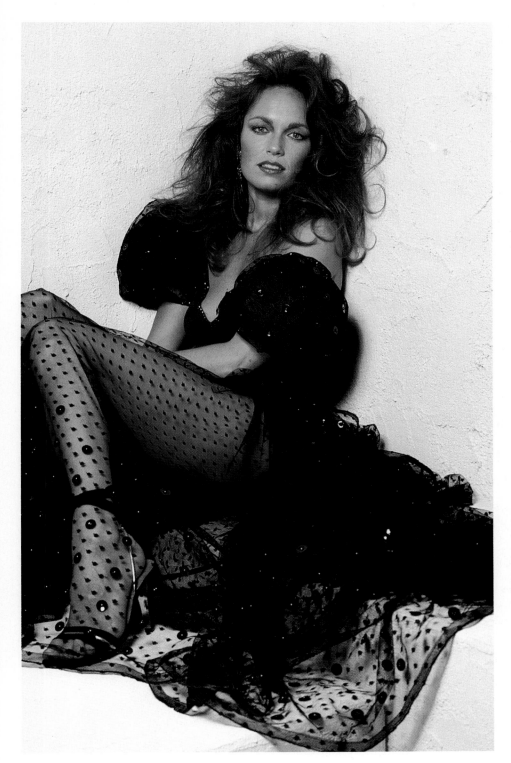

Subject: Catherine Bach
Client: Tugboat Productions
Art Director: Denny Bond
Location: Gary Bernstein Studio, Los Angeles, California
Camera: Nikon F3
Lens: 55mm ƒ-3.5 Micro-Nikkor
Lighting: One 1200-watt-second electronic flash unit
Light Control: Larson 27-inch Silvered Reflectasol
Film: Kodachrome 25
Exposure Metering: Minolta Auto-Flash III, incident-light mode
Exposure: ƒ-8 (shutter at 1/60 second)

Glamorous Catherine Bach needed a new series of publicity photographs. Shown is one photograph from a day that included six wardrobe changes and numerous location and lighting changes.

The beauty of full-figure, single-light photography is clear in this photo. Effective lighting is not dependent on complexity but on accurate light placement.

To emphasize the graphic S-curve of the body, I posed Catherine against a light, stucco wall in my studio. The stucco also harmonizes with the Spanish style of the wardrobe.

I placed the single light just to the left of the camera, about eight feet from the subject. I took an incident-light reading, placing the meter's hemisphere at Catherine's face and pointing it toward the light. A second reading was taken from the subject's leg. The light was set to fall off 1/2 an exposure step between face and leg. This added emphasis to the face.□

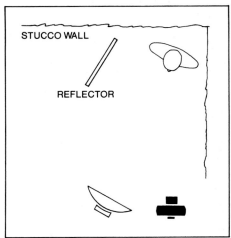

STUCCO WALL

REFLECTOR

99

Subject: Professional models
Clients: Sport Magazine and Style Auto, Inc.
Art Director: Max Evans
Location: Ontario Raceway, Ontario, California
Camera: Nikon F3
Lens: Left photo—35mm ƒ-2 Auto-Nikkor
Right photo—300mm ƒ-2.8 ED-Nikkor
Lighting: Direct midday sunlight
Film: Kodachrome 64
Exposure Metering: Through-the-lens, center-weighted
Exposure: 1/500 second at ƒ-4

These two group photos appear candid and spontaneous because the subjects are not looking at the camera. The pair of photos also shows that one scene can be shot in very different ways.

The photo at far right was taken with a long telephoto lens to emphasize the colorful subjects against a soft, blurred background. To keep each subject in sharp focus within the limited depth of field, I placed each individual at an almost equal distance from the camera.

The photo at right, which maintains the candid feeling of the scene, was shot with a wide-angle lens and from a high camera angle. To make the photo, I stood on the top of my car. The distance between the nearest and farthest subject was about six feet. I directed subject placement from the camera position. Only from there could I assess the perspective distortion that would be recorded on film.

To give prominence to the individuals in dark outfits, I placed them against the red Porsche 935. Had I placed them against the dark asphalt raceway, the subjects would have merged with the similar tonality of the background. □

Subject: Professional model
Client: Conair, Inc.
Ad Agency: Ted Bates, Inc.
Art Director: Jack Jones
Location: New York City
Camera: Nikon F2AS
Lens: 85mm *f*-1.8 Auto-Nikkor
Lighting: One Rollei 1250
electronic flash unit
Film: Kodachrome 25
Exposure Metering: Minolta
Auto-Flash III, incident-light mode
Exposure: *f*-16 (shutter at 1/60
second)

In a basic, single main-light setup, blondes look best against a dark background. Here, the light hair is framed against black.

The subject was asked to recline on black seamless paper. The main light source was a single Rollei 1250 electronic flash with a 14-inch flat-pan reflector. I placed it about five feet from the subject and slightly to her right. The light was almost frontal to her face, which was angled away from the camera slightly. Minimal facial surface texture is recorded.

The hemisphere of my handheld incident-light flash meter was located at the right side of the model's face. I pointed it toward the main light to measure highlight value. I selected the maximum power setting of the flash unit. This enabled me to stop down the lens for extensive depth of field. Everything from the nose to the back of the hair is sharp.

Notice the low position of the mainlight, relative to the face. The nose shadow did not reach the mouth, allowing the full shape of the lips to record without obstruction. □

BLACK BACKGROUND

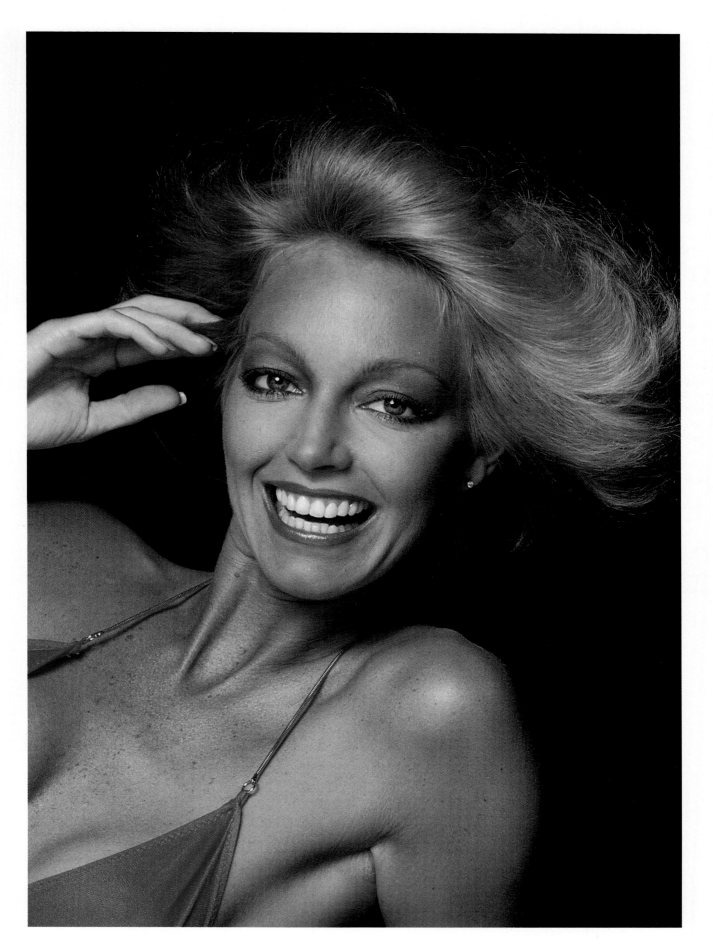

101

Subject: Professional model
Client: Pro Arts, Inc.
Location: Beverly Hills, California
Camera: Nikon F3
Lens: 85mm ƒ-1.8 Auto-Nikkor
Lighting: Direct late-afternoon sunlight
Film: Kodachrome 64
Exposure Metering: Gossen Luna-Pro, incident-light mode
Exposure: 1/250 second at ƒ-11

Taking photographs under the branches of a tree often leads to disappointing results. Patches of light and shade appear on faces where uniform illumination *seemed* to exist. The human eye has an uncanny way of ignoring such irregularities. Film, on the other hand, will record them all. To make things worse, most films exaggerate the contrast the eye sees.

Learn to see subtle differences between light and shade. It will often make the difference between an attractive photograph and a total failure.

In this case, considerable time was spent selecting the best subject position. Notice that the subject's face is lit uniformly by the sun while there's an interplay of light and shade over the rest of the scene.

Exposure was determined by placing my Gossen Luna-Pro meter next to the model's face and pointing the incident-light hemisphere into the direct late-afternoon sun.□

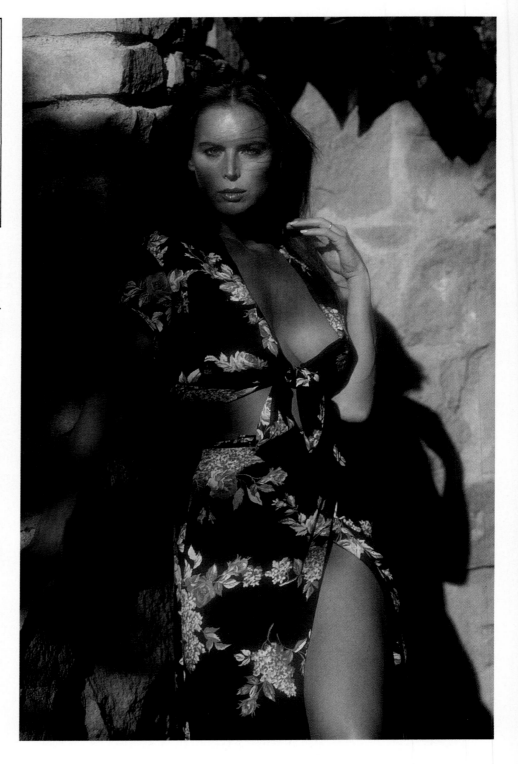

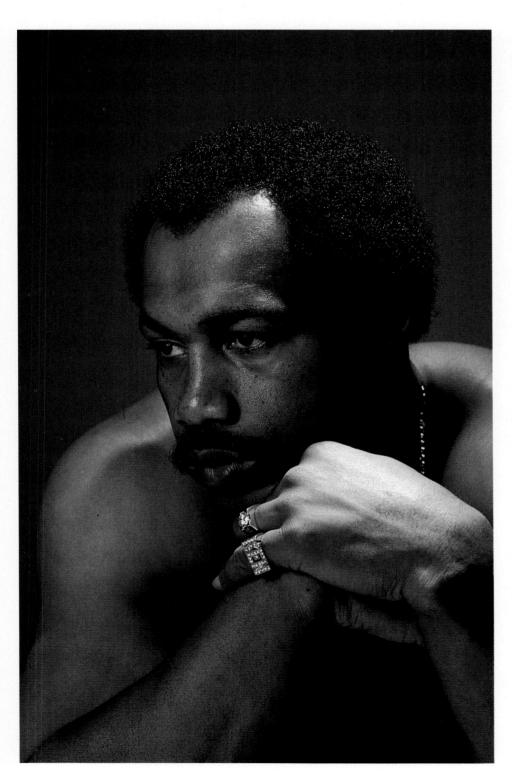

102

Subject: Ken Norton
Client: Rogers and Cowan, Inc.
Location: Gary Bernstein Studio, Los Angeles, California
Camera: Canon F-1
Lens: 100mm *f*-4 FD Macro
Lighting: Two 600-watt-second electronic flash units
Film: Kodachrome 25
Exposure Metering: Minolta Auto-Flash III, incident-light mode
Exposure: *f*-8 (shutter at 1/60 second)

In this photo, I wanted to emphasize the fist size of boxing champion Ken Norton. I achieved this by special hand placement and special lighting.

Rather than turning Ken's hands to show the fingers in a graceful manner, I directed the back of the hand toward the camera. This emphasized the man's power.

The eye is attracted to contrast. The lightest area of a dark, low-key photograph is usually the *face,* where viewer attention is intended to go. For this photo, I used a grid spot on a 600-watt-second flash unit to isolate the *hand* with light. The lamp was on a boom stand behind Ken. Facial lighting was provided by a second 600-watt-second flash, bounced from a 40-inch umbrella.

The exposure reading was between *f*-11 and *f*-16 on the hand and *f*-8 on the face. I exposed at *f*-8. This overexposed the hand by 1-1/2 steps.☐

HIGH

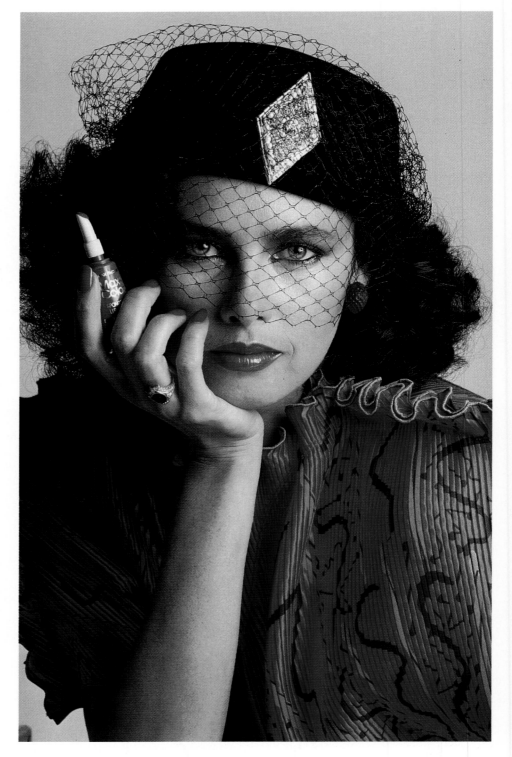

103

Subject: Professional model
Client: Max Factor, Inc.
Ad Agency: Wells, Rich and Greene, Inc.
Art Director: Bob Cole
Location: Hollywood, California
Camera: Nikon F2AS
Lens: 105mm *f*-2.5 Auto-Nikkor
Lighting: One 1250-watt-second electronic flash unit and one 1200-watt-second electronic flash unit
Light Control: White Rocaflector
Film: Kodachrome 25
Exposure Metering: Minolta Auto-flash III, incident-light mode
Exposure: *f*-8 (shutter at 1/60 second)

I had no choice but to include a hand in this shot for a Max Factor ad. The client required it! I did have a choice, however, as to its placement in the frame, its postion and the way in which it was lit.

The viewer's eye is attracted to the main subject rather than the hand. That's because the hand is on the shadow side of the image. The hand was carefully placed to create a smoothly curved, partial frame for the face. The femininity of the pose is enhanced by an exaggerated bend in the wrist and the loose, extended line of the fingers.

A Rollei pan reflector was used on the single main-light source. The result was a soft, yet directional light. To fill shadow areas and lighten the model's blue eyes, I put a white reflector below her face. A second light, with a four-inch wide-angle reflector, was placed behind the model and aimed at the white background. It was carefully positioned to record as light gray with the *f*-8 exposure.□

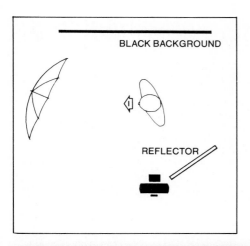

BLACK BACKGROUND

REFLECTOR

104

Subject: Hans Prauser, architect
Client: A liquor advertiser (Test session)
Location: Washington, D.C.
Camera: Nikon F
Lens: 105mm *f*-2.5 Auto-Nikkor
Lighting: One Thomastrobe 1200-watt-second electronic flash unit
Light Control: White cardboard reflector
Film: Kodachrome 25
Exposure Metering: Wein Flash Meter, incident-light mode
Exposure: *f*-11 (shutter at 1/60 second)

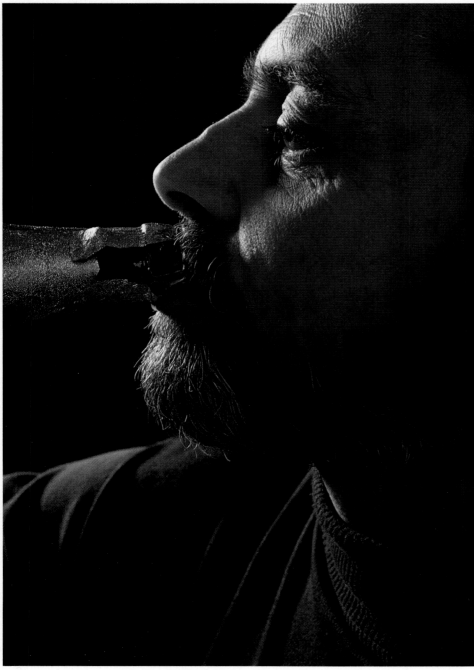

Hans Prauser, chief architect for the General Services Administration, U.S. Government, is the subject of this dramatic profile portrait. Prauser's body was turned slightly toward the camera. This provided solid graphic support for his head.

The main light was a single 1200-watt-second electronic flash. It was bounced from a 40-inch white umbrella, located in front of the subject and slightly to his right. This provided dramatic rim lighting to the nose, forehead, beard and part of the cheek.

Eye placement is critical. If a profile is a precise side view, the eye appears devoid of color and life. While looking through the viewfinder, you must instruct your subject to look slightly toward the camera direction. The iris of the eye should appear centered in the eye socket.

A white cardboard reflector, taped to a lightstand, added just enough fill light to the near, shadow side of the face. The lighting was metered by placing the meter at the tip of the subject's nose and pointing the incident-light hemisphere toward the main-light source. □

105

Subject: Professional model
Location: New York City
Camera: Nikon FM
Lens: 105mm f-2.5 Auto-Nikkor
Lighting: Window light
Light Control: Silvered Rocaflector
Film: Kodachrome 64
Filtration: Skylight filter
Exposure Metering: Nikon through-the-lens, averaging
Exposure: 1/60 second at f-5.6

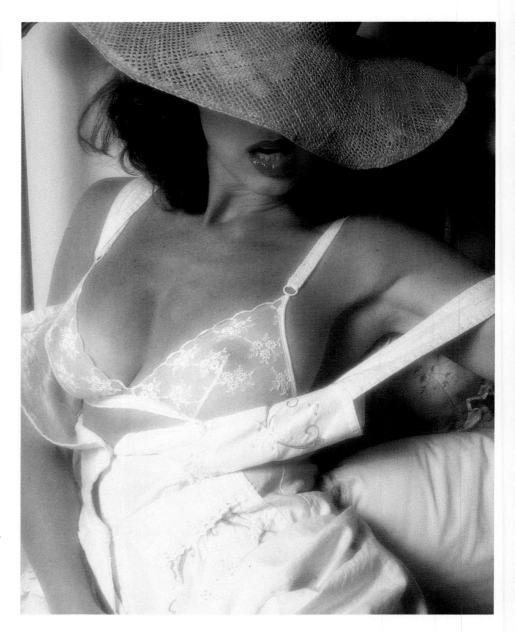

Soft, directional window light entered from the subject's right. Shadows were brightened by a large silvered reflector, placed to her left. The window was too low to produce a suitable lighting angle for good facial modeling. So I placed the hat seductively over the model's eyes, allowing only the bottom of the face to show.

Learn to visually evaluate lighting. Look for contrast and lighting angle, so there are no surprises when the film is processed. I could see the evenness of the light produced by the source and the reflector. These conditions are ideal for a camera's TTL metering system, which I used for this photograph.

To maintain sharpness throughout the image, I needed an aperture of about f-5.6. With Kodachrome 25 film, this would have required a shutter speed slower than 1/30 second. I was working without a tripod and don't feel confident handholding the camera at such a slow shutter speed. So, I switched to the faster Kodachrome 64 and increased the shutter speed to 1/60 second. □

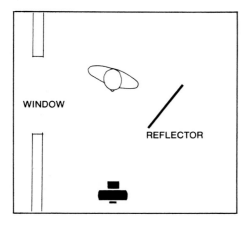

WINDOW

REFLECTOR

Models Appearing in this Book

The professional models and other subjects who are not named on the picture pages are listed below. I want to express to each of them my sincere gratitude.

COVER:

Large photo—Kay Sutton York

Film strip (left to right) —

Chad Deal, Kalani Durdan, Finele Carpenter;

Kristi Welch, Tina Wilson;

Tom Wompat, Randi Brooks;

Ben Vereen;

Kevin McLean, Chad Deal

ESSAY FIVE:

5-2	Ted Dawson
5-5	Evelyn Kuhn
5-6	Kay Sutton York
5-10	Uva Harden (with Victoria Principal)
5-11	Uva Harden (with Margaux Hemingway)
5-13	John MacMurray, Janice Johnson
5-14	Matt Collins, Cathy Cachow
5-15	Kay Sutton York, Matt Collins, Core

PORTFOLIO:

1	Kay Sutton York
2	Finele Carpenter
4	Kay Sutton York
5	Zacki Murphy, Giles Kohler
7	Caron Bernstein
9	Kay Sutton York, Scott MacKenzie
11	Kay Sutton York
12	Christie Claridge (with Lee Majors)
14	William Bumiller, Michael Lemon, Dan Grimm, John Macchia, Charlie Kearns, William Mock, Barbara MacKay, Jeff Burger, Alan Wedner
15	Zacki Murphy, Giles Kohler
18	Uva Harden
19	Kay Sutton York
20	Maggie Smith, Robin Borden
21	Kay Sutton York
23	Elain Grove
24	Elain Grove, Bob Menna
25	Zacki Murphy, Giles Kohler
26	Romé Bernstein
28	Kay Sutton York
29	Mary Maciukas, Jo Hays
31	Arthur Bernstein
32	John MacMurray, Scott MacKenzie, Michael Taylor, Bob Pitard, Kay Sutton York, Rene Russo
33	Ted McGinley
34	Matt Collins
35	Romé Bernstein
36	Matt Collins
37	Jennifer Berrington
38	Kalani Durdan
41	Cheryl Clem, Tom Greene
44	Nancy Horn, Linda Bleir
45	Petrus Antonius
46	Regine Jaffrey
49	Kay Sutton York
50	Fiona Gordon
53	Kay Sutton York
54	Kay Sutton York
55	Tim Saunders, Bill Simpkins, Eldon Goldsmith, Michael Wiles
56	Chad Deal, Kalani Durdan, Finele Carpenter, Kevin McLean
57	Caron Bernstein
58	Gina Gibbs
62	Kay Sutton York, Shelly Smith, Matt Collins
64	Evelyn Kuhn
65	Romé Bernstein
66	Kay Sutton York, Jan Sutton
67	Kay Sutton York
69	Jennifer Barrington
70	Tony Hamilton
71	Caron Bernstein
72	Kay Sutton York, Caron Bernstein
74	Uva Harden
75	Romé Bernstein
76	Adam Brown, Joe Kyle, Justin Lord, Larry Humburger, Gaylord Roloff, Fred Harding, Phil English, Lori Butler
82	Kay Sutton York
83	Kevin McLean, Chad Deal
84	Romé Bernstein
85	Joe MacDonald, Mary Maciukas, Michael Wiles, Randall Lawrence
86	Kay Sutton York
88	Laurie Alfandre, Jane Alfandre, Diane Magruder
90	Kay Sutton York
91	Uva Harden, Heidi Lane
92	Kristi Welch, Tina Wilson
95	Kay Sutton York
96	David Olander, Brenda King
100	Cyb Barnstable
101	Kay Sutton York
103	Dayle Haddon

Equipment

Listed below is equipment I have found useful in my people photography. I recommend these quality items. For information, write to the addresses supplied. Or, see your local photo dealer.

Reflectasol
Gobosol
Softbox
Larson Enterprises, Inc.
18170 Euclid Street
Fountain Valley, CA 92708

Gossen Light Meters
Rolleiflex Medium-Format Cameras and Lenses
Rollei Lighting Equipment
Sunpak Flash Units
Berkey Marketing Companies
25-20 Brooklyn-Queens
Expressway West
Woodside, NY 11377

Minolta Light Meters
Minolta Corporation
101 Williams Drive
Ramsey, NJ 07446

Canon Cameras and Lenses
Canon USA, Inc.
One Canon Plaza
Lake Success, NY 11042

Nikon Cameras and Lenses
Nikon, Inc.
623 Stewart Avenue
Garden City, NY 11530

Gitzo Tripods and Ball Heads
Karl Heitz, Inc.
34-11 62nd Street
Woodside, NY 11377

Hasselblad Cameras and Lenses
Victor Hasselblad, Inc.
10 Madison Road
Fairfield, NJ 07006

ProStrobe 400 Lighting
Photogenic Lighting
Dave Sirken Distributors, Inc.
419 Main Street
Rochester, IN 46975

Balcar Lighting Equipment
Balcar-Tekno, Inc.
221 West Erie Street
Chicago, IL 60610

Thomastrobe Lighting Equipment
Thomas Instrument Co., Inc.
1313 Belleview Avenue
Charlottesville, VA 22901

Bannister Stand Clamp
Bannister Enterprises, Inc.
Temple City, CA 91780